The Amphoto Photography Workshop Series

CAMERAS AND LENSES

Choosing equipment to suit the task

The Amphoto Photography Workshop Series

CAMERAS AND LENSES

Choosing equipment to suit the task

Michael Freeman

AMPHOTO
An imprint of Watson-Guptill Publications
New York

First published in 1988 in the United States by
Amphoto, an imprint of Watson-Guptill
Publications, a division of Billboard Publications,
Inc., 1515 Broadway, New York, New York
10036

**Library of Congress Cataloging-in-
Publication Data**
Freeman, Michael, 1945–
 Cameras and lenses.
 (The Amphoto photography workshop series)
 Includes index.
 1. Photography. 2. Cameras. I. Title.
 II. Series.
TR145.F665 1987 771.3 86-32196
ISBN 0-8174-3654-5 (pbk.)

Editor	Sydney Francis
Designer	Christine Wood
Illustrations	Rick Blakely

Phototypeset by Tradespools Ltd, Frome,
Somerset
Printed and originated in Italy by Sagdos, Milan

The author and publishers also gratefully
acknowledge the assistance of the following:
Canon (UK) Ltd, Keith Johnson Ltd, Johnsons of
Hendon Ltd, Kodak (UK) Ltd, Minolta (UK) Ltd
and Polaroid (UK) Ltd.

All the pictures in this book were taken by
Michael Freeman, with the exception of the
following: 12 Canon (UK) Ltd; 37 Hasselblad; 58
Polaroid (UK) Ltd; 60 (top) Contax; 60 (bottom)
Konica. The picture on page 145 (bottom) is by
courtesy of Midland Bank plc/Robert Lamb & Co.

Michael Freeman, an established photographer
for nearly twenty years, has emerged as one of
the most important authors of books on
photography in recent years. He specializes in
studio, reportage and wildlife photography. His
work has appeared on posters and record
sleeves and in numerous books and magazines.
Michael Freeman's other publications include
*The Photographer's Studio Manual, The 35 mm
Handbook, Collins Concise Guide to Photography*
and *Wildlife and Nature Photography*.

CONTENTS

INTRODUCTION

The intention of this book is to provide a different way of looking at a very familiar subject. Photography begins with equipment; although the camera and lens may not be the critical factor in a fine photograph, they must at least be right for the job and you must know how to use them. What follows is not a catalogue of equipment, but a course in using it.

Photography uses a huge amount of equipment, and so creates a problem of priorities, a problem that should be settled now, at the beginning of the book. For a number of reasons, there is a temptation to think that equipment can make the photograph, in the sense that the strength and appeal of the image can come from the particular choice of camera, lens or attachment. Most manufacturers foster this suggestion, for obvious reasons, and many photographers are willing to believe it because it seems an easy and straightforward

solution to the often difficult and elusive process of making satisfying pictures.

The truth is that equipment used without talent or imagination can at best produce only a technically correct image. If all that you wanted to do was to copy documents, for example, this would be sufficient. However, I assume that anyone reading this book is looking for more personal satisfaction than that; if so, the cameras and lenses simply play a part. It is an essential part, but it is not exclusive.

This is the case against becoming too equipment oriented. Cameras and lenses are the tools of the trade, not the driving force behind the imagery. However, it is as damaging to go too far in the opposite direction, to an attitude that creative ability can always overcome inadequate equipment to produce great photographs. This is just as wrong. That some of the greatest photojournalists stick to one simple camera and

one standard lens is no counter-argument; such unassuming equipment is demanded by their field of photography. In this book we encourage a balanced view of equipment; neither a panacea nor an irrelevance.

Cameras and Lenses is a workshop in the sense that it is a practical course. Let me make a strong plea at the start: do not just *read* it. Put your hands on the equipment that we discuss, and use it in the ways suggested. For the equipment that you personally do not have, try and borrow it for a day; hire some of the items if you can, from the rental department of a camera shop. Wherever possible, throughout the book, there are projects. These are not simply extra things that you can do; they are designed so that you can discover some of the essentials by means of practice. The words alone will not teach everything; you need to do the projects to get the full value out of the workshop.

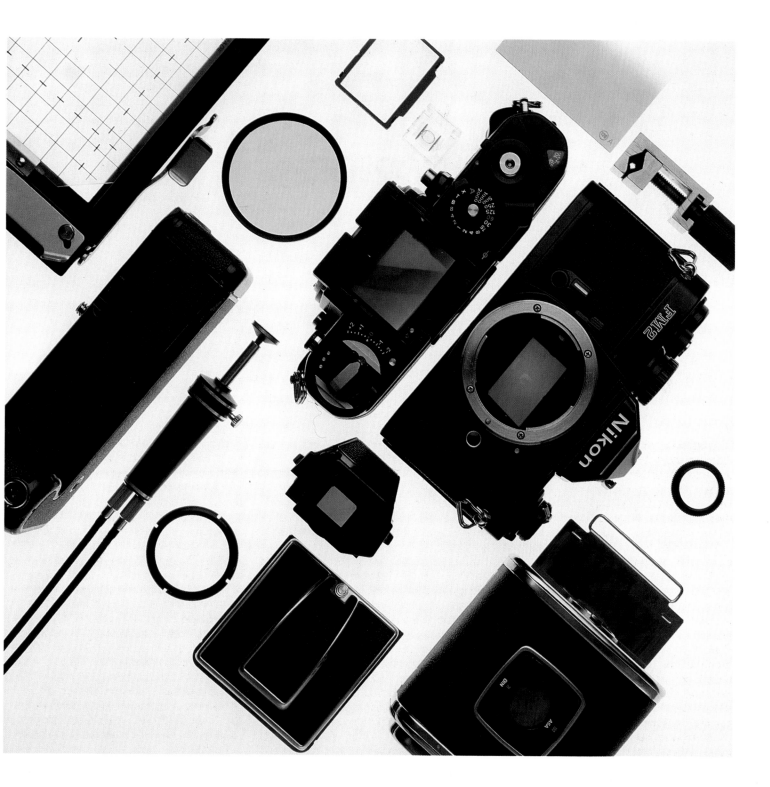

CAMERAS

In this first section of the workshop, we look at the basic mechanical unit of photography: the camera body. Above all else, the body determines the format of the photographs; most models are designed to accept only one size of film. For most photographers, this means 35mm film, although an increasing number of larger format cameras becomes available each year, fulfilling principally the needs of controlled photography.

The format has much more significance than its obvious effect on the size of the image. It affects the ways in which you can use the camera, how you can hold it, how fast you can use it; in other words, it has a profound influence on the type of photographic subject. This is one of the first and most important things that we consider in the following pages: what each camera is best suited to doing and how to make the most appropriate use of each. Modern photography is dominated by 35mm cameras, and the attention we pay to them reflects this. However, we also treat the other, larger formats – rollfilm and sheet film – even though some of these have a distinctly professional appeal. This is not only to give a comprehensive view, but also because these larger designs of camera more easily demonstrate some of the principles of photography. Though it may seem paradoxical, the largest and most professional formats of camera are in fact the simplest in design. A studio view camera, minus accessories, is the embodiment of basic photography, being little more than an adjustable, light-tight box.

The same can no longer be said of modern 35mm cameras, and if a view camera demonstrates the mechanical essentials of photography, a programmed automatic SLR conceals most of them under electronic circuitry. It is, however, important to realize that the obvious technological sophistication does not necessarily make such cameras better for taking photographs. The essentials are remarkably simple: moving the film into position, allowing the image to be framed, composed and focused, adjusting the time of the exposure and linking it to the lens controls. Beyond this straightforward set of functions, the possible improvements are mainly in the area of making operation easier. Most of the programming and micro-computer activity in a technologically advanced 35mm camera is designed to automate the process. Given identical lenses, a basic camera and a programmed automatic camera will produce images that are indistinguishable from each other in nearly every instance.

There is no attempt here to give detailed operating instructions for each camera model; the instruction booklets do that. For 35mm SLRs, we simply take representatives of the four main types: minimum automatic, programme automatic, autofocus programme automatic and professional. Each type has certain identifiable characteristics, and most of the major camera manufacturers make a range of these types. If at all possible, compare for yourself the way in which the different types work. You should find that, once you are familiar with the positions of the controls and operating procedures, there is little that is essentially different.

35mm SLR

By far the most widely used type of camera, the 35mm single-lens reflex is heavily marketed by a large number of manufacturers. While this benefits photographers because there are regular improvements, it also means that these cameras suffer more design changes more rapidly than any other. Manufacturers tend to use jargon, inventing different names for similar parts and functions, so there appear to be more types of 35mm SLR than there really are.

The idea of this book is not to help you choose a camera, but to suggest ways in which you can familiarize yourself with it. Individual camera controls now vary much more than they used to, particularly with very automated SLRs, so there is little point in running through the specifics here. Still the best method of learning the camera controls is to study the instruction leaflet; for a more objective, critical view of a particular model, read the detailed reports in photography magazines (in the US *Modern Photography* pioneered independent camera testing with strip-downs and fairly rigorous standards). This may seem obvious advice, but as the operation of automatic exposure and automatic focus can be highly specific, the user's manual is nearly always the clearest source of information.

The categories of modern SLRs are determined mainly by two things: the user that the manufacturer has in mind (casual amateur, serious amateur, professional) and the degree of automation. In fact, automation is at the heart of most of the recent design changes, and has been made possible by modern microelectronics. Every main camera function can now be automated.

Functions
The basic camera functions are limited, and do not change, whatever the model. They are the shutter operation, aperture, exposure measurement, film transport and focus. Grouped together, the first three of these make up a kind of overall function: exposure control. Which of these functions is automated, and to what degree, dis-

tinguishes the level of most of the models of 35mm SLR on the market. At the least-automated end of the range are cameras such as the Nikon FM2, which are designed to leave nearly all the controls in the hands of the user. Models in which nearly all the settings are programmed are at the other end of the range.

Automation itself takes two directions in camera design. In the first, the decisions are as much as possible removed from the photographer, and the camera provided with the minimum of controls. In the other direction, aimed at more enthusiastic owners, there are several automated modes that the photographer can select.

The idea of modes and programming, which are possible only with a central processing unit (CPU), is to group automated functions according to a choice of priorities. So, for example, in a shutter priority mode, the shutter speed remains fixed at one setting chosen by the photographer, while the aperture is altered according to the exposure measurement. The Canon T90's "variable-shift programme," shorn of the jargon, gives priority to either shutter speed or aperture depending on the lens focal length (conventionally, a reasonably high shutter speed is preferred with a telephoto lens to avoid camera shake, and good depth of field is a priority with a wide-angle lens).

Over/under exposure indicator when on non-automatic exposure

Shutter speed indicator

Aperture indicator

Ready light when electronic flash connected

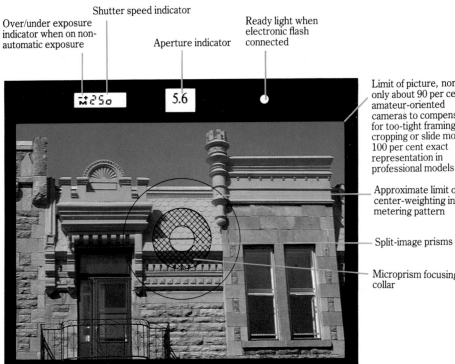

Limit of picture, normally only about 90 per cent in amateur-oriented cameras to compensate for too-tight framing, cropping or slide mounts; 100 per cent exact representation in professional models

Approximate limit of center-weighting in metering pattern

Split-image prisms

Microprism focusing collar

Basic display
Viewfinder displays are specific to each make and model. The complexity of information usually reflects the degree of automation in the camera. This display is from a Nikon F3, a professional and therefore moderately automated camera.

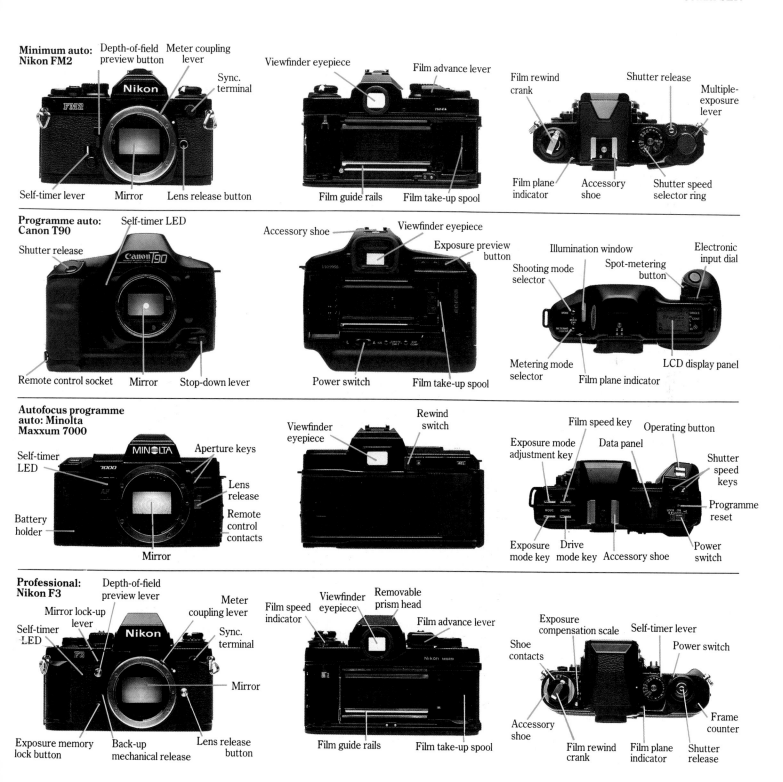

Minimum auto: Nikon FM2

Depth-of-field preview button
Meter coupling lever
Sync. terminal
Self-timer lever
Mirror
Lens release button

Viewfinder eyepiece
Film advance lever
Film guide rails
Film take-up spool

Film rewind crank
Shutter release
Multiple-exposure lever
Film plane indicator
Accessory shoe
Shutter speed selector ring

Programme auto: Canon T90

Self-timer LED
Shutter release
Remote control socket
Mirror
Stop-down lever

Accessory shoe
Viewfinder eyepiece
Exposure preview button
Power switch
Film take-up spool

Illumination window
Shooting mode selector
Spot-metering button
Electronic input dial
Metering mode selector
Film plane indicator
LCD display panel

Autofocus programme auto: Minolta Maxxum 7000

Self-timer LED
Aperture keys
Lens release
Battery holder
Remote control contacts
Mirror

Viewfinder eyepiece
Rewind switch

Film speed key
Operating button
Exposure mode adjustment key
Data panel
Shutter speed keys
Programme reset
Exposure mode key
Drive mode key
Accessory shoe
Power switch

Professional: Nikon F3

Depth-of-field preview lever
Mirror lock-up lever
Meter coupling lever
Self-timer LED
Sync. terminal
Mirror
Exposure memory lock button
Back-up mechanical release
Lens release button

Viewfinder eyepiece
Removable prism head
Film speed indicator
Film advance lever
Film guide rails
Film take-up spool

Exposure compensation scale
Self-timer lever
Shoe contacts
Power switch
Accessory shoe
Film rewind crank
Film plane indicator
Shutter release
Frame counter

11

Most camera users are amateurs, and the degree of complexity in the automatic controls normally shows whether the manufacturer intends an amateur or professional to buy a particular model. Professional users stand slightly apart, and there exists a category of 35mm SLR aimed at them. Professional cameras are distinguished by a few obvious features: the automation is restricted and not cosmetic, there are manual overrides to the automation and some simple back-up systems, usually mechanical. Construction is stronger, usually die-cast metal rather than ABS plastic, and they are highly adaptable, with means of interchanging viewing heads, screens and so on, as well as attaching a big range of accessories. Professional/amateur distinctions are, however, blurred by two things. First, a manufacturer's professional model is also the top of the range, and its

professional "status" makes it attractive to serious amateurs. Second, many professionals have turned to advanced-amateur models like the Nikon FM2 and the Canon T90, sometimes to the surprise of the manufacturer.

In the Camera Handling section of this book (pages 126 following) we will go into the details of camera operation, but for the time being, let us look at the essential knowledge about the basic camera functions, automated or manual.

Shutter
The focal plane shutters in 35mm SLRs travel across the rectangular film gate either horizontally (the more traditional method) or vertically. In some models, flexible drum-mounted curtains are used, in others a set of blades. Modern improvements include high-strength light-

weight metals such as titanium, textured ribbing to the curtains or blades, electromagnets for instantaneous release, high-voltage drives and more efficient shutter brakes. All these improvements are aimed at faster operation, which allows not only higher top speed ($\frac{1}{4000}$ second is not uncommon) but also flash synchronization at higher speed settings ($\frac{1}{60}$ second used to be the normal limit; $\frac{1}{125}$ second and $\frac{1}{250}$ second are now common). When selected manually, shutter speeds are stepped in one-stop increments, but models with electronic automatic exposure can set the speed variably in aperture-priority mode.

The normal means of releasing the shutter is the button-like release on the camera's top plate (a central threaded hole to accept a cable release is also normal), but electronic operation in many models makes remote triggering straightforward; all that

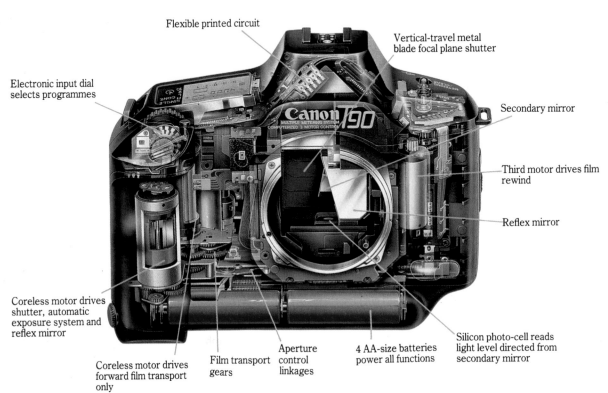

A cut-away of one of the more advanced auto cameras shows the increased importance of two elements: flexible circuitry for the micro-electronics, and motors. By separating the drives into three coreless motors, the designer has improved efficiency by tailoring each motor to one function, placing each close to its mechanism, and allowing independent control. The result is a small battery requirement: 4 AA-size with a small lithium back-up for the memory.

Flexible printed circuit

Vertical-travel metal blade focal plane shutter

Electronic input dial selects programmes

Secondary mirror

Third motor drives film rewind

Reflex mirror

Coreless motor drives shutter, automatic exposure system and reflex mirror

Coreless motor drives forward film transport only

Film transport gears

Aperture control linkages

4 AA-size batteries power all functions

Silicon photo-cell reads light level directed from secondary mirror

Sensor in prism head reads off viewfinder display

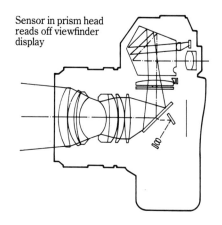

Sensor in base reads off secondary mirror

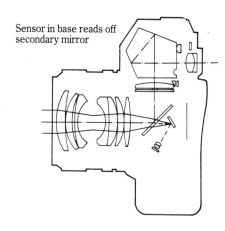

Sensor in base reads directly off film

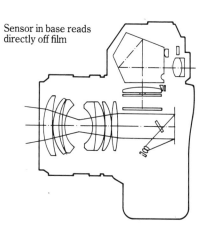

is needed is some means of closing a circuit, which can be as simple as bringing two wires together. Traditionally, the wind lever on the top plate tensions the shutter, but many of the latest electronic cameras dispense with this.

Aperture

The aperture diaphragm is, naturally enough, sandwiched between the groups of elements in the lens, but its controls in a fully-automated camera are likely to be in the camera body as well as in a ring surrounding the lens barrel. The metal-blade design of the diaphragm is consistent and traditional; when the aperture is selected manually, the settings are usually marked in full *f*-stops on the ring, with clicks at ½-stop intervals. Linkages in the form of pins and levers pass information mechanically between the aperture diaphragm in the lens and the camera controls. Normal viewing is at full aperture, so that one linkage is reserved for stopping down the diaphragm to the working aperture a moment before the shutter opens. Another linkage may be needed for the depth-of-field preview button. For metering purposes, a lever must indicate the aperture setting, while cameras that allow automatic control of the aperture (in shutter-priority mode) must have yet another linkage for changing the setting. Four linkages are normal on an automated camera.

Exposure measurement

Even a bare-bones manual SLR such as the Nikon FM2 contains a through-the-lens (TTL) metering system. The internal differences between cameras are mainly in the location of the sensors and from which part of the light path inside the camera they take their information. More obvious from the user's point of view are the differences in the parts of the image that are being measured. There are a number of possible sensor locations inside the camera body, but the most usual now are below the reflex mirror or in the prism head. Sensors in the

▼ **The mechanical sequence in shooting** Just before the shutter release is pressed, the reflex mirror is down and the automatic diaphragm of the lens held wide open to allow unrestricted viewing **1**. As the release is pressed **2**, the mirror rises, the lens stops down to its pre-set aperture, and the shutter blades open. If the camera is being used in an automatic shutter priority mode, the metering system will signal the setting of the aperture diaphragm just before exposure.

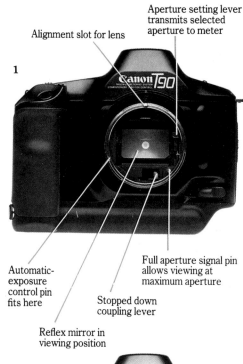

Alignment slot for lens

Aperture setting lever transmits selected aperture to meter

Automatic-exposure control pin fits here

Stopped down coupling lever

Full aperture signal pin allows viewing at maximum aperture

Reflex mirror in viewing position

prism head can read the viewfinder display; a sensor element at the base of the camera can read either directly from the film surface or from a secondary mirror hanging behind the main mirror. Some models use a combination of methods to allow for different metering modes.

Prism head sensors are reasonably straightforward; a normal precaution is to shade the eyepiece from bright light. Readings taken directly off the film have the potential for extreme accuracy, and this system simplifies TTL flash metering by being able to monitor the exposure as it is being made. Treating the front of the shutter so that it has the same reflectivity as the film makes it possible to take continuous readings before the exposure.

Readings from a secondary mirror that is attached behind the reflex mirror are better than off-the-film readings when just the center of the image area is being read, and when some kind of memory lock is needed. In the Nikon F3 system, a central area of the reflex mirror is covered with about 50,000 unsilvered points which together pass 8 per cent of the light through to the sub-mirror. Fresnel lenses on the sub-mirror concentrate the light and direct it down to a silicon photodiode which is fronted with condenser lenses to give a strong center-weighting to the reading.

The weighting of the exposure measure-

DX coding
A rectangular metallized pattern on the film cartridge is read by a strip of contacts inside the film chamber of the camera, and indicates the film speed. Automatic cameras with this feature normally transfer this information directly to the metering system. The contact strip must be kept clean.

ment has the greatest practical effect for the user. The most common metering pattern gives greater value to the center of the picture, where most photographers place the center of interest. The exact pattern varies from overall with a center bias, to just the center alone. There is often a circle engraved on the focusing screen to show the limits of this central area. An alternative pattern is spot metering, in which a very small circle (less than 3 per cent of the picture area in the Canon T90) is measured. This pattern is only practical with a memory lock, so that a part of the picture can be measured, the reading

stored, and the image then re-composed.

On a different level of sophistication are patterns that synthesize readings from several areas of the image. The result depends on a predetermined set of rules which has been drawn up by analyzing a large number of exposure situations, and stored. For example, a high level of light in a small off-center area is more likely to be a bright light than an important part of the image, and would be treated as such. The Nikon FA and Olympus PC or OM40 employ variants of this method. It goes some way towards what are called expert systems in the world of computers – programmes drawn from

Center-weighted average metering
In this, the most common metering pattern, the entire picture area is read and the light values averaged – with the addition that the center of the frame is given extra emphasis. The very top of the frame, normally occupied by the sky in typical outside views, is under-rated.

Strong center-weighted metering
Here, the central 12 to 15 per cent of the picture area is given a strong weighting. This area is usually marked by a 0.5 inch (12mm) diameter circle engraved on the focusing screen. In most Nikon models 60 per cent of the sensitivity is concentrated here; in the F3 80 per cent.

real-life experience giving solutions that have been found to succeed.

Exposure control

The last three functions, when interlinked, allow the exposure settings to be implemented directly, without involving the need for a decision from the photographer. Overtly sophisticated models like the Canon T90 make a show of allowing the photographer to select various modes; in essence, this means letting the user choose priorities. All of these exposure systems work well, but it is essential if you own one that you know what the methods are. No exposure system is appropriate for all situations. Indeed, since a premise of this *Workshop* series is to experiment with different ways of doing things, it is probably more important to know how to override an automatic system.

Film transport

Traditionally, the wind lever draws the film from its cassette across the film gate and from there onto the take-up spool. Many models, however, will accept a motor-drive or power winder, and a few have these motors built into the camera body. Although the power drain is substantial, there are several advantages. The drive moves the film as soon as an exposure is finished, so that the camera is ready for the next shot

very quickly. Also, there is no loss of concentration and, as an incidental benefit, the camera can easily be triggered by remote control or according to a timer. The difference between a motor-drive and power winder is that the former allows continuous shooting, in automatic bursts. Most advances in this area are aimed at improving the energy transmission, so that smaller motors and fewer batteries are needed.

Focus

Sharp focus is one of the basics of photography. To make it easy to achieve, the operation of the focusing gears in the lens barrel are made as smooth as possible; light transmission through the reflex mirror, focusing screen and pentaprism is kept as high as possible; and various devices are incorporated into the focusing screen (microprisms, split-image prisms and so on).

More recently, automatic focus has been incorporated in some models, such as the Minolta Maxxum 9000. In this camera, which has one of the most advanced autofocus systems, the method used is phase detection: some of the light from the center of the image passes through the semi-transparent reflex mirror, strikes the secondary mirror and is directed to the focus-detection module. Here, two small lenses separate the beam of light into two. A charge-coupled device then generates a

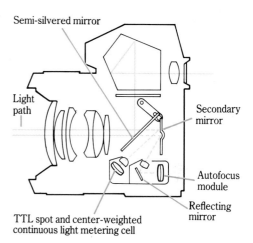

Semi-silvered mirror

Light path

Secondary mirror

Autofocus module

Reflecting mirror

TTL spot and center-weighted continuous light metering cell

This cross-section of the Minolta Maxxum 9000 shows the location of the metering cell and autofocus module. The viewfinder image is surprisingly bright, although 40 per cent of the light does not reach the screen.

signal from each beam; if both signals are in phase, the focus is sharp, but if not, a motor drives the lens focusing system until it is. Operation is fast and accurate with most subjects, but responds poorly to low-contrast scenes. A subject moving rapidly either closer or further away can also beat the system; but then it can beat manual focusing too. If the part of the picture that you want to have sharply in focus is off-center, the focus must be locked onto it first and then the image re-framed.

Spot metering
All the sensitivity is concentrated in about 3 per cent of the picture area – a small central circle indicated on the focusing screen.

Synthesized metering
The pattern shown here is from the Nikon FA. Each sub-division is read independently, the relative values compared and the exposure set according to a programme.

35mm SLR: The Universal Camera

In the same way that lenses can be interchanged on a 35mm SLR, so can the fittings for any optical system. This may sound specialized, but the range of applications is so large that virtually any means of making an image can be connected to this camera body. This means that there are a number of intriguing possibilities in adapting a camera to different uses. Although most of the ways of adapting are purpose-built by the camera or optical system manufacturers, custom fittings are also possible, and some of these are within the capability of anyone with a small workbench.

The range of applications is shown in the table, and some of the more available fittings illustrated *right*. The two features of a 35mm camera that make it practical to adapt are the reflex viewing and the small format. Simple reflex viewing means that focus and any other feature of the image can be checked instantly, no matter how the picture is projected onto the focal plane. The small film size means that the distance from the lens flange to the film is short – about 1½ inches (50mm) – so that adjusting the focus from any optical system that projects onto the eye, such as a microscope or telescope, is no great problem. The machining tolerances, however, are fine.

The basic requirements for attaching a 35mm camera to another optical system, which may be no more complicated than a lens from a larger format camera, are the design of fitting found on the rear of normal lenses (and available inexpensively from many manufacturers in adaptor rings) and a means of securing this to the viewing end of the telescope, microscope or whatever. If these use standard threads or bayonet mounts, this is straightforward, otherwise some kind of locking collar is needed (common with microscope adaptation). In addition, the film plane in the camera body must be positioned at the focal point of the new optics. This may mean extending the camera body if the focal length is considerable, or it may mean inserting an extra lens element to convert the image.

Application	Special lens needed	Adaptor needed to other optical system	Other accessories necessary
Astrophotography	No	Yes	
Close-up	Preferable	No	Lens extension
Copying	Flatfield preferable	No	Stand, even lighting
Data recording	No	No	Data back, sometimes automatic operation
Endoscopy	No	Yes	Fiber optic lighting
Fish-eye	Yes	No	
Image enhancement	No	Yes	
Infra-red	No	No	Infra-red film, possibly infra-red lighting
Long telephoto	Yes	Teleconverter in some circumstances	
Multiple exposure	No	No	Sometimes stroboscopic lighting
Oscilloscope recording	No	Yes	
Photomacrography	Yes	No	Lens extension, reversing ring, special lighting
Photomicrography	No	Yes	Special lighting
Remote control	No	No	Command or self-activating triggering, either contact closure or radio/beam. Possibly bulk film back
Stereoscopy	No	Yes	
Time-lapse	No	No	Intervalometer, possibly bulk film back
Underwater	No	No	Housing, possibly conversion lenses
Ultraviolet	Depends on wavelength	No	Suitable film, special lighting
VDU Recording	No	Sometimes	Housing

Six types of photography in one assignment
Although a professional assignment rather than an amateur project, a wide-ranging story on pearls could be photographed on one format: 35mm. The range of equipment used is shown in the layout *right*; the take, examples from which are shown *below*, covered six distinct areas of photography: still-life, studio portrait, underwater, photomacrography, photomicrography and basic reportage.

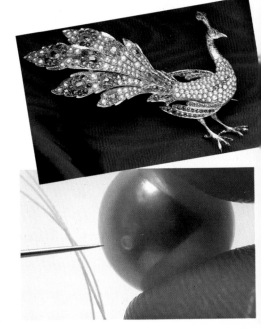

Fittings for a range of applications

The combination of reflex viewing and a hand-sized camera body makes it a simple matter to use a 35mm SLR with a variety of optical systems, not all of them purpose-built for the camera. Some of the more usual extensions of the system are shown here, ranging from photomacrography and close-up work to very long focal lengths and remote control.

Bellows extension for photomacrography

Fast super-telephoto

Optical adaptor to attach 35mm camera to microscope

Triggering socket on motor-drive or power winder allows a variety of remote operation methods

Reversing ring to improve lens performance when lens-to-film distance is greater than lens-to-subject distance

Set of extension tubes for close-up

Custom-built adaptor to fit 35mm to larger format lens

Tele-converter increases magnification of telephoto lenses by 1.4 ×

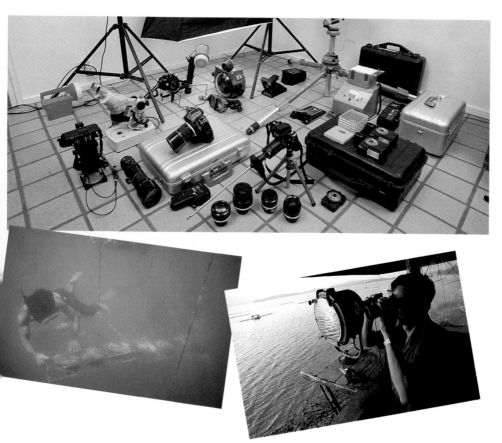

17

Project: Street photography

Despite what we have seen already – that the 35mm SLR can be put to almost any photographic use – it really excels in the kind of situation where a camera has to be used rapidly and unobtrusively, without appearing to make a major production or to involve a great deal of setting up. These cameras were, after all, invented precisely to make photography fast and simple.

One of the best practical ways of learning to work with a 35mm SLR is in its classic use, street photography. This means, as you might expect, covering an area of town or city on foot, responding to whatever picture possibilities occur and shooting either candidly, or at least without posing people or "improving" situations by interfering. In street photography, the situation rules; you are the observer, and the onus is on you to be aware and to react. Although it is part of the repertoire of a photojournalist and has a kind of internal discipline, street photography can be practised purely for your own interest and pleasure.

Here, we are going to use this form of photography as part of the learning process, and make a project out of it. The example shown here and on the next few pages is a useful demonstration in itself, but it is intended as no more than an example. The real value is in doing this for yourself: take at least a couple of hours, prepare the equipment and film with a little forethought, and then just walk the streets. The practice of simply being out and observing people will begin to teach you some interesting points about using the camera – and not everything you learn will be as you expect. In particular, what should come across fairly quickly is how little of the business of taking a photograph is tied up in the sophisticated machinery of the camera, and how much depends on seeing a potential picture and reacting quickly enough to seize it.

To simulate this, I have taken a continuous sequence of frames from an afternoon of real "warts-and-all" street photography in Singapore, including non-starters as well as some shots that worked out, and presented it with a running commentary. This kind of project is not as useful if you just select the best shots and admire those. Particularly when shooting transparencies, which most laboratories mount individually, the temptation is to throw away the duds immediately. Instead, with this and all of the projects, pause first, look at the take in its entirety, and at least learn from the mistakes and near-misses. The first part of this project is to think about it while you are doing it; the second part is to review the pictures when they are developed. For this, it is important to lay out all the frames in sequence: if you are using black-and-white or colour negative, make sure that the strips are in order on the contact sheets; if you are shooting slides, order them in a slide projector or lay them out on a reasonably large light box.

First, the circumstances. Space allows only a roll and a half of film here, but the complete half-day take was nearly four rolls – about 130 frames – shot in almost three hours. Do not read too much into this rate of shooting; it is certainly less than some photographers would use in the same circumstances, but also more than others. Equally, it is both more and less than I might use at other times. It depends as much on what you consider is worth photographing as on the richness of the situation, and also on how generous or economical you allow yourself to be with film.

The running commentary explains all the important points as the shooting progressed (staying alert to all the picture possibilities allows little time to consider the reasons behind all the decisions). With this completed and the developed film returned, we can move on to the next stage: drawing some conclusions. What can we learn from looking at a sequence of street pictures like these? To me, the most striking feature of any street photography take is how personal the choice of subject is, and how much the treatment differs from one photographer to another. Compared with most other types of photography, street shooting is very subjective indeed. Look at the way in which other photographers go about the same subject and you will start to see more clearly the decisions that you make in choosing the subjects, lenses, timing and so on.

This is why there is little value in looking for definitive lessons in one example from another person. Use it more as a basis for comparison with your own results, but be cautious about making value judgements on the choice of subjects. Inevitably, each photographer is drawn to what seems appealing at the time, so that in being critical of your own project, concentrate on your timing, framing, choice of viewpoint and lens, rather than on whether you should have been aiming at something else entirely.

The important objective lessons to be learned from this project are:

● Familiarity with the equipment pays dividends. Technical mistakes, such as those of focus and exposure, are the silliest to make and the most frustrating to see in the returned film. Efficient use of all the camera and lens controls comes under the heading of camera handling, and this is dealt with in detail in the last third of the book.

Clearly, the more familiar you are with your equipment, the fewer the technical mistakes. You will also be able to frame and expose a shot more quickly; a matter of importance in street photography, where there may be only a short gap between seeing a picture and having to take it before the person moves on or the situation changes. The man sleeping in two frames at the beginning of the sequence is obviously not going to move quickly, but the Indian woman cleaning her daughter's face took only a number of seconds. A special point to note here is that, if telephoto lenses are used, accurate focusing takes up a fraction of a second more time for each shot than when standard or wide-angle lenses are used. Street photography itself helps create familiarity through practice.

● This kind of photography heightens awareness. Looking for potential pictures as you walk will make you more observant. At the same time, of course, a relaxed walk may lose you some pictures by denying you the edge of anticipating an interesting gesture or juxtaposition.

● Chance plays a considerable part in most street photography, and it is often not possible to predict how successful the shooting will be on a particular day. This means that, generally speaking, the more hours a photographer puts in walking the streets, the better the odds. You cannot rely absolutely on taking another few good pictures from one more hour of looking, but on balance it often happens like this. Some planning can also help; in this example, a guide book had already suggested some interesting locations, such as the brightly painted Hindu temple that ends the sequence. The best shot may be entirely fortuitous, but a little research can only help.

● Analyzing which lenses you have used may give you some useful pointers as to the type of shooting you prefer. Six lenses and one camera body were carried on this day's shooting, but the bias of those actually used was very much towards the telephotos. Over the remainder of the rolls of film the standard and wide-angle lenses were used a little more, but still less than the longer focal lengths. The reasons were partly the physical setting of the streets, and partly the photographer's preference for being able to observe from a slight distance. Medium-telephoto shooting like this is reliable, as subjects move less relative to the camera, but it may also be less exciting than shooting close to the subject with a shorter focal length.

One clear point is that if you are carrying a range of lenses, you will be likely to use them. The advantage of such interchangeability is visual variety, even though most people would probably find that six lenses – and one of them 400mm – rather too much to carry constantly. (See the two shoulder bags with their different layouts of equipment on pages 160–1.)

This project is also ideal for a 35mm viewfinder camera, but even with models that allow interchangeable lenses, the lack of reflex viewing puts an upper limit on the strength of telephoto lenses. Not that more lenses make better pictures; they simply give a greater choice.

Which lenses were used most
One camera and these six lenses made up the full complement of equipment for this sequence of street photography. Of the 48 frames shown here, more than three-quarters were shot with the two medium-telephoto lenses, evidence that the photographer concentrated on across-the-street views. The 35mm moderate wide-angle, which might have been the prime lens for another photographer, was not used once.

400mm
f 5.6
8 frames

180mm
f 2.8
19 frames

105mm
f 1.8
15 frames

35mm
f 1.4
0 frames

24mm
f 2
4 frames

55mm macro
f 3.5
2 frames

Camera body with motor-drive

1 105mm lens. Underexposed through inattention and trying to include the woman in the shot.

2 Closer with the same lens for a tidier picture, but the man in the doorway at the right is staring, and will certainly continue to do so as long as the photographer is there. The view is a little dull in any case, so abandon it.

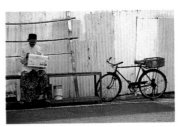

3 This shot is obvious from a distance, but the photographer waits until directly opposite so as to fill the frame with a bare wall background. This shot is a little overexposed.

7 This attempt to tighten the composition slightly cuts the figure a bit too close on his foot.

8 With the 105mm lens back on the camera, a quick shot of this nice old Chinese café to catch a figure passing. A pity there is no-one visible inside; perhaps worth waiting for.

9 After a few minutes a woman sits down. By this time, the photographer has decided on a closer view of the interior, and has fitted a 400mm lens.

13 Now that there are figures on both sides of the corner column for balance and activity, the 105mm lens shows something of everything. Time to move on.

14 A fairly pleasant combination of colours. Worth one shot.

15 Across a busy street, the 180mm lens is the right focal length for this kind of horizontal shot which includes a full-length figure. The balance is all right, but not perfect.

19 The wall turns out to be that of an Indian temple, with a view of a man praying through the doorway. A lot wrong with this picture! Bad framing leaves a section of irrelevant notice board visible, focus on the wall leaves the image of the man soft, and the exposure is over.

20 A square-on view. Wait for a passer-by, but the 1/125 second exposure needed for the shadowed interior blurs the walking feet.

21 It seems to make more sense to compose the picture using only the elements of wall and doorway and so avoid the blur problems of a figure.

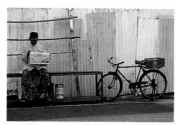 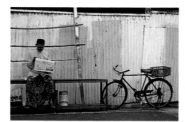 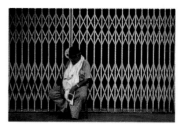

4 The pale wall in the central metering area of the frame causes some doubts about exposure, so the aperture is reduced half a stop.

5 The man has still not looked up, allowing time for a slight change in composition, raising the camera to lose the empty pavement.

6 Nearby, another man from across the street. The metal shopfront grille gives a chance of simplifying the shot, but only by changing to a longer lens: in this case 180mm.

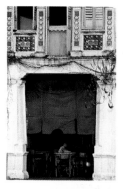

10 Unfortunately, the close view loses the best part of the exterior tile work, which was what caught the photographer's eye in the first place. Change to the 180mm lens for a compromise shot.

11 Looking for a better viewpoint from a position a few yards further on, with the same lens. The cook is visible, but in shadow.

12 After a short wait, the man comes into the sunlit area (the exposure has already been pre-set for this).

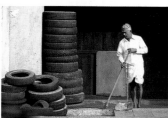 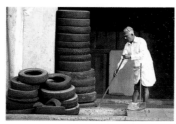 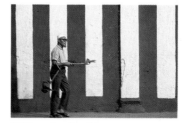

16 Framing improved by waiting for the man to move closer to the tyres. More of these in the picture helps its balance, but a passing vehicle spoils the lower left corner.

17 Essentially the same as the last frame but photographed a second or two later.

18 The painted wall is very appealing, but needs something else. Wait for a passer-by.

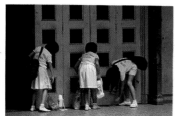 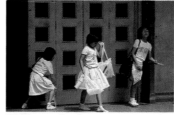 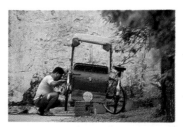

22 Nothing more shot for about 15 minutes; then this school entrance with three girls. Are they entering or leaving? Will they turn round and face the camera, or go in? There is no real justification for this shot, as no faces are visible and the attitudes are not special.

23 They are leaving, allowing time for just one shot with the 105mm lens.

24 This is a city where bicycle trishaws are a part of the scenery. Seen from the end of the alleyway, it needs the 400mm lens for a quick, moderately frame-filling shot. The out-of-focus leaves add nothing but are unavoidable.

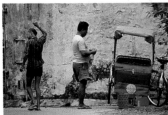

25 One way of cutting out the leaves without changing camera position drastically is to wait for a passer-by, and then re-compose the shot.

26 A song-bird in its cage: very typical, and the pastel colours are pleasant. The 105mm lens keeps other background elements out of view.

27 Incense-stick holder; good, simple colours. A standard 55mm lens was used.

31 The cow is on the wall of a Hindu temple, and sits oddly with the street signs.

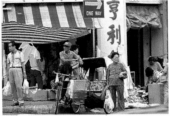

32 Busy street corner, many things visually but with the trishaw as a static focal point. Taken with a 180mm lens.

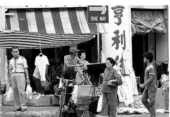

33 Another as before, but with one more pedestrian.

37 A furniture workshop.

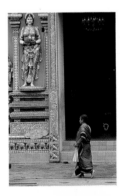

38 The spectacular exterior reliefs of this Hindu temple (well-known and marked by the photographer to visit) are irresistible. A quick first shot to juxtapose a figure with a woman visitor.

39 Here and the next two frames: details of the brightly painted sculptures.

43 A re-composed shot to feature a tall, standing figure. Some minutes later, the girl who entered in the previous shot leaves.

44 The setting is different, but the essential design elements are the same as in the last picture: 24mm lens, small figure in the lower corner.

45 A small girl plays around the pillars. Used like this, a wide-angle lens gives the impression of being pointed away from an off-centered figure, so that candid shooting is still possible, even from a distance of a few feet.

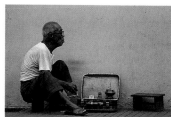

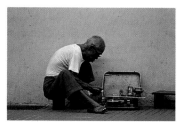

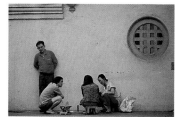

28 Another across-the-street shot, but needing the 400mm lens for this close view of a fortune-teller. The light allows a shutter speed of only 1/125 second, so the photographer uses a lamp-post as a support

29 In case the previous picture was not free from camera shake, another exposure for insurance. Both turned out sharp.

30 Another fortune-teller, this time in action. Change to 180mm lens.

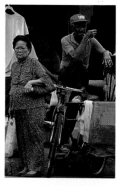

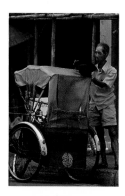

34 The same scene, but change to the 400mm lens for a much tighter shot.

35 Still with the 400mm lens and from the same camera position, another trishaw driver, with a fine hat.

36 A repeat shot, a second later.

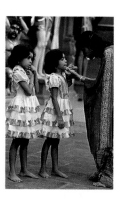

40

41

42 A pre-set position with a wide-angle 24mm lens view, waiting for someone to enter or leave the far doorway and complete the composition.

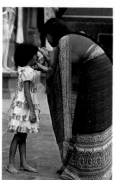

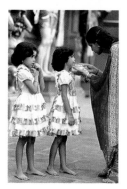

46 The same location; 105mm lens. Although quite close, no problems about natural shooting: mother and daughter are too preoccupied.

47 The mother knows by now that the photographer is taking pictures, but does not mind. Far from it; her daughters are dressed at their best for prayers.

48 A repeat shot, half a stop darker.

Project: Active subjects

This project is on a more intense level than the street photography that we have just looked at, and encounters an immediate practical problem: actually finding the concentrated action that makes up the subject. A news photographer, for instance, would have the edge in finding a fire-fighting situation of the kind shown here, but as it happened, this was not the case. The sort of action which contains some urgency with people rushing about is, by its nature, unpredictable. This, however, is a lesson in itself: some of the most exciting pictures that you can take with a 35mm camera are in unpredictable, short-lived circumstances, and the only way of being able to capture them is by being prepared and by being able to shoot quickly and confidently. Admittedly, we are plunging in at the deep end with the fire-fighting sequence shown here, but it seems better to use a real example of an active and urgent subject than to make do with something quieter.

The purpose of this project is both as a test for how familiar you have made yourself with the basic equipment, and as a demonstration that complete planning is just not possible in much of photography. On a practical level, some organized events, or even just horseplay among a group of friends, may offer enough movement and activity to practise working at speed. Political demonstrations are certainly not recommended – the action there can be unpleasant. As a back-up example, I have included a sequence of wildlife shots because, given an accessible location, it may be relatively easy to predict some fast activity. In this case, the birds are fighting for nesting places, and although there is no possibility of getting really close and moving around yourself, this kind of situation is predictable. If you have an interest in wildlife photography, you can probably find something similar.

Preparation is even more important for this project than for most others in the book; if your equipment is not ready to go, you will miss the shots. It involves nothing very complicated, simply having the camera loaded with the right film, batteries in working order, suitable lenses and reserve rolls of film. As for the last project, look at the way the camera bags are shown packed on pages 160 and 161. Some photographers like to carry with them one camera and one lens all the time so as not to miss anything.

As with the street photography example, look first at the sequences of frames. In the fire-fighting scene, 8 frames have been selected from 134 (nearly four rolls) for reasons of space; nevertheless, they are representative, and include two short

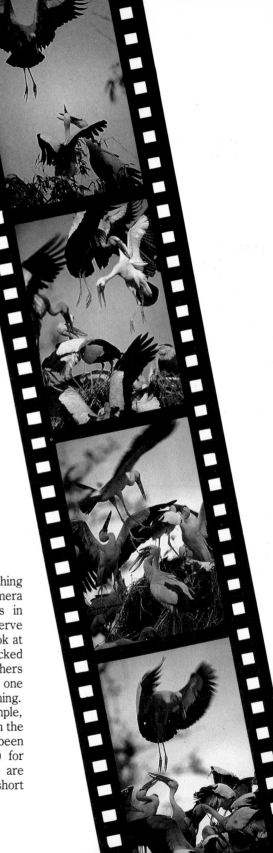

bursts. The shooting took about 45 minutes, although the urgency had gone out of the situation after half an hour. By contrast, the sequence of birds squabbling was shot over about ten minutes from one fixed position with a long telephoto. In both cases a motor-drive was used, but was only actually necessary in a few short bursts of action during the fire. In neither case was the motor-drive set to "continuous"; quickly repeating pressure on the button was sufficient for these shots.

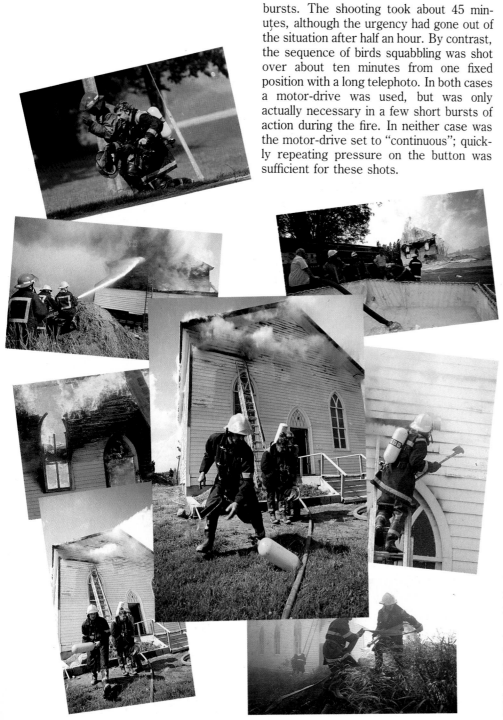

Key points

● The shutter speed is important and, generally, the faster the better. A suitable film speed is essential, allowing for the maximum aperture of your lenses, and it is sensible to have a choice – for instance, ISO 64 and ISO 200, or ISO 100 and ISO 400. If possible, assess the possible lighting range at the start. Will the action move in and out of shadow? Is the daylight deteriorating?

● Uncomplicated equipment is best, to avoid getting lost in a confusion of lens changing. The birds needed a long lens and no other; the fire was shot on just three lenses, 24mm, 35mm and 105mm, of which only two are represented in these frames.

● Action usually looks the most powerful if it fills the frame. As a general rule, then, either be close yourself or use a lens that is long enough. In the case of the fire-fighting, all but a few of the frames here were shot with a 24mm, since this lens, used very close to the scene, gives a more involved, subjective impression to the viewers: one of actually being there.

● The main ability in this type of photography is fast reaction, based on familiarity with your equipment. Ideally, you should be able to point and shoot intuitively, without having to think about the settings. An automatic camera makes this easy, except in shots where the positioning of the subject or the lighting are unusual. Automatic exposure and autofocus in a camera have similarities with automatic transmission in a car: in most circumstances they are simpler to use, but relying on them constantly makes you less able to switch confidently to manual when you need to.

The second important ability is moment-to-moment anticipation. If you can sense what is likely to happen next, you can get into a better shooting position and perhaps change to a different lens. This comes partly from experience, and partly from knowing something about your subject.

35mm SLR: Remote Operation

A slightly specialized use of the camera is a set-up in which the exposures are made at a distance or even without any direct supervision. There are only a few circumstances that justify this type of operation, but if they occur there is usually no alternative for taking a picture. One is where the presence of a person – the photographer – would upset the subject, and the most common situation where this happens is in wildlife photography.

The examples shown here are a case in point. Animals with their young are usually especially sensitive to danger, and as close shots like these would normally need the photographer to be very near, the adult stork might react badly. Remote control is a solution to this problem, and is possible because the nest is a fixed site and the camera, once set up to frame the nest, does not have to move. The nest can then be watched from a distance with binoculars and the remote control lead used to trigger the camera at appropriate moments.

Another situation for remote triggering is where there is room only for a camera, not for the photographer as well. For example, a vertical overhead shot from a height might need substantial scaffolding if a person has to climb up and take the shot, but if all that has to be positioned is a camera weighing a few pounds, the problem is mechanically much simpler. A certain amount of calculation and even guesswork may be needed for composing the shot, and a two-way spirit level is a useful accessory, as is Polaroid 35mm film to check the results before shooting for real. Incidentally, as is shown in the set-up here, the spirit level can be used to indicate angled camera positions, not just vertical or horizontal shots.

A third situation is where a series of precisely timed shots needs to be taken; for example, a sequence of a flower opening and closing. The normal way of treating this kind of shot is to connect the camera to a timing device known as an intervalometer.

While a 35mm SLR is not the only camera

Remote wildlife set-up
With the camera fixed on a tripod, framed and focused on the nest, the shutter was triggered at a little distance by the photographer, who was concealed from the bird's view. Too-tight framing resulted in some unsatisfactory shots, as the first of this sequence shows.

Suspending a camera
In the rigging shown here, the camera is pre-set at a particular angle and the accessory spirit level then levelled on both axes. When the camera is suspended, the rigging can be adjusted by observing the spirit level.

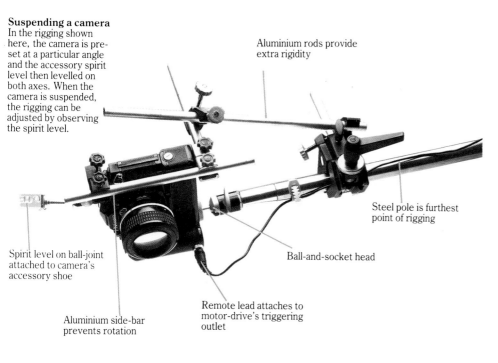

Aluminium rods provide extra rigidity

Steel pole is furthest point of rigging

Ball-and-socket head

Spirit level on ball-joint attached to camera's accessory shoe

Remote lead attaches to motor-drive's triggering outlet

Aluminium side-bar prevents rotation

that can be triggered in these ways, it is the most adaptable. Being relatively small, it is convenient to maneuver, particularly if being rigged out into an unusual position and, as models are increasingly designed with automatic features, the settings can be operated independently. Note, however, that a motor-drive or power winder is virtually essential for a sequence. There is not only a severe limit to the length of cable that will trigger the standard shutter release on the top plate, but winding on is hopelessly inconvenient if you have to approach the camera each time.

The simplest triggering method is to take two leads off the remote control socket and work out a convenient method of bringing the ends into contact. Working details are discussed in detail on pages 168–9. Alternatively, and more elaborately, you can use radio triggering or an infra-red beam. Both of these systems are available from camera manufacturers, although a radio system of the type sold for remotely operating models can be adapted very easily. The less obvious disadvantages of radio triggering are interference, screening and activation by other transmitters nearby. Infra-red triggering needs line-of-sight access.

Camouflaging a remote camera
For wildlife photography, the camera will usually have to be concealed from sight. A waterproof covering and camouflage material are usual, possibly with a sound-proofing blimp if the subjects are likely to be disturbed by noise (see page 31).

Accessories

What items count as accessories depends very much on your point of view. Here, we include everything beyond the basic configuration of camera body, motor-drive and lenses, with the exception of a few categories that are treated separately. These exclusions are: tripods and other mounts (pages 162–5), close-up equipment (pages 102–3 and 170–5), filters (pages 122–5), cleaning and repair tools (pages 180–3) and on-camera flash, which is dealt with in volume III of this series, *Light*.

The most basic accessories, such as cable releases, sync. leads or cords, tape and spirit level are essential; others are admittedly decorative or destined hardly ever to be needed. Accessory lists undoubtedly induce gadget mania, but where you draw the line between the useful and the trivial is entirely up to you. The best that can be done here is to lay out a reasonably comprehensive array, tempered by my own opinions of what may conceivably be useful. Your choice should depend on the kind of photography that you really expect to be doing and, under most circumstances, the less equipment you take, the better. I think that the one reasonable exception that justifies carrying everything you can think of is when a location shot has to be set up and planned, and for which it is more important to be prepared for any eventuality than to save on weight. This is principally the domain of the professional, but for interest we show what this can involve on pages 32–3.

Basic accessories
This small set represents what one photographer considers essential additions. Its weight – an important consideration – is almost exactly 1 lb (0.5 kg).

Stop-watch for time exposures

Spirit level fits into camera's accessory shoe

Flexible-necked flashlight

Cable release with locking collar

Small C-clamps

Thread adaptors for tripod head

Adhesive putty in spare film can

Adjustable-angle accessory shoe

Sync. lead connectors (can be unscrewed)

Ball-and-socket accessory shoe

Sync. leads

Remote triggering lead

Tape

Threaded clamp

Rubber protector pad for camera base when on tripod

2-way and 3-way sync. adaptors

Light meters
The value of these mainly hand-held meters is that they allow different types of light measurement to supplement the reflected-light readings from the camera's built-in metering system. Silicon photo cells are typical in modern digital meters, and must be battery-powered. The advantage of the slightly old-fashioned selenium-cell meter is that it draws its minimal power needs from the light that falls on it, and needs no batteries. Its disadvantage is less sensitivity.

Prism-etched disc fits over lens to convert camera's TTL meter for incident readings.

Reflex-viewing spot-meter with 1° angle of acceptance with a measuring range of EV1 to EV22 at ISO 100. Memory allows recall of highlight, shadow and average data.

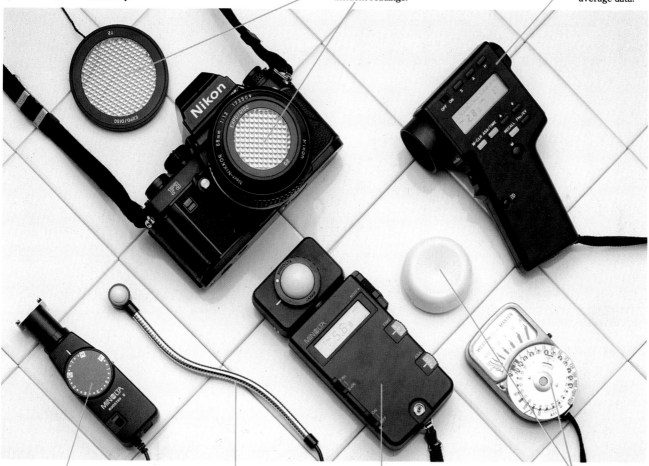

Booster attaches to the meter *right* to allow more sensitive readings directly off the film plane or viewing screen. Needs calibration. The measuring range is EV6 to EV18 at ISO 100.

Miniature receptor on flexible neck attaches to the meter *right* for close-up photography.

Multiple-function meter allowing both reflected light and indicator readings, for continuous light and flash. Acceptance angle for reflected light readings, without plastic dome, is 40°. Measuring ranges are EV1 to EV18 for continuous light at ISO 100, and f1.4 to f90 for flash.

Selenium-cell meter capable of reflected light readings with an acceptance angle of about 40°, and of incident readings when the indented plastic dome is attached.

Accessory containers
Small, loose accessories
are liable to become lost.
This set of containers
makes good use of free,
empty packaging for
other items.

Soft cloth bag

Empty metal can for bulk
35mm film

Screw-top metal cylinder
for replacement screws,
nuts and other very small
items

Aluminium fishing-tackle
box with spring clips and
a small tray

Empty film can for 35mm
cartridge. Clear variety
from Fuji leaves contents
visible

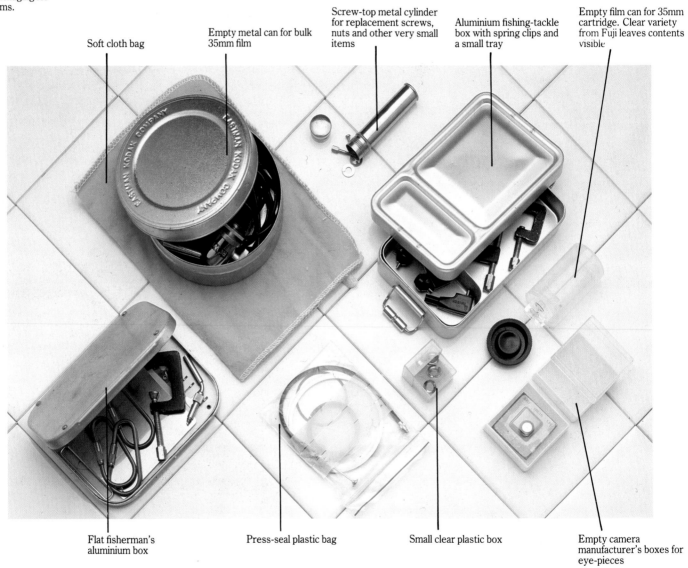

Flat fisherman's
aluminium box

Press-seal plastic bag

Small clear plastic box

Empty camera
manufacturer's boxes for
eye-pieces

Light meters

Accessories apply to any format of camera, but as all modern 35mm SLRs contain their own metering system, usually through-the-lens (TTL), we include additional light meters. But why, given the sophistication of in-camera TTL metering, bother at all with any hand-held meter?

The principal reason is that TTL meters read the light values that are reflected from the subject, and this is by no means always a good guide to the exposure. In particular, such so-called reflected light readings do not show how much light is actually falling on the scene. If the subject is of average reflectance (this will be dealt with later, in Exposure Basics, pages 152–7), then all is well. But if the subject is inherently dark, or light, or occupying an unusual part of the picture frame, then the exposure informa-

tion is likely to be inaccurate, simply because the meter has no way of making such judgements. In-camera meters, as we have seen on pages 14–15, are designed by the camera manufacturers to deal with average picture-taking. Hence there are many situations where it is very useful indeed to be able to compare the reflected light reading from the camera's display with a more objective reading of the light source. Sunlight falling on the black surface of a driveway will reflect much less than from the bright bodywork of an automobile, and the camera's meter will read both quite differently. Yet the sunlight itself is, for that moment in that place, unchanging. An incident reading in this example is one made of the sunlight itself, uninfluenced by the different amounts of light reflected from the surroundings.

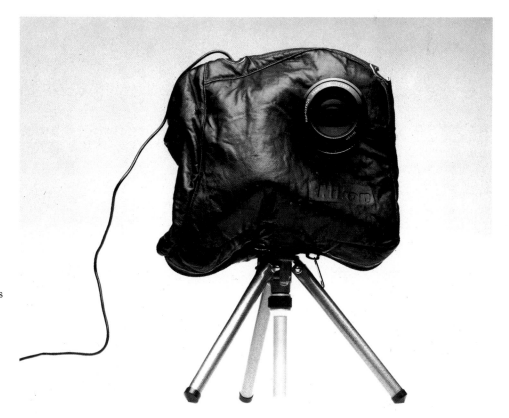

Sound-proof blimp
Beyond basic accessories that are likely to have regular use are esoteric items that have highly specific uses. Among these is a sound-deadening bag, needed principally in wildlife photography or close distances with an otherwise noisy motor-drive.

All hand-held meters except spot-meters will give an incident reading by means of a white translucent dome-like receptor. In addition they can, of course, be used for reflected light readings, but this is not so useful when shooting with a 35mm SLR. A radical and very simple alternative is a translucent cover that can be placed over the camera's lens to convert the TTL reflected light readings into incident readings. In a sense, it turns the camera into a hand-held meter; the camera is aimed away from the subject and into the light that falls on the scene.

A spot-meter, although also hand-held and so independent of the camera, is used in a way that is different both from the camera's TTL system and incident meters. The readings it takes are reflected, but from a very small, precisely marked angle: 1 per cent is typical. Its use takes care and time, but the results are likely to be very accurate indeed. The range of light values in the scene can be measured by the number of stops and then compared with the latitude of the film: roughly 7 stops for negative film and 5 stops for transparency film.

With micro-electronics and memories, modern meters are highly adaptable and can perform various calculations, such as showing the exposure that will just hold highlight detail. There are attachments for some that allow readings off the film plane of a camera or in small spaces. Exposure measurement is a major subject in itself. It is treated to a basic level on pages 152–7 and in greater detail in Volumes III and IV, *Light* and *Film*.

Light meters make a distinct category; it could be argued that they are more than just accessories. Classifying all the other items is pointless; there would be almost as many categories as accessories. The illustration on page 29 shows a fairly basic set. Bear in mind, though, that to an extent any selection is idiosyncratic.

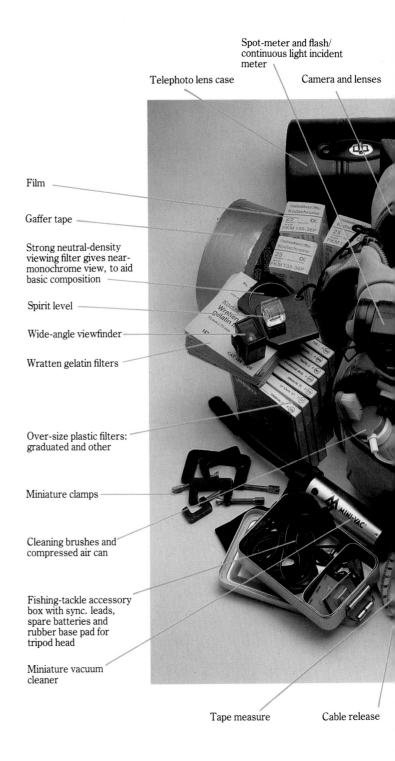

Spot-meter and flash/continuous light incident meter

Telephoto lens case

Camera and lenses

Film

Gaffer tape

Strong neutral-density viewing filter gives near-monochrome view, to aid basic composition

Spirit level

Wide-angle viewfinder

Wratten gelatin filters

Over-size plastic filters: graduated and other

Miniature clamps

Cleaning brushes and compressed air can

Fishing-tackle accessory box with sync. leads, spare batteries and rubber base pad for tripod head

Miniature vacuum cleaner

Tape measure

Cable release

Portable flash units with extension leads to allow off-camera dedicated use

Spare AA batteries

Sample book of gels for lights

Waist-level viewfinder

Spare camera body sealed in plastic

Remote triggering lead

Polaroid 35mm instant film and processor, for checking camera settings and composition before final shooting

Tape for attaching gelatin filters

Karabiner

Small flashlight

Pocket recorder for note-taking. Underneath, Polaroid instant camera, also for keeping notes

Coiled extension sync. lead

Adhesive putty

Basic repair kit (jewellers' screwdrivers, pliers, tweezers)

Spare eyepieces

Notebook, marker and pens

A full location kit
Loaded to the point of being difficult to carry, this array of equipment and accessories, even without tripod and lighting gear, is close to the top limit of what photographers carry. Such a collection is useful when a planned shot is to be arranged on location. In these circumstances weight and portability are not important considerations – lights, stands and reflectors, and maybe even a generator will be far more bulky. What is important is to be prepared for anything, and many of these accessories are taken as insurance. On the grounds that what has been left behind is likely to be the item that is needed at the crucial moment, the safe answer is to take everything. Such an approach is typical of professional photography, in which mistakes and things missed are not easily shrugged off.

35mm Viewfinder

This more traditional design of 35mm camera lacks some of the technological sophistication of an SLR, but to no disadvantage as long as it is used as intended. It is not universally adaptable, and cannot be used for long telephoto shots, close-up work or other, specialized, applications, but for rapid, candid shooting it is often ideal. From our point of view in this book, it is important that, if this is the type of camera you will be working with, you should put it to its best uses, and not try to force it to perform on jobs to which it is not suited.

There is a major difference between one make – the Leica – and virtually all others. The Leica is very much the top-of-the-line among viewfinder cameras; it is rugged and extremely well made, has interchangeable lenses and, in the latest models, several automatic features. Other viewfinder cameras are aimed at the amateur market and are much simpler, with fixed lenses. Nevertheless, they perform their function very well: straight, uncomplicated photography of people at a normal distance range. Although most of the people who own viewfinder cameras use them for family and holiday snapshots, they can be very good for basic candid shooting. In particular, they do not look professional, and there are many situations in street photography where that is an advantage.

The viewing system is clearly very different from that of an SLR (which is now the norm in camera design), and it generates a particular way of working. The viewfinder gives direct vision, which is clearer and brighter than the equivalent reflex view. Focusing, if the camera has a coupled rangefinder, is different with an SLR but not necessarily slower or more difficult.

The illustrations here show how a rangefinder operates, by means of a kind of triangulation. The base is obviously very small – less than the width of the camera – but the system works accurately, with the focusing controls linked to the focusing system of the lens. Learning to focus quickly and accurately is the first exercise

▼ Leica

The Leica, in its various models over the years, is *the* professional 35mm viewfinder camera. There is no extravagant technology, but as much as is necessary for shooting at "normal" distances (a few feet to infinity) with a moderate range of lenses. Unlike most other 35mm cameras, the back does not open; the film is loaded through the base. A power winder is available for some models.

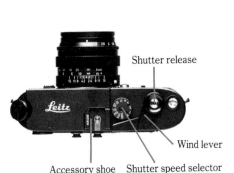

Shutter release
Wind lever
Accessory shoe Shutter speed selector

▼ Pocket 35mm viewfinder

Compact and with a fixed lens, a simple 35mm viewfinder camera has the advantage of being small and not elaborate.

As a result, a model such as the Olympus XA offers encouragement to be carried frequently and in use draws little attention. A sliding integral cover protects the lens and

settings when closed but adds little to the overall bulk. A small on-camera flash screws onto the side (*below left*). The dark chamber (*below right*) is basic and uncomplicated.

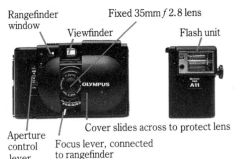

Rangefinder window
Viewfinder
Fixed 35mm *f* 2.8 lens
Flash unit
Cover slides across to protect lens
Aperture control lever
Focus lever, connected to rangefinder

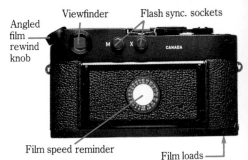

Rangefinder window Viewfinder window
Frame illumination window
Lens change button

Angled film rewind knob
Viewfinder Flash sync. sockets
Film speed reminder
Film loads through base

Wind knob
Pressure plate

you should perform with a new rangefinder camera. No special project is needed; simply use the camera as much as you can. Also, challenge yourself to focus rapidly, constantly pushing the speed at which you can aim, alter focus and shoot. At the beginning, when this focusing exercise is important, make it a practice to examine every frame under a magnifier for focus

accuracy. Do this as quickly as possible after shooting – that is, do not delay in processing the film – so that you can remember the circumstances that caused the soft-focus mistakes.

Although rangefinder focusing is essentially a matter of matching two images – the principal one and the ghosted image – there are actually two methods. One is known as

split-image, the other as double-image. In split-image focusing you should concentrate on the break in a line or edge of the subject, as shown. In double-image focusing, bring two shapes together. Which is more useful depends on the image: a vertical line favours the former, a small distinct shape favours the latter. Note that either method works perfectly well in dim lighting conditions – an area where this kind of camera has a definite edge over SLRs. Some of the latest amateur viewfinder cameras incorporate automatic focusing. (This is covered in more detail on pages 15 and 112–13.)

Typically, the viewfinder shows more of the scene than the picture frame. Within this view the picture is marked, usually by bright frame lines. One potential problem is composing the shot too tightly, to just within the entire view, and you are more likely to encounter it if you are already used to shooting with an SLR. In practice, however, it takes very little time to avoid this. A virtue of the frame lines is that they allow you to see what is about to enter the frame with the camera to your eye. With the Leica, lens interchangeability means that for many focal lengths the frame lines are well within the viewfinder image. This is an extremely useful aid to composition, and can help you to anticipate the best moment to shoot in, for instance, street photography. When people are moving in and out of the shot, practise using the out-of-frame area by paying attention to what is happening there. Make this an exercise.

The Leica, with its mechanical sophistication, automatically takes care of parallax error, but for some other cameras this may need some attention, particularly if the lens is a wide-angle, or at close range. The amount of parallax error is controlled by the amount of separation between the lens and the viewfinder. A typical mistake is a close image in which the top is cut off; the lens has a slightly lower view than you have. If the camera does not have parallax correction (in which the frame lines in the viewfinder move with the focus to compensate),

▼ Rangefinder operation
Using the width of the camera as a baseline, rangefinding in a camera works on a principle that is similar to the way we judge distances with our eyes. A second view, from the smaller window on the right of the camera, is projected onto the eyepiece by prisms and lenses. When the photographer has focused the rangefinder image, the system measures the angle between two views, and so determines the distance.

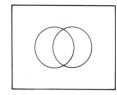

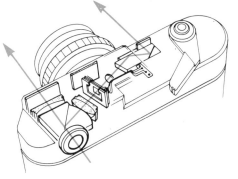

▲ Rangefinder image
There are two methods of using a rangefinder. The double-image method (left pair) matches any shape small enough to appear completely within the central rectangle. Split-image focusing (right pair) relies on matching the break in a vertical line or edge.

Bright frame lines mark the picture area with the viewfinder image. Here, the outer frame in a Leica display is for the 28mm lens being used, the inner frame is for a 90mm lens. The central rectangle is for rangefinder focusing.

the way of avoiding framing errors is practice and experience. Make a point of shooting subjects at close distances simply to improve your judgement.

Project: Street photography
The best project to undertake with a viewfinder camera is the one described on pages 18–23, with an important difference. Rangefinder focusing, although accurate, works less well at a distance, so even the Leica does not accept long telephotos. The range of focal lengths for the Leica is from 21mm to 135mm, and the latter needs its own magnifying viewfinder. Essentially, viewfinder camera photography uses at most a few lenses, and often only one. This will have a profound effect on the way you approach street photography, and severely limit the role of across-the-street shots.

Rollfilm SLR

Film format determines camera design, and the size above 35mm, rollfilm, has produced a variety of medium-format cameras, some with quite different operating features. The film is large enough to permit several formats, from 6 × 4.5cm (2.3 × 1.8 inches) to 6 × 17cm (2.3 × 6.7 inches), and some camera models are designed for shooting on more than one format, accepting different sizes of film magazine. A common designation for this size of film is 120, although it also appears in two less well-used forms: 220 rollfilm, which has a greater length wrapped on each spool, and 70mm, which is sprocketed along both edges and so is slightly wider.

The most sophisticated designs of rollfilm cameras are the SLRs, which use reflex-viewing systems that are more or less similar to those in 35mm cameras, though considerably more bulky. The *raison d'être* of these cameras is a relatively large format (nearly four times that of 35mm) that still allows rapid shooting of sequences, so that

their appeal is very much towards professionals and serious amateurs. As with all the equipment we are discussing in this book, it helps enormously to understand the limitations and the best features of this kind of camera design, and to use it for what it does most successfully. Rollfilm cameras are not particularly good for street photography, for example, but they are excellent for subjects that benefit from being reproduced in fine detail. Among the "classic" range of rollfilm subjects are portraits, landscapes, certain types of nature (flowers and approachable subjects rather than shy, fast-moving animals), most still-life subjects, and close-ups.

Rollfilm SLR designs vary much more than among 35mm cameras, and there is no standard model. Nor are there as many makes. Nevertheless, allowing for different picture formats, most models are modular and feature both interchangeable lenses and interchangeable film magazines. Penta-prisms are normally available for eye-level

viewing, but as the style of use tends towards the planned and considered rather than quick reaction shots, it is normal to use most rollfilm SLRs with a plain focusing screen, shaded only by a hood. As shown in the plan view of the Hasselblad (*opposite*), the image is reversed left to right when seen like this. This can be disorienting if the subject moves or if the camera is panned, but under most shooting conditions it makes no difference to the composition.

Interchangeable backs are a design feature that can be put to good use by shooting different films on the same subject. A dark slide at the front of the film magazine shields the film from light when removing it from the camera body, and backs can be changed in mid-roll. One common practice is to keep one magazine loaded with colour and a second with black-and-white (or reversal film in one and negative in another). Also, in situations where a 35mm user might carry a second body loaded with high-speed film just for low-light shooting, a

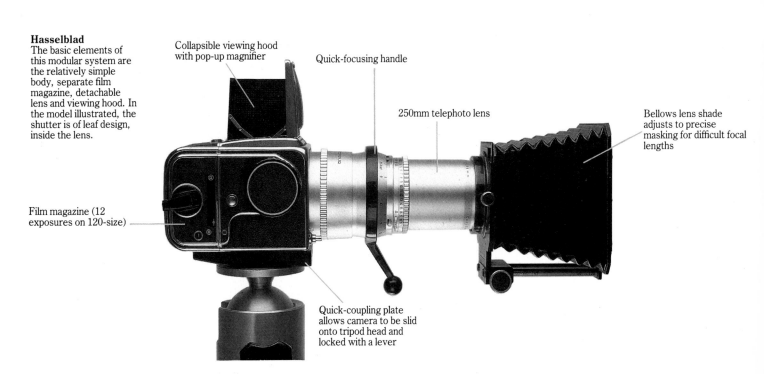

Hasselblad
The basic elements of this modular system are the relatively simple body, separate film magazine, detachable lens and viewing hood. In the model illustrated, the shutter is of leaf design, inside the lens.

Collapsible viewing hood with pop-up magnifier

Quick-focusing handle

250mm telephoto lens

Bellows lens shade adjusts to precise masking for difficult focal lengths

Film magazine (12 exposures on 120-size)

Quick-coupling plate allows camera to be slid onto tripod head and locked with a lever

spare film magazine is less costly and relatively less bulky.

Format variations are mainly a matter of personal preference. The smallest size – 6 × 4.5cm (2.3 × 1.8 inches) – is the most economical, but there is correspondingly less of a size advantage over an equivalent 35mm SLR. The traditional format for this film is 6 × 6cm (2.3 × 2.3 inches) but the more useable picture proportions of 6 × 7cm (2.3 × 2.8 inches) are now more common. One feature of the film size is that it allows cropping without a great loss of picture quality. To some extent, the practice of cropping a shot after it has been taken rather than composing it precisely in the viewfinder has become common because the traditional square frame is not the easiest shape for designing within. The problems and potential of a square picture format are dealt with more thoroughly in the second volume of this series, *Image*, but our purposes in this volume can be covered by the following project.

When a rollfilm SLR is used with only the focusing screen, the image is reversed left to right. A pentaprism attachment is needed for a rectified image.

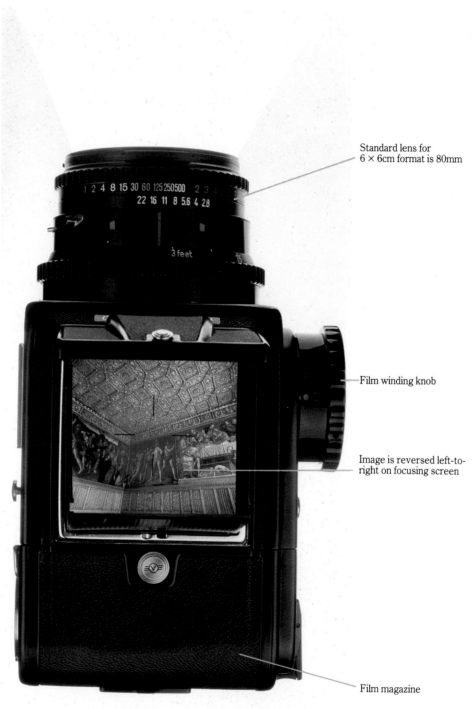

Standard lens for 6 × 6cm format is 80mm

Film winding knob

Image is reversed left-to-right on focusing screen

Film magazine

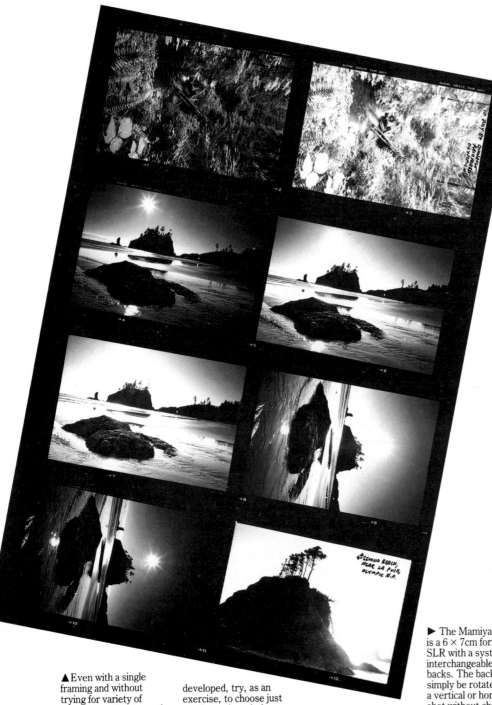

▲Even with a single framing and without trying for variety of expression, the range of subtle differences is considerable in a contact sheet. Once the shooting is complete and the film developed, try, as an exercise, to choose just one frame for printing. To make such a decisive choice will sharpen your assessment of the sequence.

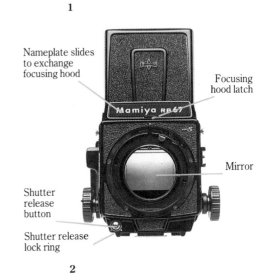

1

Nameplate slides to exchange focusing hood

Focusing hood latch

Mamiya RB67

Mirror

Shutter release button

Shutter release lock ring

2

Focusing knob

Focusing screen

Film advance lever

Multi-exposure lever

3

Shutter cocking lever

Dark slide

Distance graduation

Distance scale

Rollfilm holder

► The Mamiya RB67 is a 6 × 7cm format SLR with a system of interchangeable rotating backs. The backs can simply be rotated to give a vertical or horizontal shot without changing the position of the camera itself. The three views shown here are **1** front, **2** top and **3** side.

Eye-level SLR design

The Pentax 6×7 needs a separate mention, having a design unlike any other rollfilm camera. It is, as far as format allows, a scaled-up version of the standard 35mm SLR design, with eye-level viewing through a roof prism, and virtually all the controls in similar positions to those illustrated on page 11. Necessarily, it lacks the modular construction and interchangeable backs of other rollfilm SLR models, but in place of these features it is much more convenient for handheld shooting. Its design pushes the limits of rollfilm camera use not quite as far as easy candid photography, but a distance towards it.

The design of the Pentax invites comparison with smaller 35mm SLRs. Apart from bulk, the method of holding is not the same, and the left hand has to be used much more as a support for the base and lens. The depth of field, even with the wide-angle lenses, is by no means as great; a natural consequence of the larger format that requires longer focal lengths to give equivalent angles of view. As with all rollfilm cameras, the range of holdable lenses is curtailed at the upper, telephoto, end. Focal lengths that will give a substantial compression of perspective and strong magnification, such as 800mm, are too heavy to hold and must be tripod-mounted.

Project: Cropping and composing with 6×6cm (2.3×2.3 inches)

The idea here is to practise two distinct ways of framing a picture with a square-format camera. In the first, rely on later cropping to make the composition. This means thinking forward to the result, and imagining the picture not exactly as you see it in the square viewfinder, but taken in either at the sides or above and below. At first, you might find it helpful to mark on the focusing screen a vertical mask or a horizontal mask, although this will serve to limit you to an exact format. It is definitely more useful to develop the knack of "seeing" the frame that you want in your mind, dis-

regarding the areas on either side. One positive thing that you should find is that this gives you a little freedom in shooting – some "breathing space" around the picture. In particular, on occasions where you cannot immediately decide whether to frame the shot vertically or horizontally – or even want both alternatives – the extra room will allow you to defer decisions until later. The bad side of this method is that it can induce a kind of laziness or sloppiness in composing. When it is possible to say: "I'll solve that problem later," you may find that there is no really good solution and that you ought, for instance, to have moved camera position or changed lenses instead. What you will also discover from this project if

you enlarge the prints yourself (strongly recommended) is that the more you crop, the more you lose the original advantage of rollfilm: the greater size that gives a less grainy, better quality image.

The second part of the project is to work in the opposite way, and not crop at all. The ability that you will need here is design skill – that of being able to use the entire format and place the image of the subject in such a way that it is balanced. (See the first section of volume II, *The Image*, for a fuller discussion of this.)

The combination of these two parts of the project should heighten your awareness of the design of photographs, as well as showing the practical values of this image size.

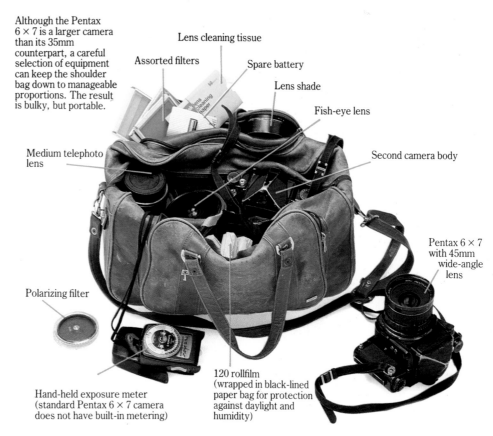

Although the Pentax 6×7 is a larger camera than its 35mm counterpart, a careful selection of equipment can keep the shoulder bag down to manageable proportions. The result is bulky, but portable.

Lens cleaning tissue

Assorted filters

Spare battery

Lens shade

Fish-eye lens

Medium telephoto lens

Second camera body

Pentax 6×7 with 45mm wide-angle lens

Polarizing filter

Hand-held exposure meter (standard Pentax 6×7 camera does not have built-in metering)

120 rollfilm (wrapped in black-lined paper bag for protection against daylight and humidity)

Project: Indoor portrait

Just as we used street photography as a project for developing familiarity with a 35mm camera, this project is geared to rollfilm cameras – at least to one important type of shooting in this format. The object of the exercise is a head-and-shoulders portrait, to be eventually cropped and printed. Black-and-white is a good medium to work in for this, as the print enlargements will demonstrate the value of using a large negative (fine grain and smooth tonal gradations) and the choices available in cropping. For the purposes of this exercise, the lighting set-up is not important, and the session could as well be shot out of doors. Nevertheless, to follow the principle of showing as much of the workings of a shot as possible, the studio set-up is illustrated here, and annotated.

Ideally, the focal length should be at least slightly longer than normal. The most common medium-format lens for this type of shot is about 150mm; the one used here is a little longer at 250mm. The longer-than-standard focal length ensures that the perspective is compressed, so that the nose and front part of the face do not appear out of proportion to the rest of the head. This is not a rule of portrait photography, but it is a precaution if you want the results to be flattering to the person sitting. For the record, one main, overhead, diffused light was used, with reflectors for shadow fill and a second light to lift the background a little. Both lights were integral flash units, sufficiently powerful to allow an aperture setting of f 27 with ISO 125 film. Flash is a convenience in that there will be no blur due to the sitter moving, and a healthy depth of field from this aperture avoids the problem of out-of-focus nose, ears and so on.

One of the principal lessons to learn is that it pays to shoot in some quantity. The two reasons can be seen in your resulting pictures: it may take a little time and a few frames before the sitter relaxes, and there is always the chance that peculiar expressions and blinks may be caught in mid-

Indoor portrait project: the set-up Although not essential for this project, the lighting used was mains-powered flash, with a 750-joule (watt/second) main unit and a 400-joule second unit. The camera was mounted loosely on a tripod, allowing just enough play to follow any slight movement of the sitter.

White card reflector for shadow at side

Clamp and pole support crumpled-foil reflector to fill shadows on lower part of face

Translucent umbrella attached to mains-powered flash unit gives principal, diffused light

Background light is a 16 inch (400mm) square diffused window on mains-powered flash, bounced off white wall

Adjustable steel frame for positioning lights and reflectors

Height-adjustable chair for model

action. Another lesson is that the waist-level viewfinder, which in some situations seems cumbersome and slow, here has some advantage: it allows the photographer to be a little apart from the camera and talk face-to-face with the sitter. Ordinarily, with eye-level viewing, your face would be hidden behind the camera, and this can be inhibiting to a rapport with your subject. One point to watch, though, is that if you stand too far away from the camera, the sitter is likely to be looking at you and not at the lens, and the results may show this. A longer lens reduces this danger, but then it also puts you at a greater distance and may leave the sitter feeling a little isolated.

Try this project with several people as subjects: friends, acquaintances, anyone you can persuade to sit in front of the camera. Incidentally, one of the good things about a set-up that you have tried out, are familiar with and can reproduce is that you can arrange a portrait session at a moment's notice. For a thorough look at the choices of lighting a portrait, see volume III, *Light*, in this series.

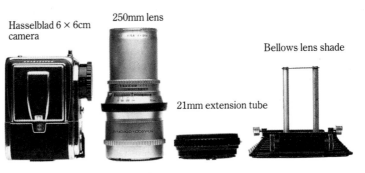

Hasselblad 6 × 6cm camera

250mm lens

21mm extension tube

Bellows lens shade

Indoor portrait project: the equipment With a Hasselblad 6 × 6cm camera, the lens used was a little longer than is usual for this kind of shot: 250mm. For a tight framing of the head and shoulders, a 21mm extension tube was added, and to protect the lens from flare from the exposed main light, a bellows lens shade.

Hasselblad field kit
Packed for landscape
photography with a tripod
rather than for handheld
use, the equipment
shown here features a
three-lens outfit –
standard, wide-angle and
telephoto. The rugged
case is designed for back-
packing, but access is
slow. Note that the
rollfilm is poorly
protected from humidity
and light in comparison
with 35mm cartridges,
particularly after
exposure; here, the rolls
are wrapped in a plastic
bag with a sachet of
desiccant.

250mm telephoto lens
with bellows lens shade

Spot meter

Magnifying hood for
focusing screen

21mm extension tube

Close-up and light-
balancing filters

Camera, film back,
standard 80mm lens

Quick-coupling plate on
large ball-and-socket
tripod head

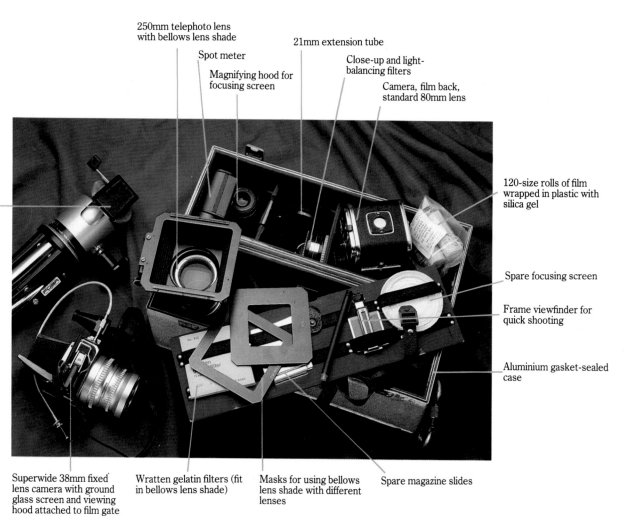

120-size rolls of film
wrapped in plastic with
silica gel

Spare focusing screen

Frame viewfinder for
quick shooting

Aluminium gasket-sealed
case

Superwide 38mm fixed
lens camera with ground
glass screen and viewing
hood attached to film gate

Wratten gelatin filters (fit
in bellows lens shade)

Masks for using bellows
lens shade with different
lenses

Spare magazine slides

Rollfilm Viewfinder

Enjoying a recent revival in spite of their lack of sophistication, rollfilm viewfinder cameras offer easy portability without any frills. The very basic nature of their design may contribute to their appeal. There are several makes, and even more formats than among SLRs (without the need for reflex viewing, it is relatively simple to make the picture area larger on the film). The smallest format is 6 × 4.5cm (2.3 × 1.8 inches); 6 × 17cm (2.3 × 6.7 inches) – which by the extreme length of the image counts as a special film for panoramic cameras (see pages 64–5) – is the largest.

The principal advantage of these cameras is that they weigh little more than a 35mm SLR – less if you take the lightest or include a motor-drive on the 35mm camera – yet give the image qualities of a large negative or transparency. In particular, they are good for any kind of technically uncomplicated shot, such as landscape or even candid photography of people. Street photography is possible with a rollfilm viewfinder camera, and offers the unusual interest of an unexpectedly large image; if the model you use has a wide-angle lens (most do), this will give you the opportunity to crop the image when printing.

There are natural limitations, and these do restrict the uses to which you can put this design of camera. The lack of reflex viewing, which allows a leaf shutter inside the lens to be used rather than a bulky focal plane shutter with a mirror, makes it impossible to check the depth of field accurately. Where depth is important, in still-life photography and other types that involve close shooting distances, the only solution is to follow the depth of field scale on the lens very closely – neither convenient nor completely safe. Remember that, compared with 35mm cameras, the focal length of equivalent lenses are longer, and this is one of the factors that make the depth of field shallower. Extra care is needed.

This, and the greater opportunities for making focusing mistakes with a larger-format camera, is one of the reasons why wide-angle lenses are commonly fitted. Most models have fixed lenses, and there are several produced specifically as "wide-angle cameras".

Parallax error is another potential problem, and because these cameras are larger than 35mm models, the distance between the lens and the viewfinder also tends to be greater. With a camera that does not incorporate parallax correction in the viewfinder, there is a way you can compensate for it if you are using a tripod. The method is first to compose the shot as you want it through the viewfinder, and then to raise the central column of the tripod by exactly the distance between lens and viewfinder – a few inches or centimeters only. Naturally this is a little cumbersome, and if the viewfinder is off-center you will also need to make allowance at the sides.

Folding compact
This 6 × 4.5cm model, incorporating a range-finder and parallax-compensating frame lines, resurrects a traditional design in which the lens is articulated to the inside of a folding cover. A short bellows provides the collapsing light seal for the standard (for this format) 75mm lens. There is metering through the viewfinder window with LED display.

Lens cover in closed position

Frame illumination window

Lens swings out on bellows supported by articulating arms

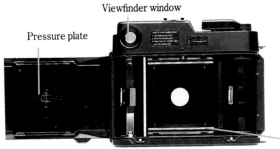

Viewfinder window

Pressure plate

Focal plane rails

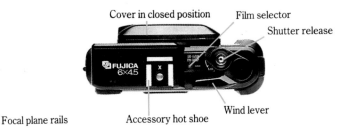

Cover in closed position

Film selector

Shutter release

Accessory hot shoe

Wind lever

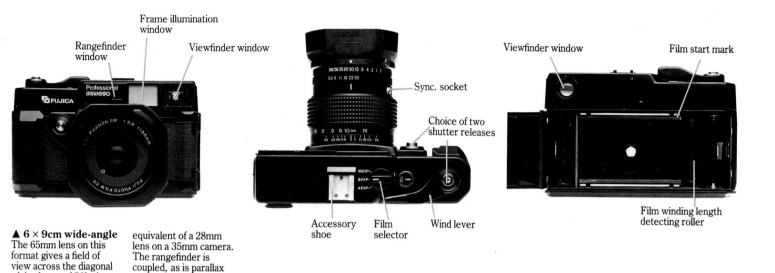

Rangefinder window

Frame illumination window

Viewfinder window

Sync. socket

Choice of two shutter releases

Viewfinder window

Film start mark

Accessory shoe

Film selector

Wind lever

Film winding length detecting roller

▲ 6 × 9cm wide-angle
The 65mm lens on this format gives a field of view across the diagonal of the frame of 76°, the equivalent of a 28mm lens on a 35mm camera. The rangefinder is coupled, as is parallax compensation.

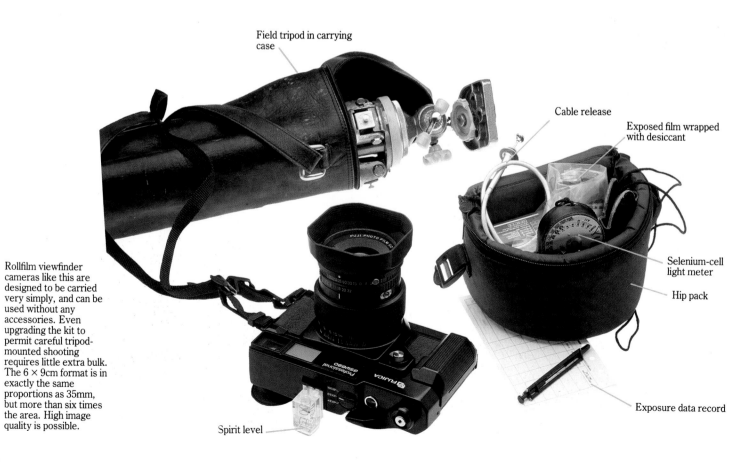

Field tripod in carrying case

Cable release

Exposed film wrapped with desiccant

Selenium-cell light meter

Hip pack

Rollfilm viewfinder cameras like this are designed to be carried very simply, and can be used without any accessories. Even upgrading the kit to permit careful tripod-mounted shooting requires little extra bulk. The 6 × 9cm format is in exactly the same proportions as 35mm, but more than six times the area. High image quality is possible.

Spirit level

Exposure data record

43

View Camera

Despite its reputation as professional equipment, the view camera is, in principle at least, the most simply designed of any camera. Although some top-of-the-line monorail view cameras are embellished with micrometer drives, the basic construction of these large-format cameras has remained essentially unchanged since the beginnings of photography in the nineteenth century. In a sense, nothing could be more straightforward: the camera is a flexible light-tight box, consisting of a rigid panel at the back to hold a sheet of film, another rigid panel at the front that carries the lens, with both panels connected by concertina-like bellows that extend and compress for focusing at different distances.

Because view cameras do not, as a rule, contain features of convenience, such as reflex viewing, instant return mirrors or even means of transporting film within the camera, they have remained this simple. For us here, the value of the view camera is

that this is grass-roots photography. None of the basic principles – focus, light transmission, the distribution of sharpness and so on – are obscured by technology, and the size of everything is such that tolerances are reasonable and there is not much call for miniaturization. You can learn more about the basic principles of photography by practising with a simple view camera than with any other piece of equipment. Do not be put off by the slowness of using it; not every picture needs to be taken in a hurry.

There are two basic types of construction, both shown here. The traditional one, and still used, particularly in outdoor photography, is the flat-bed, so-called because the mechanical support for the camera is a flat base. Wood construction with metal fittings is common; this is lightweight, and therefore useful for carrying, and the tolerances are not so close as to make metal absolutely necessary. A more finely machined, metal version of this design is

made by a few manufacturers, as an all-purpose camera that can be used for precise studio work as well as outdoor shooting. Flat-bed designs are built to fold up for convenient carrying.

The second type of construction is the monorail, very much a studio camera. Instead of a flat base, the support is a well-machined rail, circular, rectangular or even triangular in cross-section. Think of this as a version of an optical bench. The parts of the camera – front and rear standards, lens shade, and even supports for close-up subjects held in front – attach to this rail and slide along it. This modular design means that different configurations are possible, depending on the type of photography.

There are several different sizes of view camera. The original nineteenth-century models varied considerably, but the common film formats now are 4 × 5 inches (102mm ×127mm) and 8 × 10 inches (203×254mm). Other standard sizes are listed in the table.

SHEET FILM SIZES

3¼ × 4¾ inches	(83 × 121mm)	– Quarter Plate
90 × 120mm		
4 × 5 inches	(102 × 127mm)	
4¾ × 6½ inches	(121 × 165mm)	– Half Plate
6½ × 8½ inches	(165 × 216mm)	– Whole Plate
8 × 10 inches	(203 × 254mm)	
11 × 14 inches	(280 × 356mm)	

The Quarter, Half and Whole Plate sizes, although still available as film from Kodak in some emulsions, are slowly becoming obsolete.

Field camera
This type of view camera, traditional in design, is named for its portability that allows easy outdoor carrying and use. Mahogany, with brass fittings, is a common construction.

Ground glass focusing screen in spring back

Two knobs on either side allow limited tilt and swing movements of film back

Lens panel rises and falls in grooves

Non-detachable bellows

Flat "bed" is the support of lens panel and film back

Knob drives rack-and-pinion to move film back along bed for focusing

Camera folds at this hinge to form compact box for carrying

Monorail

This is the most common type of view camera in studio use, and although it can, and is, carried for outdoor photography, its particular benefits of precision are at their most valuable in controlled still-life shots.

Flexible bellows extends and contracts for focusing; here at infinity focus for the standard 150mm lens fitted

Focusing screen mounted on sprung back allows insertion of film dark slides

Both standards can be raised and lowered

Fine-focusing knob uses gears

Rear standard slides along monorail for focusing

Lens, in its own shutter, mounted on lens panel

Lens shade is basic bellows held in place by clips

Levers on both standards allow panels to be tilted and swung (i.e. rotated slightly on two axes)

Monorail

Rail clamp attaches to tripod

Front standard (slides as rear standard)

Monorail: professional model

This more precise and expensive version of the same camera features heavier supports for the front and rear standards, and separately geared movements for each.

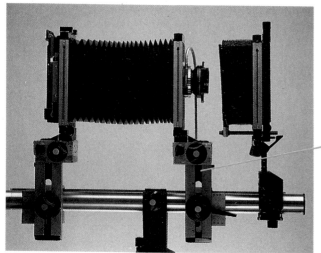

Heavy-duty supports for the front and rear standards incorporate micrometer drives and graduated scales for fine, accurate focusing and image control

Monorail: wide-angle configuration

With a wide-angle lens, camera movements (shifts, tilts and swings) need the extra facility of soft bag bellows.

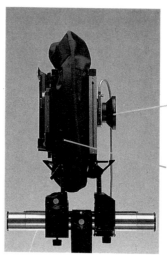

Wide-angle 90mm lens

Shorter distance between film and lens when a wide-angle lens is focused at infinity. Needs bag bellows: more flexible to allow movements

The format shown and used here is 4 × 5 inches (102 × 127mm), possibly the most common of all, and having the special advantage that a good variety of instant films are made to fit it by Polaroid. To make up for some of the inconveniences of viewing with this type of camera, instant film provides a valuable means of checking results that is used by virtually all professionals (not for every shot, but for important and uncertain ones). The full size of this film is shown *below* in the form in which it appears in-camera: upside-down on the ground glass focusing screen.

Most view cameras do not come supplied with a lens, and large-format lenses are produced by independent manufacturers. Users of 35mm cameras become accustomed to classifying lenses by their focal length, but usually mean the perspective effect (so, 28mm denotes wide-angle with its stretched perspectives; 300mm denotes a lens that compresses the planes of the subject and magnifies the image). With a view camera, however, the different formats available, sometimes on the same camera by means of a change of film back, means that one lens can have different pictorial effects. The rule-of-thumb whereby the diagonal of the film frame is the same as the focal length of a standard lens still applies, so that for the 4 × 5 inch camera being used here, a 150mm lens would be considered standard. For an 8 × 10 inch camera, a 300mm lens is the equivalent.

Camera movements

Another consideration that does not occur with fixed-body cameras is the coverage of the lens. We will deal with this more thoroughly on pages 106–7, but for the time being the issue is that, in order to make use of camera movements, the lens should project a much larger image than the picture area. These camera movements, explained on the next few pages, are the shifts, swings and tilts of the lens panel and film back that make it possible to correct converging verticals, change the shape of the image and alter the distribution of sharpness in the picture. They have their effect by using different parts of the projected image, and in order to have the freedom to work they should have a comfortable margin beyond the limits of the picture frame. The useful image area in 4 × 5 inch format is 6 inches (155mm) across the diagonal, so that a lens that gives just that diameter of image circle can only be used without movements. In practice, a diameter of 8¼ inches (210mm) or more is normal. These figures are for when the lens is focused on infinity (at any closer distance the image circle is, naturally, larger) and at a mid-range aperture setting, conventionally *f* 22.

Given that the state of the art in camera technology lies in modern 35mm SLRs, there are just two – albeit very powerful – reasons for the continuing popularity of view cameras. One is that the film area is so much bigger, the other that the wealth of camera movements gives an unmatched degree of control over the image, its shape and sharpness. These two reasons are the essence of view camera photography, and so the subject of the first two projects.

Reproduced here at its actual size, the image of a 4 × 5 inch format camera is projected upside-down onto the rear focusing screen, made of ground glass. Corner cut-offs allow direct inspection of the lens aperture, useful to check vignetting (see pages 106–7).

Project: Image quality

This is a short project, and one more to do with looking than anything else. The simple matter of a bigger picture area has a direct and important effect on image quality. You can judge this for yourself by taking the same photograph in two different formats, 4 × 5 inch and 35mm. In linear terms the 4 × 5 inch image is just over 3½ times larger than the 35mm image, measured across the diagonal, but the difference in area is 15 times. Use the same film emulsion, and make sure that the magnification of the image is the same, by using a focal length for the 4 × 5 inch shot that is 3½ times that used for the 35mm image.

However the picture is used, whether enlarged for display in a frame, or reproduced in a book or magazine, the 4 × 5 inch image needs much less enlargement, so preserving sharpness. Not only is the resolution better (more detail has been recorded on the film), but the grain of the film is suppressed. In fact, under most normal enlargements, there should be no graininess apparent in the 4 × 5 inch picture. Compare the two transparencies or negatives on a light box under a loupe, then make enlargements of both to the same print size.

In choosing the subject for this comparative test, try and find one that combines both fine detail in part of the image, and some smooth tones. Most landscapes with either a deep clear sky or dark clouds will offer this combination. You should be able to see two ways in which the image quality is higher in the larger format. One is the straightforward quantity of detail; the other is that the absence of graininess gives a clarity and subtlety to the way in which tones merge. You can see this most plainly in the mid-tones. Now, we are talking about objective image quality, and while most scenes probably have more presence and realism when the image quality is high, there are many occasions when the texture of the film can add to the atmosphere of a shot. It would be a mistake to come away from this project believing that ultra-sharpness and smooth tonal gradations are the only things to aim for. It is, however, very satisfying to be able to produce them when you want.

Both the images *below* were shot on ISO 64 Ektachrome – essentially the same emulsion – so that a direct comparison is possible. The extra detail becomes important when a substantial enlargement is made; the 4 × 5 inch transparency *bottom* can fill a page of a book without showing signs of its grain structure, unlike the enlargement *right* to the same size from the 35mm transparency *below*.

Project: Camera movements

This is a fairly involved exercise, but at the end of it you should have a comprehensive idea of how much you can control the image just by moving the lens panel and film back on a view camera. What we will do over the next four pages is to use all the possible movements, one at a time, on a single subject. For our reference subject, we need something that will show the effects of each movement as clearly and simply as possible: a white cube, marked with grid lines to help with the focusing and show the shape of each face.

There are three kinds of movement possible: shifts, tilts and swings. The shift movements apply to both the front standard (carrying the lens panel) and the rear standard (which supports the film back), and work both up-and-down and side-to-side. Except in close-up photography, where the lens panel is much nearer the subject than is the back of the camera, there is no real difference in the effect between using the front and the back shifts.

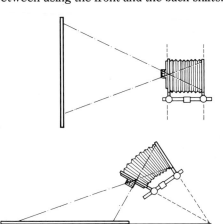

Changing the distribution of sharpness
In the upper diagram there are no camera movements, and the plane of sharp focus, lens panel and film back are all parallel to each other. Changing the focus merely alters the distances between these elements. In the lower diagram, the lens panel has been tilted forwards, and all three planes meet at one point. By looking side-on at the camera, the position of the plane of sharpness can be predicted by imagining the dotted lines.

Provided that the covering power of the lens is significantly greater than that needed for just the picture area, operating the shift control of the camera "slides" another section of the image into view. By far its most popular use is to correct converging verticals, as shown on page 56.

The tilt movement is a rotation around a horizontal axis, and on the camera shown here both the front and the back can be tipped upwards or downwards. Here the optical effect is not quite so simple as with the shift movements, and requires a little theory. Using the tilt movement alters the plane of sharp focus. Without any movements, the lens panel and film back are parallel, just as in a normal, fixed-body camera. The plane of sharp focus, however near or far, is also parallel to these – you could imagine it as a large sheet of glass directly facing the camera. So far, so good; everything that is the same distance from the camera is equally in focus. However, tilting either the lens panel or the film back puts this plane of sharpness at an angle. As the diagrams *left* show, imaginary lines drawn from the plane, from the lens panel and from the film back all meet at a common point. The more the tilt, the more acute is the angle of the plane. This is the "Scheimpflug principle", and is invaluable for making the best use of whatever depth of field you have. Most subjects stretch across one dimension more than another, and with a flattish arrangement on the surface of a table, the image can be made at even an extreme angle without the need for much depth of field.

Something else happens when the back of the camera is tilted rather than the front. The shape of the image changes. The reason for this becomes clear when you actually use a view camera in this way. By tilting the back, one side of the film plane is pulled away from the lens, and as long as the image is all in focus, this part will be magnified slightly: in other words, stretched. By contrast, the other side of the film is pushed closer to the lens, and so

The movements
Shifts (vertical and horizontal)

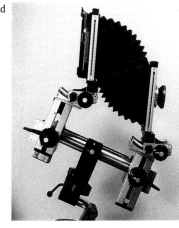

Tilts

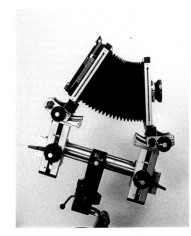

Swings

the image is reduced. The overall effect is a distortion in which the image is stretched in the direction of the tilt.

Swing movements are also rotations, but this time from side to side, around a vertical axis. All that has been said about tilts applies to swings: moving either the front or the back alters the distribution of sharpness, but moving the back will alter the shape as well.

Most people find that it is much easier to get to grips with the effects of these movements by simply handling the camera and seeing what happens to the image on the focusing screen. Some practical points:

take the lens-movement shots at full aperture for a clearer view of what happens to the sharpness distribution (stopping down would mask it) but for the shape-changing movements of the back, maximize the overall sharpness by stopping down and by adjusting the lens panel as necessary. You will also find that you need to use the shift movement with some of the tilts and swings just to bring the image back into the center. Finally, extreme movements of the back will need extra exposure, because they pull much of the film plane away from the lens. The ones photographed here were given an extra stop.

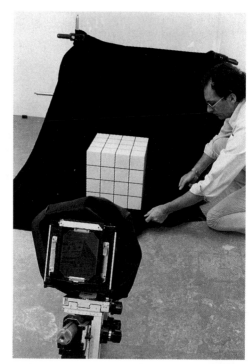

▶ Prepare for this project by making or adapting a white cube (the one shown here was a box of drawers up-ended). Mark a few grid lines accurately on the top, front and sides, and place it on a dark background for strong contrast.

Normal
Without movements, the camera is pointed slightly down at the cube, with expected convergence of both the top and bottom.

Front tilted forward
The point of focus here is the top face of the cube. The plane of sharp focus has been tilted to lie flat, so that the top of the cube is completely in focus, and the front completely out of focus.

Front tilted back
By tilting the lens panel back until it is parallel to the front face of the cube, the whole of that face is sharply focused. The top is all out of focus.

Front swung left
The plane of sharpness is now through the cube from front to back, and at a slight angle because of the position of the camera.

Front swung right
Rotating the lens panel the other way gives a mirror image of the last shot. Note the apparent (not real) distortion caused by the unfocused areas.

Back tilted back
Now at the smallest aperture, *f* 45, we can see the shape changes from moving the back. Tilting the film plane to vertical makes the front of the cube seem square-on.

Back tilted back and swung left
Combined movements of the back are not as easy to predict in their effects. The two movements were half the amount of all the others – 20° each – but even so the distortion is not so great, being offset by the downward angle of the camera.

Back tilted forward and swung right
These are the exact two opposite movements to those in the previous photograph. However, as the tilt goes "with" the camera angle, the distortion is extreme.

Back shifted left
Here, the back has been shifted 1⅕ inches (30mm), but to keep the image centered, the entire camera has had to be moved 7 inches (180mm) to the left. All the horizontal lines remain horizontal, but now we can see the side of the cube.

Back tilted forward
In contrast, tilting the back in the other direction exaggerates the downward convergence of the front face of the cube. Compare this with the first, normal image: the top face does not appear to recede as much.

Back swung left
The swing is combined with the downward-pointing position of the camera, pulling the shape of the cube towards one corner, and giving a very exaggerated appearance. Note that the exposure is less in the distorted part of the shot.

Back swung right
Swinging the back in the opposite direction by the same amount – about 40° – gives an equal but opposite distortion to the previous shot.

Back shifted right
A mirror image of the previous photograph. These shifts could, incidentally, be as easily performed with the front of the camera, and there would be virtually no difference made to the image.

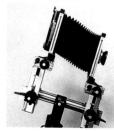

Back shifted up
In order to keep the cube in the middle of the picture, the camera has been raised (by 7 inches – 180mm – for a 1⅕ inch – 30mm – shift); more of the top face can now be seen.

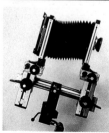

Back shifted down
With the camera lowered, almost nothing can now be seen of the cube's upper surface.

Project: Still-life

The most typical use of the view camera, at least among professionals, who make the most use of it, is still-life photography under the controlled conditions of a studio. The large film size gives all the image quality anyone could want, and the movements allow extremely fine control over the details of the picture, including depth of field, focus and composition.

Attention to detail is the hallmark of view camera photography. The result must be good enough to stand up to close scrutiny, and there is no excuse for the technical aspects of the image to be anything less than perfect. Since you have the means of control, you are obliged to use them carefully, and everything in the picture should be as you intended it. This takes time, of course, and there is no point in hurrying this kind of shot.

The relatively lengthy process of making a still-life image can be demonstrated by showing what it took to produce this photograph *below*. The brief was for a picture that says "camera" and "lens" without showing much detail and without playing up a particular make of equipment. In addition, the background had to be black.

The camera chosen is a Canon T90 because of its clean, smooth lines, and the intention is to highlight just its edge. As only the top plate will be shown, from the front, there is no problem about concealing the mount for the camera; it can be masked off during shooting. The first step, then, is to fix the T90 in front of a black background. Black velvet reflects less light than any other common material, and to make doubly sure that it remains a dense black, it is hung up a couple of feet behind the T90, away from the lighting.

Next, the light; very simple in this case. A broad area light is used (to give an even effect across the width of the camera rather than a sharp, concentrated reflection), and positioned above and behind, so that it will bounce off the top edge of the T90. The view camera is then set up, using a layout already sketched, and the image focused and composed.

At this point we have a slight complication. We cannot shoot the lens at the same time and still catch recognizable reflections from the coated surfaces; the reason for this is that the light would need to be shining directly into the lens, whereas at the moment it is behind. So, the lens will need its own, second, exposure with the light moved forward. There is no point in attaching the lens at present; it will simply be in the way.

Concentrating on the body of the T90, close examination shows that some of the details on the front are visible. These are masked off by positioning a circle of cardboard in front. Finally, the adjustable lens shade is masked down to cut off the view of the mount and surroundings.

The lens is then fitted, and the details worked out for this second exposure. Because it is closer, the focus needs to be changed, but this can be marked accurately on a scale on the view camera. The light is brought forward; again, to a position that can be marked. Polaroid test shots confirm each of the two exposures.

With both images (that of the T90 body and that of the lens) worked out in advance, we can now shoot. First, the lens is exposed, with the light forward, hanging right over the view camera, and the focus in its closer position. This is shot on several sheets of film, and for safety, the position of the lens image is drawn on the ground glass screen of the view camera (another advantage of working on a big scale). The lens is then removed, the round card mask put up in place of it, the light pushed back and the focus altered. The second exposure is made, and the result shown *left*.

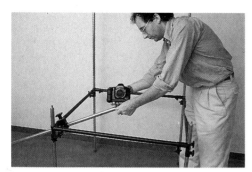

1 T90 camera is fixed securely to a stand of jointed steel sections.

2 Black velvet sheet is hung behind, for background, and large diffused light is suspended above and behind to give rim-lighting effect.

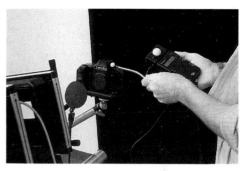

3 Image is composed and focused, view camera is tilted to give required angled view of T90, and front of T90 blacked out with a circular card mask close to the view camera. Light reading taken with small incident probe.

4 Details are checked with small flashlight so that image can be viewed on ground glass screen with aperture stopped down, and an adjustable mask in front of the view camera lens is set to cut out surroundings, before a wide-angle lens is fitted to T90 for second exposure.

5 Light is re-adjusted to give best reflections in the lens. Polaroid prints are shot to check composition and exposure.

6 Just before shooting, dust is cleared from the lens with a small vacuum cleaner. Lens is exposed, and position of lens is marked on focusing screen.

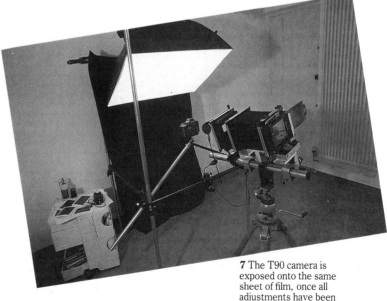

7 The T90 camera is exposed onto the same sheet of film, once all adjustments have been made.

View Camera Outdoors

After familiarizing yourself with the operation of a view camera under controlled indoor conditions, take it outside for field photography. In general, the scale of subject matter is likely to be easier to work with: landscapes and buildings are at distances that need only limited movements for correcting converging verticals and changing the plane of sharp focus. On the other hand, view cameras are more difficult to use physically. Bright daylight makes it harder to view the focusing screen, and some kind of viewing shade is needed (the simplest is a black cloth to hang over your head as you look at the screen). Also, even a mild breeze can be an irritant when setting up the camera and viewing, while long exposures may suffer from camera shake. View camera users learn quickly to assess

the amount of vibration caused by wind, and adjust the shutter speed accordingly; making the best use of the tripod is essential (see pages 162–5).

Bright light is always a potential hazard for the film in dark slides, so take special precautions to protect these – more than you would with film for a smaller camera. Whenever possible, load the sheets into the dark slides indoors, before setting out, and keep them in shade and wrapped. The greatest danger of a light leak occurs during the exposure, when the slide is held in the spring back and the cover withdrawn. Test the lightproof efficiency of your slides, and if they do allow some light through at the open edge, make future exposures with a dark cloth covering the back of the camera.

Field kit
A highly portable variant of the kit shown *right* is this fixed-body, wide-angle view camera made by Sinar. Because the focal length of the lens is short – 60mm – it can be focused conveniently in an ordinary focusing mount that has a standard helical movement. Without bellows, the camera is both sturdy and fast in use, and shift movements are possible

by means of a sliding inset to the lens panel, operated by a geared knob. Tilt and swing movements are not possible, although the great depth of field of the lens goes some way towards overcoming the disadvantage. A pistol grip makes hand-held shooting with this 4 × 5 inch camera almost as easy as with a rollfilm viewfinder.

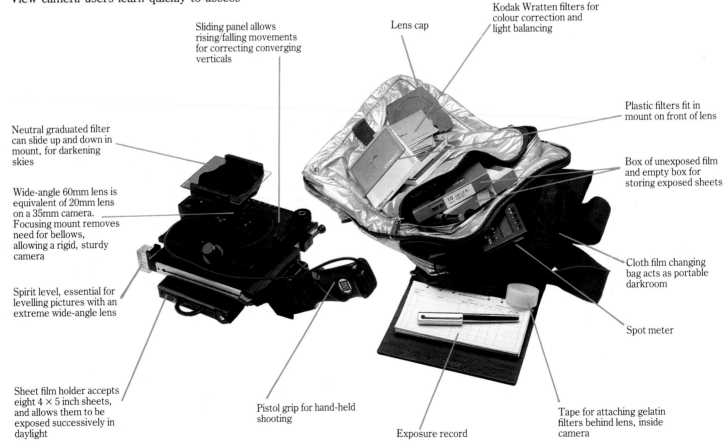

Sliding panel allows rising/falling movements for correcting converging verticals

Lens cap

Kodak Wratten filters for colour correction and light balancing

Plastic filters fit in mount on front of lens

Neutral graduated filter can slide up and down in mount, for darkening skies

Box of unexposed film and empty box for storing exposed sheets

Wide-angle 60mm lens is equivalent of 20mm lens on a 35mm camera. Focusing mount removes need for bellows, allowing a rigid, sturdy camera

Cloth film changing bag acts as portable darkroom

Spirit level, essential for levelling pictures with an extreme wide-angle lens

Spot meter

Sheet film holder accepts eight 4 × 5 inch sheets, and allows them to be exposed successively in daylight

Pistol grip for hand-held shooting

Tape for attaching gelatin filters behind lens, inside camera

Exposure record

Field kit
This is a fairly typical camera bag laid out for view camera photography in the field, featuring a mahogany and brass flat-bed camera with two lenses: one standard (150mm) and the other wide-angle

(90mm). Possibly the only extravagance is a box of Polaroid sheet film with holder, used for checking details of composition, exposure and the effects of graduated filters. Nevertheless, instant film is very much a

legitimate emulsion to work with as a finished material; the print quality is very high, provided that special care is taken outdoors to prevent dust and debris settling on the surface. Instant negatives, produced by the Type 55 film shown

here, have the special advantage of being pre-packed, so need no loading into dark slides, and dust-free. You must, however, also carry a small container filled with sodium sulfite solution to protect the exposed film.

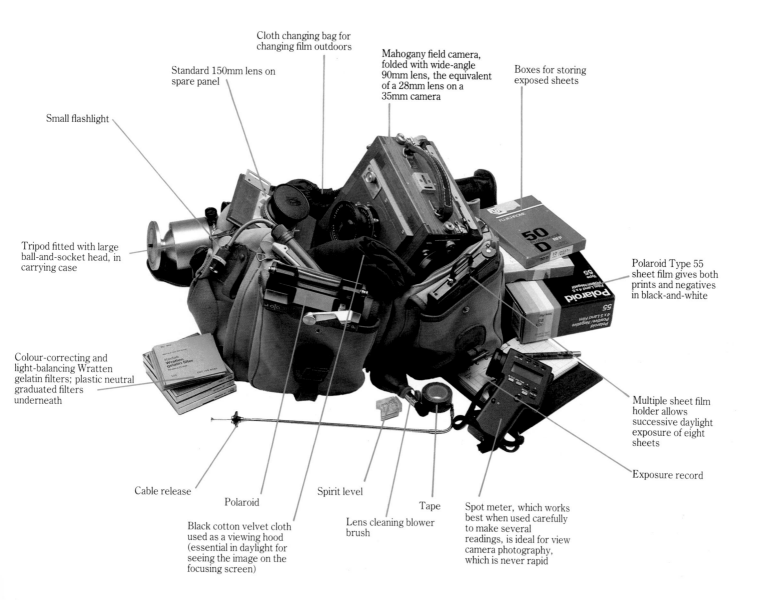

Cloth changing bag for changing film outdoors

Standard 150mm lens on spare panel

Mahogany field camera, folded with wide-angle 90mm lens, the equivalent of a 28mm lens on a 35mm camera

Boxes for storing exposed sheets

Small flashlight

Tripod fitted with large ball-and-socket head, in carrying case

Colour-correcting and light-balancing Wratten gelatin filters; plastic neutral graduated filters underneath

Polaroid Type 55 sheet film gives both prints and negatives in black-and-white

Multiple sheet film holder allows successive daylight exposure of eight sheets

Exposure record

Cable release

Polaroid

Spirit level

Tape

Black cotton velvet cloth used as a viewing hood (essential in daylight for seeing the image on the focusing screen)

Lens cleaning blower brush

Spot meter, which works best when used carefully to make several readings, is ideal for view camera photography, which is never rapid

Project: Correcting convergence

For this project, begin with a straight-sided building, ideally one that stands alone and has an unrestricted working space in front of it. The best distance to work from, for the purposes of this exercise, is one that allows a frame-filling image. Use either a standard or wide-angle lens; the latter will show the difference more clearly.

Begin by setting up the camera on its tripod with all the movement settings at zero; i.e. the lens panel and film back should be parallel and at the same height, just as if the camera had a fixed body. Frame the shot, which will mean angling the camera upwards, but leave a little extra room above the top of the building. Note the angle of the camera, and make an exposure. The convergence should be obvious.

Adjust the camera angle until it is aimed horizontally. A spirit level is the best way of judging this, but an alternative on level ground is to walk over to the building, note a point that is exactly the same height above the ground as the camera, and then aim the camera directly at this, so that the point is located at the center of the focusing screen. At this stage the top of the building will be cut off, but its sides and other vertical lines will be vertical on the focusing screen (if your camera has grid lines etched on the ground glass, this will be easy to confirm). Now raise the front standard, or lower the back, until the top of the building appears in the picture and the excess foreground is lost. Make the exposure.

At home, you can compare the two images, as we do here. With the verticals corrected, in the second shot, the image is conventionally better, although the proportions have changed. Superimpose one transparency (or negative) on the other, and you will see that the corrected version is taller. In appearance, the upper stories of the building have been stretched upwards. With a moderate correction, as here, this is visually acceptable, but with extreme shift correction the result may be very peculiar. Visually, what this kind of correction does is to replace one kind of distortion (convergence) with another (stretching).

One other effect can be seen, especially with a wide-angle lens. In the corrected version, the edge of the image circle is being used rather than the center, and so there is likely to be some fall-off in illumination towards the top of the picture. And, if you use the shift right up to the edge of the image circle, you may lose image quality.

1

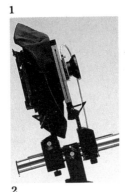

2

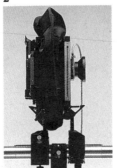

3

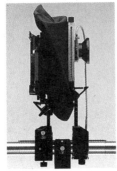

◄ **Correcting convergence: camera movements**
In step **1**, with zero movements, aim the camera up to include the entire building. In this shot, the verticals will converge towards the top. In step **2**, level the camera; the verticals will appear vertical but the top of the building will be out of frame. In step **3**, shift the lens panel upwards until the entire building appears once more in view, this time corrected.

Vertical lines converge upwards

Less illumination because close to edge of image circle

Top of image "stretched"

Vertical lines appear vertical

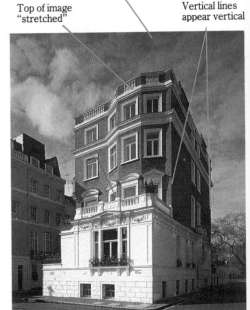

► **Correcting convergence**
Both images were made with a 90mm wide-angle lens on a 4 × 5 inch view camera. The uncorrected version (*top right*) was made without camera movements, the corrected shot (*right*) by raising the lens panel on the front standard.

Project: Changing the plane of sharpness

Once you have worked through the project with the cube (pages 48–51), using the tilts or swings in an outdoor scene will seem very straightforward. Because the distance scales are so much greater here than in a studio, smaller movements are needed to align the plane of sharpness with the main axis of the scene.

In the example we show here, the setting is typical of many; a close foreground and an array of subjects that essentially lie flat (the depth of field "spreads" further away from the camera, so that the elevation of the hill beyond the lake is of little consideration). First, choose the plane of the scene; in this example it runs naturally from the foreground rocks to the hill beyond. The idea, then, is to line up the focus with this plane.

The basic method is to tilt the lens panel forward until the front edge of the foregound rock and a point near the top of the hill are in focus together, at full aperture. Some view cameras incorporate a system for making this kind of alignment, but with others trial-and-error is normal. Experience speeds the process up, but because the degree of tilt is not likely to be great (12° in the set-up shown), this is not difficult even if you are doing it for the first time. With these two points in focus, check the depth of field (which is now more up-and-down rather than near-to-far). With luck, you will need to stop down only a little, and so be able to use a respectable shutter speed. Also, as explained on pages 114–17, shooting at the smallest aperture has its own problems, often reducing image quality due to diffraction.

Sharp focus from foreground to background
Tilting the lens panel forwards changes the plane of sharpness in the picture from vertical to nearly horizontal. Even with the aperture setting only two stops less than its widest (f16 on this 90mm wide-angle lens), the overall sharpness is better than in the smaller picture, which was shot for comparison on a 35mm camera fitted with a 20mm lens at the same aperture.

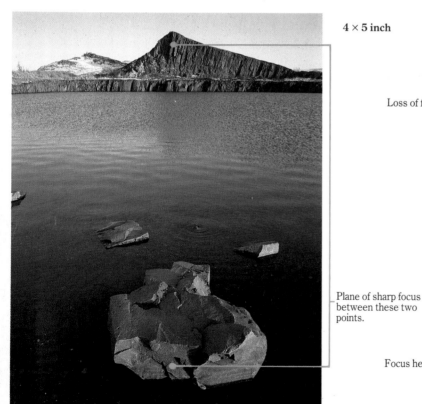

4 × 5 inch

Plane of sharp focus between these two points.

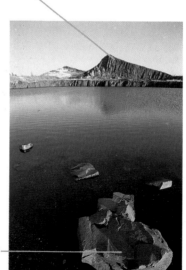

Loss of focus begins here

35mm

Focus here

Instant Picture Cameras

For patent reasons, only Polaroid now manufacture instant film; not surprisingly, therefore, they make most of the instant film cameras. The variety of films in their range is large, both in type and in size, and as the film determines the equipment, the range of cameras and film backs is wide and a little complex.

Instant film is available in three basically different forms: integral film, peel-apart film and 35mm slide film. Integral film is the type in which each part of the process, from negative to chemicals, remains sealed inside a single "packet", and there are no pieces to discard. The front of the film packet is a transparent plastic window through which the developed image is viewed; the negative and used chemicals stay hidden from view beneath the picture and its opaque white backing. Peel-apart film is self-descriptive; the final print is peeled away from the negative and chemicals, which are discarded. The third form, 35mm instant slide film, is supplied as sprocketed emulsion in standard cartridges, and is handled and exposed in exactly the same way as ordinary 35mm film.

Of these three, only integral and peel-apart films require special cameras or film backs; the 35mm film is designed to be used in regular 35mm cameras. Integral film cameras, now manufactured only by Polaroid, occupy the bulk of the instant picture market, and are designed for straightforward, no-nonsense amateur photography. They are not compatible in any way with other cameras and lenses, and so are simply an addition to whatever equipment you normally carry. Nevertheless, they can be a very useful addition, and beyond straight picture-taking can help with checking out a picture in advance, as a visual notebook, and to give to people whom you want to photograph, as a means of relaxing them and breaking the ice.

The original integral film camera was the SX-70, launched in 1972. Its unusual shape – a slab when closed, an angular arrangement with rubber bellows when in use – is

Image/Spectra integral instant print camera

This exploded illustration shows the relative complexity of a camera that requires virtually no technical input from the photographer.

Electronic three-blade shutter operates from $\frac{1}{245}$ second to 2.8 seconds and is set automatically by metering system. Apertures range from $f\,41.8$ to $f\,10$ in available light, from $f\,31.5$ to $f\,10$ in full-flash mode

Ultrasonic echo-ranging system controls the pivoting of the lens system for automatic focusing

Sonar transducer

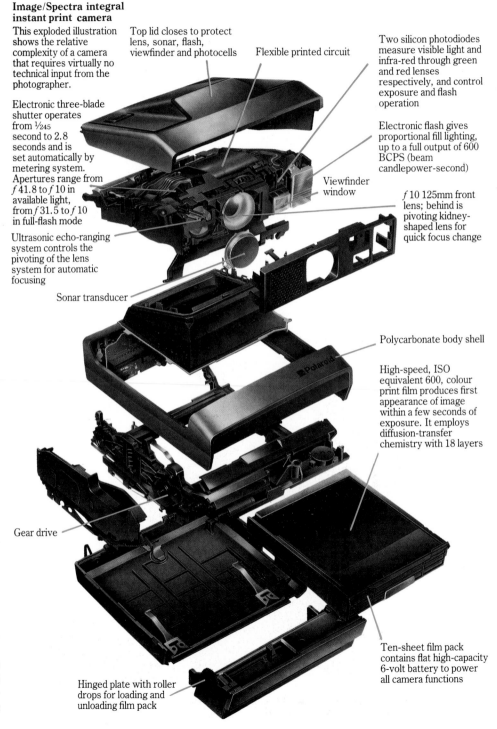

Top lid closes to protect lens, sonar, flash, viewfinder and photocells

Flexible printed circuit

Two silicon photodiodes measure visible light and infra-red through green and red lenses respectively, and control exposure and flash operation

Electronic flash gives proportional fill lighting, up to a full output of 600 BCPS (beam candlepower-second)

Viewfinder window

$f\,10$ 125mm front lens; behind is pivoting kidney-shaped lens for quick focus change

Polycarbonate body shell

High-speed, ISO equivalent 600, colour print film produces first appearance of image within a few seconds of exposure. It employs diffusion-transfer chemistry with 18 layers

Gear drive

Ten-sheet film pack contains flat high-capacity 6-volt battery to power all camera functions

Hinged plate with roller drops for loading and unloading film pack

due to the special needs of instant film. In particular these include the need to project a fairly big image – 3⅛ × 3⅛ inches (80 × 80mm) – in a small space, and to produce an uninverted image when the film has to be exposed through the front. Regular film is exposed through the side opposite the side viewed, but with a film pack that must store all the used chemicals beneath the image, this is impossible. The result is a complicated light path that includes a mirror to reverse the image projected by the lens.

The successor to the SX-70 was the SLR 680; mechanically and optically this is essentially the same type of camera, although much improved in its electronics and automation. Its film is also improved, with better dyes and faster development, and a much higher speed: the ISO equivalent of 600, allowing photography in a much wider range of circumstances. This camera is fully automated, to the extent of having a sonar rangefinder that controls focus automatically, an electronic flash that delivers a range of doses according to the light level, and a motor which enables the exposed print to be ejected by the camera.

Both these cameras are on their way to becoming obsolete, however, as Polaroid have developed a model which is mechanically quite different and accepts a different type and format of print film. This model, called the Spectra in the United States and the Image System in Europe, dispenses with reflex viewing, is bulkier, but more sophisticated and rapid in operation. The body folds, the camera is used in a "binocular" fashion, and operation is fully automated. When you are using this camera, there is very little that you actually need to know, although the technology is advanced, and some of it is intriguing.

The lens is a complete change from its predecessors. One of the elements in the lens system is kidney-shaped, and this slides between the other two fixed elements to alter the focus. The advantage of this original design is that big changes of focus can be made by moving the element just a little, and that a relatively long focal length (125mm) can be fitted into a small space. The micro-electronics are advanced and permit great accuracy and speed in monitoring exposure, flash pulse and focus.

The film is as fast as that used in the SLR 680, has improved dye chemistry to give better picture quality, and is a larger format, with a picture size of 3⁹/₁₆ × 2⅞ inches (91 × 73mm).

Equipment for peel-apart film

Peel-apart films include colour print, a fine-grain black-and-white print, an equally fine-grain black-and-white print that has an accompanying permanent negative, a high-speed black-and-white print and a high-contrast black-and-white print. Not all of these are available in all formats, but the basic range of film sizes are:

3¼ × 3⅜ inch	(83 × 86mm)	pack-film
3¼ × 4¼ inch	(83 × 108mm)	pack-film
4 × 5 inch	(102 × 127mm)	sheet film
8 × 10 inch	(203 × 254mm)	sheet film

There are a few cameras and several special holders that fit onto certain regular cameras in place of the normal film back, which accept this array of print films. The special holders are useful because so many professionals use instant film to test for

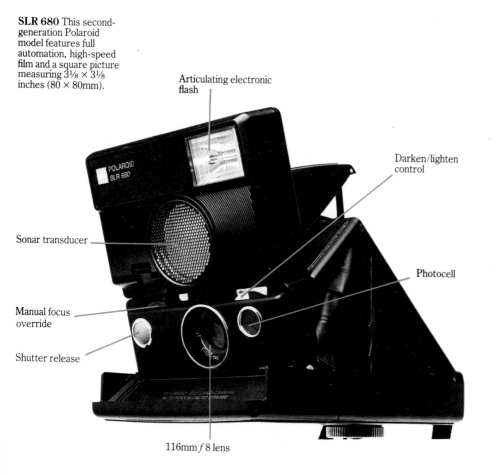

SLR 680 This second-generation Polaroid model features full automation, high-speed film and a square picture measuring 3⅛ × 3⅛ inches (80 × 80mm).

Articulating electronic flash

Darken/lighten control

Sonar transducer

Photocell

Manual focus override

Shutter release

116mm f 8 lens

Contax Preview

Prism for eye-level reflex viewing

Pack-film holder

Sync. socket

Shutter speed control

Konica Instant Press

Rangefinder window

Viewfinder window

Grip

Focus knob

110mm ƒ4 fixed lens accepts close-up attachment for 1:1 magnification or wide-angle converter

Folding cover

exposure, composition, lighting and so on, before making the real exposure on regular film (an example of how this works is on pages 52–3).

There are very few cameras designed specifically for instant film. Excluding specialized equipment for copy work and close-up photography, Polaroid make two models, the 600SE and the EE100S, and Konica make one, the Instant Press. All three accept the 3¼ × 4¼ inch (83 × 108mm) film packs, and in addition the Polaroid EE100S will take the smaller 3¼ × 3⅜ inch (83 × 86mm) format.

The simplest of the three is the EE100S, a basic, folding camera with a fixed 114mm ƒ9 lens, with automatic exposure but without rangefinder focusing. The 600SE is manufactured by Mamiya and is basically a special version of the Mamiya Universal Press camera, capable of accepting three different lenses: 127mm ƒ4.7 standard, 75mm ƒ5.6 wide-angle and 150mm ƒ5.6 moderate telephoto. The Konica Instant Press, a recent model, has a high-quality fixed lens (110mm ƒ4) in a worthy traditional configuration: a folding bellows protected by a hinged front cover.

In contrast to the rather poor showing of cameras for peel-apart films, there are film backs for every type, to fit the majority of medium- and large-format regular cameras. Even some professional 35mm cameras can be used with instant print film.

View cameras pose no problems at all, as regular sheet film must be loaded first into holders. Polaroid holders for these sizes are just a little bulkier. The 8 × 10 inch (203 × 254mm) holder is similar in use to a regular version, but the size of the print, which must be exposed evenly to the chemicals in the pod, mean that a mechanical film processor must be used. For 4 × 5 inch (102 × 127mm) film there are two choices: Polaroid's model 545 for single sheets and the model 550 for film packs. After exposure, the film is drawn out of the holder by hand, the rollers squeezing the chemical pod.

Locking bar for pack-film holder

Timer to indicate film processing time

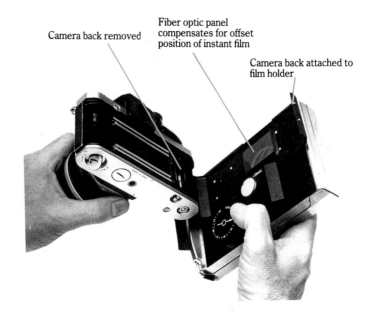

Camera back removed

Fiber optic panel compensates for offset position of instant film

Camera back attached to film holder

A greater variety of film backs are made for medium-format cameras and the $3\frac{1}{4} \times 4\frac{1}{4}$ inch format, and are listed in the table *right*. Almost every manufacturer of a rollfilm camera includes an instant film back in their range of equipment. Some manufacturers, such as Hasselblad, even offer a choice of backs for both the small format cameras.

At the specialized end of the range of film backs are the "specials" available for professional 35mm users. The Tekno back for 100 series $3\frac{1}{4} \times 4\frac{1}{4}$ inch film fits directly onto the body of certain 35mm SLRs, temporarily replacing the hinged back. Naturally, this can only be used before loading a cartridge of regular film. The Contax Preview is an unusual design, being almost a camera in its own right. It is essentially a highly simplified body attached to a Polaroid pack-film holder, and is intended for test shooting. Having set up the shot with a conventional camera, the photographer transfers the lens to the Preview and takes a Polaroid exposure as a check. The Preview only accepts lenses that have a Contax or Yashica bayonet mount, however.

	Backs for instant films			
▶ **Film types**	8 × 10 Peel-apart film (Types 809, 891)	4 × 5 Peel-apart film (Types 59, 559, 52, 552, 55, 51, 57)	3¼ × 4¼ Peel-apart film (Types 669, 668, 665, 107, 084, 107C, 667; "100 Series")	3¼ × 3⅜ Peel-apart film (Types 88, 87; "80 series")
▼ **Camera types**				
8 × 10 view cameras	Polaroid 81–05 and 81–06 film holder	Polaroid 545 film holder for single sheets, 550 film holder for pack films, both used in a reducing back	Polaroid 405 film holder used in a reducing back	
4 × 5 view cameras		Polaroid 545 film holder for single sheets, 550 film holder for pack films	Polaroid 405 film holder	
Medium-format cameras Bronica ETRS, SQ GS1		Own back	Own back	
Hasselblad 500C/M, SWC, ELM, FC/M		Own back/Arca back		
Mamiya RB67, RZ67, 645, Universal Press		Own back/Arca back*	Own back	
Pentax 6 × 7		"Professional Camera Repair" (M. Forscher)		
Rollei 6006, SLX SL66, SL66E		Own back/Arca Back		
35mm cameras Canon F1, F1N			"Professional Camera Repair" (M. Forscher) Tekno**	
Contax			See Contax Preview (page 60)	
Nikon F2, F3			"Professional Camera Repair" (M. Forscher) Tekno**	
*Twin-shot capability				
**Built-in dark slide for removal without losing any film				

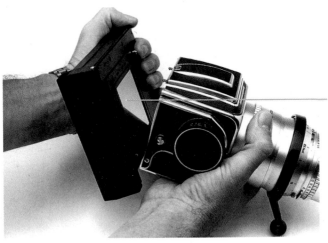

Hasselblad pack-film holder

Slide protects film from exposure

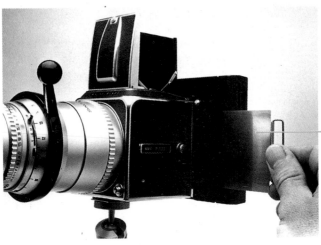

Slide removed before exposure, as with regular film magazines

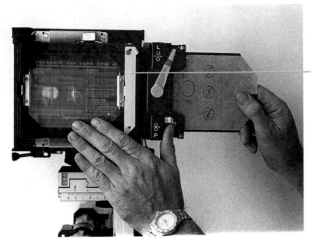

Polaroid 545 sheet holder

Holder sits under spring back

Project: Strong, simple design

Shooting with an integral film camera calls for some changes in the way you see images. The principal one is accepting that the print size is small and fixed. Even though most regular emulsions produce an even smaller image – 24 × 36mm (1 × 1½ inches) in the case of 35mm cameras, or 6cm (2½ inches) by a variety of dimensions in the case of rollfilm cameras – all the results are intended to be seen in enlargement. Either the picture is recorded on a negative and will then be enlarged into a print, or it is a transparency and will normally be projected or printed. An instant print, on the other hand, is as much as you will get; no more and no less.

What you shoot, therefore, must work at that exact size. Whereas you learn with a normal camera and film to think of the picture in terms of its final appearance, so allowing for a certain degree of enlargement to help the design, a more immediate approach is needed for composition with an instant film camera.

The theme of this project is thinking small, at least in terms of the picture size. First consider how prints are viewed. At this scale, a print is looked at rather than looked into. With a normal enlargement, it is possible to look at the image without being constantly aware of the edges of the frame: in fact, the larger it is, the easier it becomes to imagine yourself inside the scene, studying the picture by looking around it from one area to another.

Here, however, everything can be seen at a glance. This is why strong, simple design often works so well in this format. Try keeping the various elements of the pictures – lines, shapes, colours and the focus of attention – clean and bold. This is not intended as didactic advice on successful photography, but to encourage you to explore this approach. Also make use of the borders of the picture, thinking about the angles and shapes that the lines within the photograph make with the edges and corners. If the picture is dark overall, then the

edges will be particularly prominent against the consistent white borders of the print.

If you are shooting with an SX-70 or SLR 680, you will also have to cope with the slightly difficult square format. Unlike the 2:3 proportions of a 35mm photograph, a square picture area is not a natural one to compose within. This does not mean that the results need to be unsatisfactory, but you will have to remain aware of the format as you shoot; there is no single "direction" to the picture area.

Project: Testing with Polaroid

Provided that you are working with a camera that has a simple facility for accepting Polaroid film as well as the regular emulsion, combine this project with any other shooting. It works best in relatively static situations, where you have the time to consider the design of the image and lighting, and to make alterations as necessary. Although instant film can be and is used almost as an exposure meter, it is more valuable to learn to use it sparingly. For example, when you have reached the point in preparing, say, a still-life where you are ready to make the exposure, first make a test shot on instant film, and then sit down and study it as objectively as you can. It is often interesting to discover that, simply by having a two-dimensional result in your hands, improvements suggest themselves. A black-and-white instant test is no disadvantage for a colour photograph; the monotone version can help to highlight the elements of the composition.

Simple graphic composition
Although not the only way of designing within a small picture area, strong lines and simple elements usually work well.

Diagonal frame
This variation on a square format is easy to shoot, provided there is a combination of strong vertical (tree) and horizontal (skyline) components.

Special Cameras: Panoramic

The attraction of a panoramic view is that it gives the sensation of a broad sweep, and for this reason it is usually most successful in landscape photography. The length of the picture is in the same direction as that in which the eye most comfortably scans a view, and for broad open landscapes it has the advantage of cutting sky and foreground out of the shot (if neither are interesting, this can help the design considerably).

Although panoramas can be made from regular negatives or transparencies simply by cropping the top and bottom when making an enlargement, the image quality is likely to suffer. A panoramic view needs two particular qualities to work well: it should be seen large and have plenty of detail. An enlargement from a 35mm frame would need to be at least ten times longer than the original to achieve this effect, and the impression of detail would not hold.

As a result, there are a number of specially designed panoramic cameras. Although none are cheap, they can, in cities at least, often be hired from photographic dealers. There are two basic designs of panoramic camera, operating on quite different principles. One, which could be called "passive", makes use of the extra-wide coverage of lenses that are made for view camera use. As already seen with the view camera projects, the best lenses have a wide angle of coverage; when used with a smaller film format, a panoramic effect is possible. The Linhof Technorama shown here is designed on this principle, and essentially is built to fit a Schneider 90mm f 5.6 Super-Angulon. This, for a 4 × 5 inch (105 × 127mm) format, is a wide-angle lens, and projects an image diameter of 235mm at f 22. In the Technorama it covers 6.7 inches (170mm) of rollfilm length, giving picture proportions of almost 1:3.

There are no special technical problems in using this type of panoramic camera, although you should be aware of one or two slight disadvantages. The first of these is that there is a noticeable fall-off in illumination away from the center of the picture. This is a natural result of using almost the full coverage of a wide-angle lens, and is just what happens when extreme movements are used on a view camera (see pages 48–51). You can appreciate this even more easily by opening the back of the Technorama. The distance from the lens to the far left and right edges of the film frame is obviously greater than that to the middle of the frame; hence the edges will be darker. Full correction needs a filter that

Widelux
In this design of camera, the panoramic proportions are achieved by means of a rotating lens, which projects the image through a slit onto the 35mm film behind. The 26mm lens gives a 140° field of view.

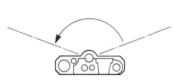

Shutter release

Film wind-on lever

Viewfinder

Rotating lens

Vertical columns not only converge upwards but curve as well

Distortion occurs only lengthwise: the edges of this frieze appear straight in the vertical shot, curved in the horizontal

Widelux: distortion
The special barrel distortion from a rotating lens is obvious in these three photographs.

A slight downward tilt to the camera creates a slight upward curve to the line of the street

Ideally, use a tripod and spirit level to ensure an absolutely level horizon, and a small aperture for good depth of focus.

▼ **Technorama**
The panoramic effect with this camera is created by the use of a lens designed for view cameras, giving wide coverage onto rollfilm (105° at *f* 22, for an image circle of 235mm diameter).

darkens progressively towards the center, but if you intend to make your own enlarged prints, a less expensive alternative is to adjust the condensers in the enlarger to create the same amount of vignetting: the two effects will cancel each other out. Otherwise, try to compose the pictures so that an even tone does not cross the picture and show up the vignetting.

The length of film exposed may result in it not lying completely flat, which can cause soft focus in some parts of the picture. A small aperture, which will give good depth of focus, is a sensible precaution. This in turn makes a tripod useful.

The other type of panoramic camera uses a rotating lens (in the case of 360° panoramic cameras, the entire body moves). This covers the required angle, projecting its image through a slit onto the film, like a form of scanning. The special feature of using one of these cameras, such as the Widelux shown here, is that the rotation of the lens introduces curves into the picture. This is a type of barrel distortion. If you tilt the camera slightly up or down from a level position, you will see this effect very clearly on the horizon. If you want to avoid it, use a spirit level.

▼ The drawback of the Technorama approach to panoramic photography is that almost the full image circle of the lens is used. Consequently, there is a noticeable fall-off in illumination towards each end of the picture, as is obvious in this scene. To correct it fully, an expensive central-graduated filter is needed.

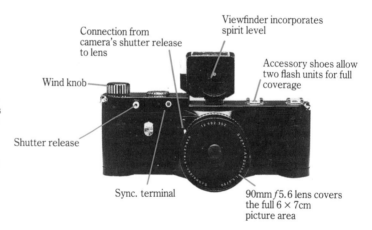

Connection from camera's shutter release to lens

Viewfinder incorporates spirit level

Accessory shoes allow two flash units for full coverage

Wind knob

Shutter release

Sync. terminal

90mm *f* 5.6 lens covers the full 6 × 7cm picture area

Special Cameras: Underwater

There are two methods of making cameras amphibious: submersible housings for regular equipment, and cameras and lenses that are internally sealed against water under pressure. In practice, there is a wide choice of submersible housings, in different materials and at various levels of ruggedness and sophistication, but no choice in real amphibious cameras; the Nikonos is the only serious design.

The advantages of the Nikonos as the only representative of a truly amphibious camera are that it is compact and efficient, being no larger than a regular "on-land" camera. Its great drawback is that it is a non-reflex camera, and also, incidentally, lacks such features as a power winder, which would be particularly useful for one-handed operation when diving. The benefits of housings are that, for a relatively small cost, you can take your existing equipment – motor-drive and all – underwater. Against this, housings are bulky out of water (the extra buoyancy when diving removes this

problem) and there is always the risk of ruining the equipment inside by making a mistake in assembling the housing.

Optics
Water refracts light more strongly than air, which affects both focusing and the size of the image. If you think of the water as an extra lens in contact with the front of the camera lens, it should be easier to appreciate why objects appear closer and larger underwater than they really are, and lenses have a smaller angle of view.

This needs less consideration with the Nikonos than with a regular camera in a housing. As the Nikonos is non-reflex, there is no need to focus the actual image, only to estimate the distance and set the focusing knob accordingly – and as both the lens and your eye suffer the same distance illusion, there is no discrepancy. The effect on the lens angle of view *looks* like a difference in the focal length, although it is not. Nevertheless, underwater 35mm is the

"standard", equivalent to a 50mm lens on land, and wide-angle lenses all have a quarter less wide-angle effect.

Using lenses underwater
The focal length of a lens remains the same, but it behaves as if it were longer. For example, the standard lens for a 35mm camera underwater is 35mm rather than 50mm.

Lens focal length (on a 35mm camera)	Angle of view at the surface	Angle of view underwater
16mm	170°	127.5°
20mm	94°	70.5°
24mm	84°	63°
28mm	74°	55.5°
35mm	62°	46.5°
50mm	46°	34.5°
55mm	43°	32°

With submersible housings there is a choice, and it can be confusing. In the cheaper housings, the port (the window in front of the lens) is flat, and so does nothing

1 Objects appear closer than they are, by one quarter of their distance.

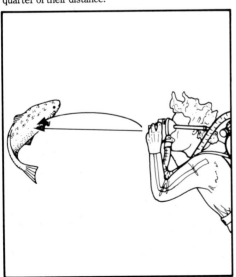

2 The angle of view of a lens is smaller, by one quarter.

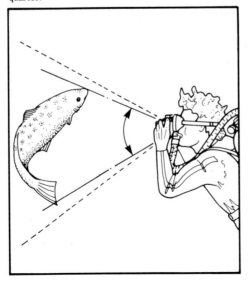

3 Objects appear larger than they are, by one third.

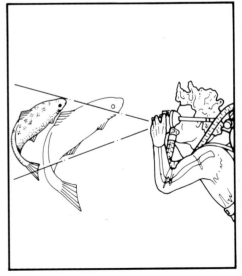

to correct the effects mentioned above. In addition, it reduces image quality by introducing pincushion distortion and chromatic aberration (see pages 114–17). The answer to all these problems is to fit a curved port, also known as a dome port. Ideally, its center of curvature should be at the center of the lens, and it is normal to have two interchangeable ports – one for close-to-standard focal lengths, and one for wide-angle lenses. However, one side-effect is that the focusing scale on the lens no longer applies and with wide-angle lenses it may be necessary to attach either a supplementary close-up lens or a thin extension ring. The extra curvature can affect the focus at the edges of the picture area with wide-angle lenses, and it is helpful to stop down for improved depth of field.

Water-contact lenses for the Nikonos are the ideal solution. They cannot be used on land, but underwater show none of these optical problems. The Nikonos 28mm and 15mm lenses have this design.

Nikonos

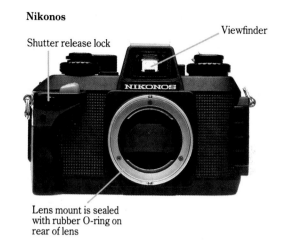

Shutter release lock

Viewfinder

Lens mount is sealed with rubber O-ring on rear of lens

Film rewind crank

Shutter release

Shutter speed dial

Film speed dial

Accessory shoe

Frame counter

Wind lever

Hydro 35 housing

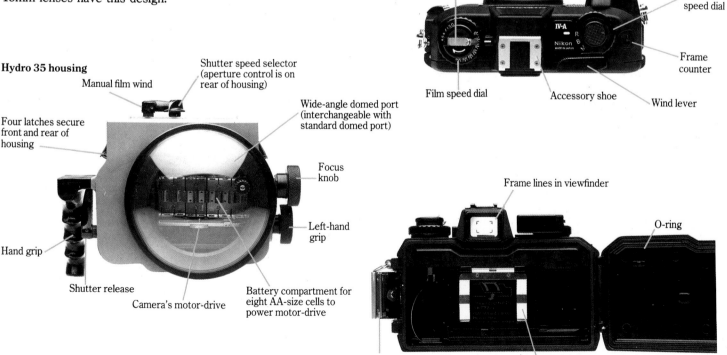

Manual film wind

Shutter speed selector (aperture control is on rear of housing)

Four latches secure front and rear of housing

Wide-angle domed port (interchangeable with standard domed port)

Focus knob

Left-hand grip

Hand grip

Shutter release

Camera's motor-drive

Battery compartment for eight AA-size cells to power motor-drive

Frame lines in viewfinder

O-ring

Camera back latch

Hinged pressure plate

Available light

Water absorbs a surprising amount of light, and it does so selectively, beginning at the red end of the spectrum. Depth limits the shutter speed and aperture setting that you can use, and for underwater landscapes it may be necessary to use the widest aperture and a shutter speed as low as $\frac{1}{60}$ second or even $\frac{1}{30}$ second.

Another problem is colour. At only a few feet under the surface the illumination is noticeably blue-green, and for correction you will need a reddish filter. The table below shows the ideal filter correction, but in practice most divers fit only one, and make do with any differences due to depth.

Feet (m)	Filter
0	No filter
5 (1.5)	CC10R
10 (3)	CC20R
15 (4.5)	CC30R
20 (6)	CC40R
25 (7.5)	CC50R
30 (9)	All red absorbed
65 (20)	All yellow absorbed
75 (23)	All green absorbed

▼ This sequence of unfiltered shots shows the increasing loss of colour with depth, from 1 foot (0.3m) below the surface to 20 feet (6m).

1ft (0.3m)

5ft (1.5m)

10ft (3m)

20ft (6m)

Flash

Natural light shooting is obviously the only way to take landscape views, but it has such disadvantages that electronic flash is standard procedure for medium-range and close-up photography. Handling conditions are more difficult underwater than on land, so there is considerable advantage in using flash on automatic setting, and for most medium-range shooting this usually works well. Units such as the Nikonos SB-101 give a choice of automatic ranges – for example, with ISO 100 film this might be either $f4$ between $1\frac{2}{3}$ feet (0.5m) and 13 feet (4m), or $f8$ between $1\frac{2}{3}$ feet (0.5m) and $6\frac{1}{2}$ feet (2m).

The main precaution in normal underwater flash photography is to position the flash head appropriately. To begin with, it must be pointing at the subject – obvious enough, but it is easy to knock the head out of position without noticing, and changes in distance should be compensated for. A common problem, more in dirty water than in clean, is "backscatter". This effect, which looks like a mild snowstorm on the developed image, is caused by particles in the water between you and the subject reflecting light from the lens. The standard position on a bracket is above and to the left of the camera, and the more you can extend the flash unit, the better. There are also aesthetic reasons for keeping the flash high and apart: most subjects look better when lit from above rather than from in front. When you first use an underwater flash, experiment with different flash positions, even taking the head off the bracket and holding it at arm's length (this is admittedly more difficult, as it occupies both hands).

See for yourself which position gives you the results you prefer.

Fill-in flash is an important but difficult technique to master, and is most valuable when used to bring colour and life to a scene which has both depth and foreground detail. Practice and experiment are essential, but follow this procedure: first take a reading of the background, as this will not benefit from any flash output. Set the camera accordingly, but make sure that the shutter speed is slow enough for the sync. – usually about $\frac{1}{60}$ second or $\frac{1}{90}$ second. Now use the flash chart on the unit and see what the correct aperture should be for the foreground; this may be at or a little less than the available light reading. Usually, you have two choices for adjustment: moving back if there is a risk of overexposure, or selecting a lower output setting on the flash.

▶ **Nikonos: normal flash configuration**
This electronic flash model, the Nikon SB-101, has an underwater guide number of 16 (ISO and meters) and an angle of coverage underwater of 50°, making it suitable in this configuration for 35mm and longer focal lengths. It can be used automatically, with the sensor, or manually (full or quarter-power settings). The two automatic shooting ranges available cover 2 to 7 feet (0.6 to 2.1 meters) and 2 to 14 feet (0.6 to 4.3 meters).

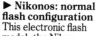

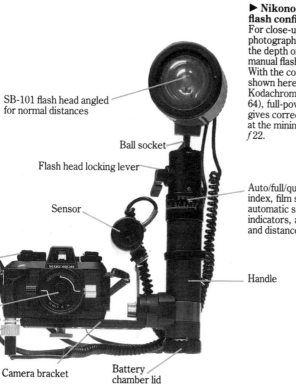

SB-101 flash head angled for normal distances

Ball socket

Flash head locking lever

Sensor

Camera shutter set to "A" gives $\frac{1}{90}$ second flash sync.

35mm $f2.5$ lens

Sync. cord or lead screws into base of camera

Camera bracket

Battery chamber lid

▶ **Nikonos: close-up flash configuration**
For close-up photography, maximize the depth of field by using manual flash settings. With the configuration shown here and Kodachrome 64 (ISO 64), full-power flash gives correct exposure at the minimum aperture, $f22$.

Auto/full/quarter power index, film speed scale, automatic shooting range indicators, aperture scale and distance scale

Handle

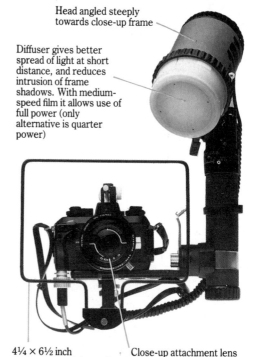

Head angled steeply towards close-up frame

Diffuser gives better spread of light at short distance, and reduces intrusion of frame shadows. With medium-speed film it allows use of full power (only alternative is quarter power)

$4\frac{1}{4} \times 6\frac{1}{2}$ inch (108 × 165mm) frame for 35mm lens

Close-up attachment lens on 35mm camera lens

Close-up

Underwater close-up photography is virtually always flash photography also. Automatic flash operation is not normally a good idea in this case, as the sensor feedback on most units is likely to be inaccurate, and the available settings are for moderate apertures only. What you need is an output that will allow the smallest aperture setting on the lens: usually f 22.

With the Nikonos close-up systems everything is pre-set, including the frame that marks out the area being photographed. This means that you can be certain of consistent results once you have tested the set-up. This test is all-important; make a series of exposures at different apertures of a single subject at the same distance. If you use the Nikonos set-up shown here, there is only one distance, but with a macro lens in a housing, repeat the test for a few distances that you are likely to use in future. If your flash unit allows different manual outputs, test these.

With the SB-101 used for the photograph of the tiger cowrie here, the flash was used at full and quarter-power settings, and both with and without the diffusing head shown. The result was that with ISO 64 film, full power with the diffuser gave the best exposure at f 22. Film speed variations can then be calculated rather than tested.

Nikonos close-up outfit

To avoid parallax, viewing and focusing problems, the close-up attachment for the Nikonos gives pre-set conditions. A supplementary close-up lens and frame allow shots to be composed simply by placing the frame over the subject; the viewfinder does not have to be used at all. The standard outfit shown here allows a 4¼ × 6½ inch (108 × 165mm) picture area. With the camera's 28mm lens the area is larger at 5¾ × 8½ inches (146 × 216mm), giving a reproduction ratio of 1:6. With the 80mm lens the picture area is only 2⅛ × 3⅛ inches (54 × 79mm) – a reproduction ratio of 1:2⅓. Depth of field at f 22 is 3 inches (76mm) with the 28mm lens, 1¾ inches (45mm) with the 35mm lens, and ½ inch (13mm) with the 80mm lens.

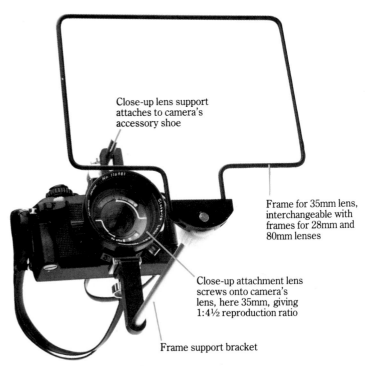

Close-up lens support attaches to camera's accessory shoe

Frame for 35mm lens, interchangeable with frames for 28mm and 80mm lenses

Close-up attachment lens screws onto camera's lens, here 35mm, giving 1:4½ reproduction ratio

Frame support bracket

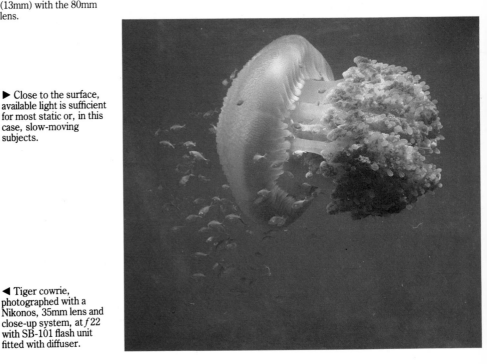

▶ Close to the surface, available light is sufficient for most static or, in this case, slow-moving subjects.

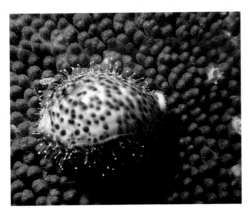

◀ Tiger cowrie, photographed with a Nikonos, 35mm lens and close-up system, at f 22 with SB-101 flash unit fitted with diffuser.

Underwater kit
Shown here is a dual diving outfit of Nikonos with flash and close-up system, and Hydro 35 aluminium housing for a Nikon and several lenses. The flash unit fits both.

Hydro 35 die-cast housing for 35mm cameras, fitted here with dome port for wide-angle lenses

Colour correction lens for shooting without flash at shallow depths

Domed port for standard focal lengths: Hydro 35 housing

Light meter

Close-up kit for Nikonos with frames for 35mm and 28mm lenses

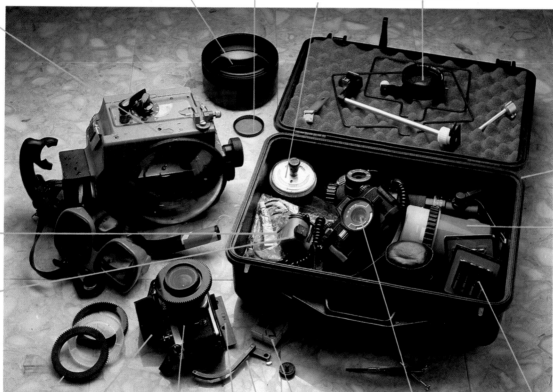

Spare O-rings

Photo-cell sensor for flash

Watertight, floatable, non-corrodible equipment case

Nikon underwater flash, fitted with milky plastic diffuser

Focusing gear wheels for different focal lengths of lens

Action finder projects large image for easier viewing through face mask

Nikon with motor-drive and 20mm lens fitted with plastic gear wheel for focusing when inside housing. Battery housing is detached; batteries are installed directly in housing

Small fittings for control linkages in Hydro 35 housing

Armature linking lens aperture setting ring to outside controls

Fixing plate to attach camera in housing

Nikonos amphibious camera fitted with 35mm lens ("standard" focal length underwater)

Fresh AA batteries to power motor-drive in aluminium housing and flash (total 16 needed)

LENSES

Although you would be hard put to distinguish what camera was used just from looking at a printed photograph, the characteristics of the lens are usually spread all over the picture. From the point of view of equipment, it is normally the lens that gives the image its character; how sharp it appears, how much of it is in focus, the contrast, the impression of perspective, and more. There is little need to know the details of lens construction, but it is essential to understand the visual effects of the different types of lens.

For the most part, I am assuming that you have a camera that takes interchangeable lenses, so that you can work out these different effects for yourself. At the beginning of the book I made a point of saying that this is not a guide to buying cameras, but for lenses I must make an exception. If your camera allows you the facility to change lenses, you might want to consider making the most of the opportunity. Over a period of time, most photographers end up with a group of lenses that they carry and use regularly. The lenses that make up a set naturally vary from person to person.

A lens can be a single piece of glass, but in a camera it consists of several pieces, called elements. Look at the cut-away diagram of a standard 50mm lens for a 35mm

SLR. The reason for using differently shaped elements is to improve its performance; correcting the natural faults that all lenses have (see pages 114–17) and determining characteristics like the amount of magnification and the angle of view. A large aperture lens needs more elements (the lens shown here has a large maximum aperture of $f1.2$ and so has seven elements), as does a wide-angle lens. Zoom lenses generally have the most elements because they combine several focal lengths.

Lenses are either symmetrical or asymmetrical in design. In a symmetrical lens, the elements on either side of the aperture diaphragm are more or less the same; most standard lenses, including the example shown here, are built like this. Telephotos and most wide-angle lenses for 35mm SLRs, however, have a different layout of elements in front of and behind the aperture diaphragm.

The mechanism of a lens is concerned chiefly with two functions: focusing and changing the aperture. Sharp focus depends on the distance of the subject from the camera, and to focus closer means moving the lens elements further away from the film. In practice, most lenses do this by means of a helicoid gear; turn the focusing ring on the outside of the barrel and the

elements inside are moved backward or forward. In time, the focusing mechanism will become a little loose and you should make it a habit to check your lenses from time to time. Make two tests. First, take hold of the focusing ring in one hand and the main body of the lens in the other; twist the ring to see if there is any loose play, or "slop" as it is sometimes called. Then, if the lens is a telephoto, hold the camera pointing down, as shown in the photograph *opposite*; if the helicoid is too loose, the focus will shift by gravity alone. If you get such a result from either test, have the focusing mechanism professionally repaired. (For other tests, see pages 114–17.)

The aperture diaphragm controls the amount of light passing through the lens, and at the same time the depth of field. The mechanism is a set of curved metal blades arranged around the inside of a ring-shaped mount; turning the aperture selection ring on the outside of the barrel causes the blades to open or close. The size of the circle in the middle – the aperture – is indicated by an f-number (also known as an f-stop). The smaller the number – which is actually the ratio of the diameter to the focal length of the lens – the larger the aperture, so that $f1.8$ is wider than, say, $f11$ (see pages 146–51).

Triplet

Types of lens design
These are some of the most common styles of lens design used in photography. The triplet, with only three elements, was one of the first, and is rarely used today because it does not offer enough possibilities for correcting aberrations. The principle of symmetrical designs like the Gauss is that the aberrations caused by the front group are cancelled out by the rear group.

Gauss

Tessar

Sonnar

Ernostar

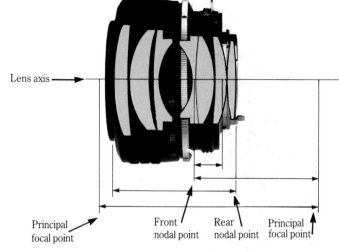

Lens axis →

Principal focal point

Front nodal point | Rear nodal point | Principal focal point

The points of a lens
Most lens measurements are made along the center line, known as the lens axis. The point behind the lens where the parallel light rays entering from the front meet is called the focal point; when the lens is focused on infinity, this is where the film is situated. There is a second focal point in front of the lens, but this is usually only of practical importance if you reverse the lens for close-up photography (see pages 174–5).

The use of several elements mean that there is no simple "center" to the lens, but instead two nodal points (also called principal points). Measurements like the focal length are usually made from the rear nodal point.

If helicoid is loose, weight of lens will make it fall slowly

Checking the focusing mechanism
Twist the focusing ring backwards and forwards (*below*) to see if there is any loose play. A long lens (*left*) will slowly extend if the mechanism is loose when held downwards. Both are indications for professional overhaul.

Loose play in focusing mechanism can be felt if ring is turned from side to side

Focal Length

Of all the features designed into a camera lens, none makes such an obvious difference to the image as focal length. When I mentioned earlier that most photographers come to use a set of lenses, I was referring to a variety of focal lengths.

Practically, most of us think about focal length – if we do so at all – in terms of three types: wide-angle, standard and telephoto. This is the normal terminology, although strictly, wide-angle lenses are short-focus, and telephoto lenses long-focus. To a working photographer, the differences are in the angle of view, in magnification, and in the character of the image (for instance, "compressed" or "expansive", and other descriptions of the visual impression). But first, a word about the fundamentals.

As just explained on pages 72–3, the focal length is the distance between the principal point of a lens and the focal point, at which light rays from a distance are in focus. For example, imagine a standard 50mm lens focused on a tree; the size of the tree's image, for the sake of argument, is ½ inch (12mm) on the film frame. Now, if the lens were designed differently, so that it focused further back, that image would be larger because the light rays would still be spreading from the lens. If the focal length is double, 100mm, the image of the tree would be 1 inch (25mm) high, almost filling a horizontal 35mm frame.

Using a standard 50mm lens as the base line, anything longer magnifies. At the same time, of course, the view is restricted. Now, if we reduce the focal length with yet another design of lens, the film will be closer to the lens instead of further away, the light rays have less space in which to spread out, and the image of the tree will be smaller. The size of the picture frame, meanwhile, has not changed, so that the lens takes in more of the scene – a wider angle of view, in other words.

These are the two main effects of changing from a lens of one focal length to another: magnification and angle of view. But what about perspective? One important reason for using a different focal length is to give a particular visual style, and this is intimately connected with perspective. Yet perspective stays the same as long as the camera is not moved, regardless of what lens is used.

So often the word "perspective" is used loosely, and this gives rise to confusion. Perspective really means the impression of distance and relative positions, and this only changes if the viewpoint is changed. Focal length only has an effect if the lens is used at a different distance. The following two practical lens projects will demonstrate the differences between focal lengths.

Project: Testing different focal lengths
The effect of this project is to take all the different focal lengths that you can lay your hands on, and shoot one scene from one position without moving the camera, switching from the widest-angle lens to the longest telephotos. You can find much the same exercise carried out in lens catalogues, and it is, on the face of it, rather uninspired. However, the value is in doing it, and afterwards there is a second contrasting project.

In the example shown here, the range is greater than most photographers are likely to have. The very long telephoto lenses demonstrate magnification very clearly, but do not worry if the longest you can find is less. Used like this the range of lenses does just two things: it gives you a choice of magnification and a choice of angle of view. The two go hand in hand. As you change from each lens to one of a greater focal length, the view narrows, but that smaller part of the scene is enlarged to fill the same frame size. The perspective, as you can see, really does not change. Yet something in the character of the picture changes. The wide-angled views have a greater sense of depth, and you can see at a glance that the view is expanded to cover more than would normally be seen unaided. The telephoto views, on the other hand, feel flattened and foreshortened. Each picture bears the hallmarks of a certain focal length, and it is this

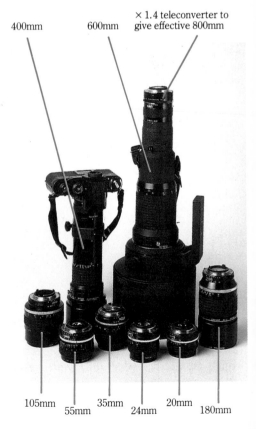

The lenses used
For this sequence of photographs, all taken from exactly the same viewpoint on Hollywood's Sunset Boulevard, nine focal lengths from 20mm to 800mm were used. To repeat this yourself, first preview a scene with your longest lens to find a worthwhile small central subject.

400mm 600mm × 1.4 teleconverter to give effective 800mm

105mm 55mm 35mm 24mm 20mm 180mm

20mm Linear perspective and distortion in the corners of the foreground make the wide angle of view obvious.

24mm Predictably, little different from the 20mm view.

35mm A moderate wide-angle lens, giving a view fairly similar to that of the human eye.

55mm A fairly standard focal length, giving a view that seems normal in magnification and angle.

105mm Moderate telephoto, marking the point in this sequence at which the view starts to appear magnified.

180mm The central cartoon figures become the clear focus of attention.

400mm The figures are now isolated from the scene.

600mm Strong magnification, giving no information about the surroundings.

800mm Extreme magnification, with an obvious sense of compression.

that gives the viewer a sense of distance. The last shots are so compressed that you would never think that they were taken from a point close to the cartoon figures. The perspective thus remains unchanged.

This, however, is not the way in which real photography is practised, and is simply a lens demonstration. One thing you may have noticed is that a single viewpoint does not give a satisfactory picture with every focal length. The 20mm and 24mm shots are framed very uncomfortably; both have too much sky and a lack of interest in the foreground. You may even feel the tendency to reframe each shot by pointing the camera at a different angle. With this in mind, it is time to move on to a realistic use of a range of lenses.

Project: A range of lenses

In contrast with the last project, what happens in the real world is that each focal length in a set of lenses encourages the photographer to use it in a particular way. You can demonstrate this for yourself by finding a subject that is viewable from several different locations but different distances, and try to use all the lenses. The only criterion in this case is that the design of each picture must work, and this alone will eliminate certain lenses from some viewpoints.

The example here is a building, a famous mosque in Singapore, and the variety of shots is treated more or less in the sequence in which they were taken. Here, perspective *does* play an important part, because the different focal lengths are used from different distances.

20mm
The first shot to be tried, in the late afternoon, was the easiest to find; a wide-angle view almost at street level. The relatively narrow streets, combined with the size of the mosque, gave little choice other than this view, which is, to be honest, too close. Converging verticals (see page 56) are a natural consequence, but not always unpleasing. The lighting gives the picture some strengths, but other viewpoints are likely to be better.

105mm
By walking around the mosque on another day, this partial view was found, suitable for a shot with a moderate telephoto. Here, for the first time, we can see the different perspective in using two different lengths – this viewpoint is much further away than the first, so changing all the relationships between the buildings.

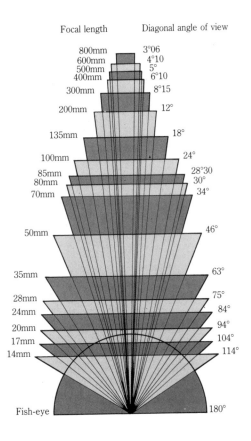

Focal length Diagonal angle of view

Focal length	Diagonal angle of view
800mm	3°06
600mm	4°10
500mm	5°
400mm	6°10
300mm	8°15
200mm	12°
135mm	18°
100mm	24°
85mm	28°30
80mm	30°
70mm	34°
50mm	46°
35mm	63°
28mm	75°
24mm	84°
20mm	94°
17mm	104°
14mm	114°
Fish-eye	180°

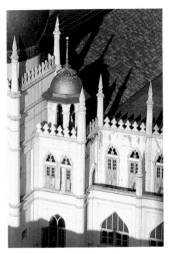

180mm
This longer telephoto suffers the same drawback as the 105mm: too close for an overall view, but not close enough to concentrate on an important detail.

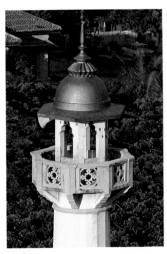

400mm
Fortunately, this focal length from the hotel balcony is just right for the top of a minaret.

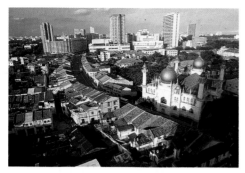

24mm
This and five other shots were taken from a nearby hotel balcony (the view backwards from close to the mosque showed this possibility). This focal length sets the building in its surroundings, giving it context. The 20mm lens would have done no better, only making the mosque appear smaller.

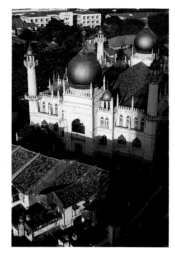

55mm
This is the focal length that gives the closest to a frame-filling view, and both a horizontal and vertical treatment are possible.

105mm
The next longest lens from the same hotel balcony viewpoint cuts into the image of the mosque, and offers hardly any good possibilities.

105mm
A different high viewpoint spotted from the hotel balcony is much further from the mosque, giving an undistorted, distant perspective. The horizontal treatment subordinates the mosque to the downtown skyscrapers behind; the vertical composition makes the mosque more central and includes the old, traditional quarter of the city below. The afternoon lighting is satisfactory but not perfect, encouraging a return visit.

180mm
In clearer morning light from the opposite direction, the mosque is picked out better against the background. A longer focal length reduces the significance of the skyscrapers, particularly in a horizontal treatment.

400mm
Closing in from the same viewpoint, the longest lens in the set gives a very concentrated view.

The Standard Lens

There is, surprisingly, no good single reason why the "standard" lens for 35mm cameras should be 50mm in focal length. Certainly it is the lens that is usually sold with the camera, but it owes its position as the normal lens only to historical accident; 50mm is a round figure.

That said, it remains the most well-used focal length for very sound reasons, the most important being that it gives an apparent perspective that is roughly the same as the way we see. If you think this is a rather bald statement, try this exercise. Raise the camera to your eye with a 50mm lens fitted. Study the scene. Now open your other eye and compare both images: one through the camera, the other unaided. Notice how similar they are; this lens neither magnifies nor reduces the apparent image. Contrast this similarity by doing the same with a wide-angle lens and with a telephoto lens.

This is why the 50mm lens is the reference for other focal lengths, and the balance between wide-angles and telephotos. It gives, simply, a natural view. The value of this is that it imposes no special optical characteristics or obvious perspective effects on the image. You can use it to let the subject, to use an expression, speak for itself. This will be the theme for the project.

The standard lenses for other camera formats are more or less in proportion to 50mm. The vagueness is deliberate, because there really is no method of calculation that will deliver a precise measurement. You may come across a misleading formula by which the diagonal of the picture frame (another way of referring to the image circle) is supposed to indicate the standard focal length. This can work for some formats, but it does not for 35mm film. Here the diagonal measures only 43.2mm, and no one makes a fixed lens with that focal length. In fact, as long as a lens gives approximately the perspective of the eye, it fits the bill. The standard lens for a 6×6 cm camera is 80mm; 150mm is the more popular for a 4×5 inch format.

20mm

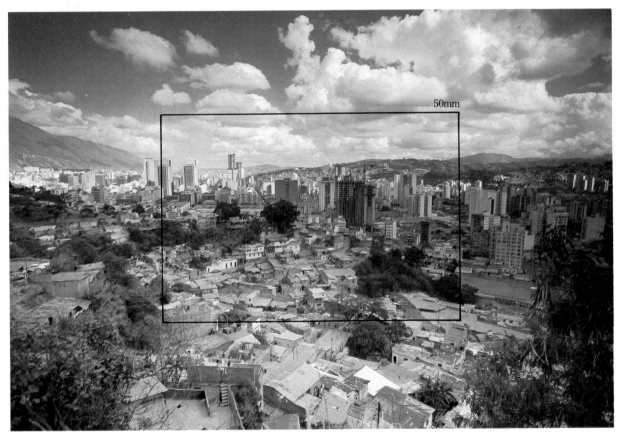

50mm

Cropping into a wide-angle view duplicates the image of a standard lens.

It is best not to compare the angle of view too closely to that of the eye, however. This is another over-quoted fallacy, that the 43–50° diagonal angle of view (that is, corner to corner on the picture) is the same as that of the eye. The comparison is almost meaningless; our eyes do not have a frame. Look straight ahead for a moment. What can you see? It is possible to notice things out of the corner of your eye vaguely, while at the same time have a sharp, detailed view of just a small area in front of you. Your total field of vision is probably more than 220°, but you may be concentrating on only about 2°.

The focal length of the standard lens has, for many people, acquired an unfair reputation for being dull. The existence of so many other focal lengths has led to the idea that extreme perspective, being quite exciting in a graphic way, is more "creative". Well, it would be wrong to put down all the good possibilities from wide-angle and telephoto lenses, but there are obvious dangers in using their special effects as a creative crutch. Most of us do this from time to time, but it is often unnecessary. Not only can you make powerful, arresting images with a standard lens, but the discipline of using just that focal length and no other is wonderful training when it comes to designing a photograph.

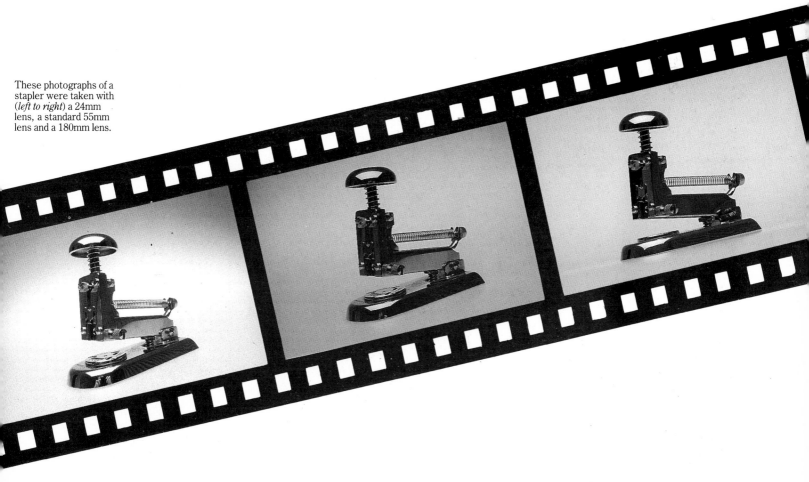

These photographs of a stapler were taken with (*left to right*) a 24mm lens, a standard 55mm lens and a 180mm lens.

Project: Natural images

Here is an interesting fact: by far the majority of still-life pictures are taken with standard lenses. I am not at all sure that the same can be said of most outdoor photography, but the implication is worth considering. Most still-life photographs are taken by people who make their living from photography, and for professional reasons large format cameras are normal, but this is a project that is perfectly suited to any camera. Typically, though, a still-life studio photographer working with a 4 × 5 inch camera might use only a 150mm and a 90mm lens, and the former much more (the 8 × 10 inch equivalent would be 300mm or 360mm standard focal length and 210mm wide-angle).

The reason for this is simple. A professional studio photographer has a trained eye, and can, under most circumstances, design a photograph perfectly well without the "creative" help of an extreme focal length. There are so many other elements involved in effective design, as the selection of still-life photographs here shows.

The project, then, is no more involved than to make a selection of still-life subjects – things from around the house, or borrowed, or found – and shoot them only with a standard lens. Make the images interesting by the way you position the objects, by experimenting with the framing, with the lighting and choice of background. In particular, do what you see here: make a variety of images.

Wide-angle Lenses

Wide-angle lenses cover a range of focal lengths; in theory, anything shorter than standard. In practice, the most moderate wide-angle lens for a 35mm camera is 35mm, but it has more of the character of a standard lens than the qualities normally associated with this group of lenses. At the other end of the scale of focal lengths, the limit is around 13mm or 15mm: expensive, heavy lenses that give diagonal angles of view well over 100°. Wider coverage than this is possible with fish-eye lenses; these are dealt with separately on pages 88–91.

The essential qualities of wide-angle lenses are that they give expanded coverage of a scene, their great depth of field if used at small apertures, and the way they emphasize linear perspective. All of these are illustrated here with a 20mm lens to give a relatively strong impression.

Coverage
A prime function of a wide-angle lens is coverage; the ability to take in a substantial angle of view. This is an absolutely essential quality for photographing interiors, particularly cramped ones like this aircraft cockpit. The side-to-side coverage of the 20mm lens used here is 84°, and although the total field of vision of the eyes is greater, this gives a fair approximation of the view. To make full use of the good coverage it is important to position the camera right up by one wall or, even better, into a corner. A tip for gaining an extra few inches: if the camera's prism head is removable, take it off and press the camera against the wall and view from above. Coverage of cramped space like this normally needs good depth of field for the best effect, so stop the lens down and use a slower shutter speed.

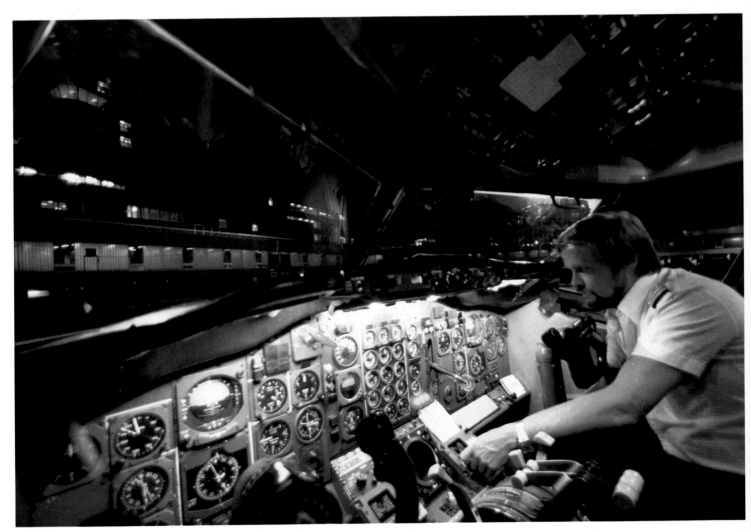

Linear perspective
This is what too many people think of as the "creative" use of a wide-angle lens, but used well it can produce a powerful graphic impression. One of several ways of emphasizing the depth relationship between parts of the scene, converging diagonal lines are given more prominence by a wide-angle lens. In both of these examples, each photographed with the same 20mm lens, the effect was deliberately intended. The keys to this kind of emphasis are first to find suitable lines in the scene, then to position the camera close to the leading edge of the lines and add enough of an angle to them so that they "travel" across a good part of the frame. It is even more effective if the lines run out of the frame in the foreground.

In the cemetery overlooking Jerusalem *right*, the important lines are the long edges of the gravestone. The camera is far enough forward for these lines to go beyond the frame edge, so that the flow is unbroken and they appear to be moving

Depth of field
Because the actual size of the apertures in a wide-angle lens (not the *f*-stop) are smaller, the depth of field is greater than with longer focal lengths. The strongest impression of depth of field is when the smallest aperture is used and the focus set so that the farthest limit is in the distance. Here, a 20mm lens was used at its minimum aperture, *f* 22. The point of focus was just over 2 feet (0.6 m), so that everything from the far buildings to the foreground fence (a little more than 1 foot – 0.3m – away) is sharp. The camera, on a tripod, was moved until it was

exactly this distance from the fence, using the depth of field scale engraved on the lens barrel as a guide. For a critical check, the preview button was depressed; this stopped the lens down to its working aperture. (See pages 146–7 and 150–1 for more details on depth of field and hyperfocal distance.)

This depth of field function is only useful if the lens has a small minimum aperture, and a drawback of extremely fast wide-angle lenses for 35mm cameras is that they usually stop down only to *f* 16 instead of the more common *f* 22.

into the picture.

The horizontal interior *below*, of a Shaker meeting house in Maine, employs a symmetrical design. All the lines converge centrally: the ceiling beams, the benches, and the reflections of light through the windows. Bare simplicity is an important feature of the room, emphasized by this symmetrical linear perspective.

Distortion

Distortion is the side effect of the powerful linear perspective that makes wide-angle lenses exciting to use. In itself it is neither good nor bad, but it needs to be treated with care if it is to contribute to the image.

Outdoors, one of its most recurring forms is the convergence of lines when the camera is tilted upwards. For buildings this is difficult to avoid; the easiest viewpoint is usually at ground level from fairly close, leaving little alternative but to raise the camera. Elsewhere, on pages 56 and 108–9, ways of overcoming this kind of distortion are looked at. Here, however, we will concentrate on using it effectively.

The first thing to establish is that there is nothing wrong with converging verticals. Perceived textbook wisdom is that they should be avoided, but if you like the effect, use it; the issue is only one of taste.

For maximum benefit, follow these examples with exercises of your own. Make sequences of shots from slightly different positions so that you can judge the importance of the visual differences.

Project: Converging verticals

Distortion is the essence of wide-angle lenses, and is responsible for their most interesting graphic uses. The down side of this distortion, however, is that it can appear unintentionally and in the wrong parts of the image. Unwanted distortion tends to look peculiar rather than interesting. Despite the danger of laying down rules of acceptability, it is important to go through some exercises that show the differences between workable and unworkable distortion.

One of the most common situations of converging verticals is the view looking up at a building. For this, use as short a focal length lens as possible and, most important, take a sequence of shots while trying to "develop" the image by changing the viewpoint. Analyze the results from the photographs rather than at the time of shooting.

Convergence project
An isolated building with space in front is ideal for this project; if there are other elements in the picture, the problems of viewpoint will be more interesting. Trees in front of this court-house in Bridgeport, California, obscured any long distance view, making a close, wide-angle shot the only practical alternative. This sequence of four shows some of the possibilities with a 20mm lens.

In the first shot the viewpoint is from a standing position, close enough to keep most of the overhanging branches away from the image of the building, and at an upward angle that includes the entire court-house. The building is centered exactly in the frame.

Potentially, the combination of white building, grey shadows and blue skies is very clean, apart from the background and branches. The branches can be made to serve a purpose by occupying the upper corners, and in the second shot, with the camera lower, they no longer cut into the image of the court-house. The camera is on the ground, with the prism head removed, so that little of the background can be seen, while showing all of the court-house.

The third shot is an attempt to simplify the image even more. Using the line on the façade just above the door as a base, the camera is tilted upward more strongly, and all of the background is lost.

The fourth picture, which does not work satisfactorily, is an attempt to balance the weight of the building against the branches and surroundings by placing it off-center. Although this is a reasonable way of handling the balance of the picture, the distortion is overpowering. In fact, two directions of convergence are combined; given the formal proportions of the building, the effect is uncomfortable. With some modern styles of architecture, though, this might have worked.

Project: Stretch distortion

Barrel distortion is a natural, but now rarely seen, fault in short focal length lenses, showing up as a curvature near the edge of the picture (see page 115). It survives deliberately in fish-eye lenses, but in others is normally corrected. However, rectilinear correction, as it is known, introduces a different kind of distortion. Dimensions are stretched radially: that is, on lines away from the center. It is most extreme in the corner of a wide-angle view, and most obvious with simple, familiar shapes, such as circles and human faces. For this project, take a clean, obvious shape such as that shown here and shoot it framed in the center, then framed near the edge; the distortion should be obvious.

Stretch distortion
Take any isolated object with an obvious outline, and photograph it from a viewpoint that gives it roughly this size in the frame. Keeping the same distance, swing the camera so that the image appears nearer the edge. The distortion is more pronounced the shorter the focal length; a 20mm lens was used here.

Project: Juxtaposition

Drawing a relationship between two subjects, even though they may be very different in size, is a common requirement in photography for all kinds of reasons, commercial and otherwise. Wide-angle lenses are regularly used for certain types of juxtaposition, for two reasons. One is that their depth of field with a small aperture is usually good enough to bring everything into sharp focus. The other, more important for practice and experiment, is perspective. Used close to one of the objects, a wide-angle lens can make it dominate the image, even if it is relatively small. As we have seen, small changes in the camera angle with a wide-angle lens create major changes in the design, and the theme of this project is to take two subjects in one shot, trying different viewpoints to discover the range of graphic relationships.

Juxtaposition

These three pictures of the Peninsula Hotel in Hong Kong and one of its fleet of Rolls Royces use one of the standard techniques of professional wide-angle photography: juxtaposing two elements for comparison or contrast. What this short sequence demonstrates is that the possibilities for combining two subjects in one image lie not just in the good depth of field, but in the strong perspective.

The lens, as in all the examples on these pages, is 20mm, and its minimum aperture of $f\,22$ is sufficient to keep everything from a distance of 80 feet (25 m – the hotel) to just over 1 foot (0.3 m) sharply focused. Within this range of distance, there was a wide choice of viewpoint, and as you can see from these three shots, relatively small changes in the camera position – forward/backward, raised/lowered, and the degree of tilt – produced big graphic changes. Standing back, and from about shoulder level, the view *top* is of the Rolls Royce in a setting – fairly conventional. Moving closer at the same height, and tilting the camera down introduces a strong linear perspective, and alters the balance of visual weight in favour of the car. At this same distance, but looking up from below the radiator grill, the car occupies a little less of the picture frame, but by looming over the camera appears even more prominent.

Lens accentuates perspective of diagonal lines leading out.

Entire car in normal proportions faces out, matching outward direction of diagonal lines above.

Hotel façade subordinates to car.

View down onto car gives strong converging lines, makes bonnet appear long and introduces symmetry to the picture.

Close viewpoint draws attention to the famous mascot and insignia.

Mascot still prominent.

Identity of car represented by its key features: radiator, grill, mascot and headlights. Low viewpoint increases strength of this part of the image.

Project: Vertical/horizontal choice

Wide-angle lenses have an inherent design problem in 35mm photography. Because the proportions of the picture frame are 2:3, there is often too much "empty" foreground when you shoot a vertical picture. For this project, whenever the natural format for a wide-angle shot seems to be horizontal, in addition take as good a shot as you can with a vertical composition. The examples shown here give you an idea of some of the decisions involved.

Camera levelled for a convergence-free shot, considered necessary for a faithful representation of traditional architecture.

Floor area reduced in image by swinging camera right, drawing attention to foreground statuary.

Sufficient detail in roof to allow camera to be tilted up. Insufficient, however, for the same to be done with a vertical composition.

Converging distortion present, but suppressed by curved lines of roof.

Uninteresting and largely empty floor eliminated by tilting camera up.

Vertical/horizontal
This set of photographs of the Residenz Museum in Munich illustrates some of the choices and problems that influence composition in two formats. Distortion is as always a consideration; the solution with a non-shift lens of levelling the camera creates design difficulties because there is little of interest on the floor.

Vertical composition fights to some extent against the horizontal visual bias of the hall, so the shot makes more of the detail of the arches and statues.

Figure helps to overcome visual emptiness of the floor.

Fish-eye Lenses

Fish-eye lenses are a mild oddity in the range of commercially available lenses. Produced originally for very specific scientific uses – astro-photography and meteorology – they now have some popularity just for illustrative use. In truth, their special design restricts their value enormously; this is a lens that you will rarely need, yet there may well be occasions when no other will do the job. Being so specialized, fish-eye lenses can usually be hired from photographic dealers who have a rental department, and for this reason we have some projects for them. One thing above all others that you will probably find in doing these projects is that a full roll of 36 exposures of fish-eye images looks very repetitive. This in itself is a useful encouragement to find different ways of structuring the images, but it is hard to escape the conclusion that, if you were to select only one lens to carry, this would probably be the last choice.

A true fish-eye gives a circular image that covers a full 180°; if you laid the camera flat on the ground outdoors, pointing upwards, the horizon would appear all around the edge of the picture. As you can see from the picture of the lens, the front element is strongly curved, and refracts light to such an extent that even from the side you can see the inside elements. This front element gathers 180° of image and refracts it into a 90° cone, which is then projected by the rear element onto the film.

Curved horizons
Take any outdoor scene, photograph it once with the camera level, and once with the camera tilted up by the amount shown here. Only radial lines (that is, leading from the center directly outwards) stay straight, so that the only condition that allows a straight horizon is when this passes exactly through the center of the picture.

7.5mm fish-eye
The key characteristics of a fish-eye image can be seen here: 180° coverage, great depth of field even at $f8$, strong barrel distortion of straight lines and a prominent perspective between the center foreground and the edge distance. The image circle is 23mm, almost the height of the horizontal film frame.

At a distance of 3 feet (1m), the door frame bows out prominently. Depth of field is so great that the focus is fixed.

Barrel distortion causes lines close to the circumference of the picture to be curved almost to the same degree as the circumference itself.

The 180° coverage is obvious here: the entire length of this street is included.

If hand-held from a standing position, there is always a danger of the photographer's feet appearing in the picture. Here they are only inches out of the frame.

Project: Angle and distance

As small movements of the camera make significant changes in the image, the basic exercise with a fish-eye lens is to view potential subjects with the camera to your eye from as many different angles and distances as you can manage. If you walk while looking through the viewfinder, you may find the changing image very interesting. Of course, the actual *changes* of line will not appear in the photographs.

Specifically, do two exercises. In one, take a subject and approach it in a direct line, taking a sequence of shots. In the second, photograph an outdoor scene with the camera level, and then with it tilted up or down; notice the effect this has on the horizon line.

Camera level: horizon level and centered.

Tilted camera brings tops of buildings behind into view.

Radial pavement lines stay fairly straight.

Empty foreground is a visual waste of space.

Radial and near-radial lines, such as the verticals of these buildings, are the least affected by curvature distortion.

Camera tilted up until horizon line almost at bottom of picture, becomes strongly curved.

Rapidly changing perspective
Moving successively closer to a subject demonstrates the massive effect that a fish-eye lens has on size relationships. In particular, see how the relative sizes of the columns in the balustrade alter. You can also see the design value in the second frame of keeping a distinct line close to the edge of the picture, and in the third frame of having a continuous texture of leaves.

Distance to wall: 4 feet (1.3m)

Camera is aimed slightly above wall, makes top of wall appear curved. Empty foreground is a design fault in this shot, and always a potential problem.

Distance to wall: 3 feet (1m)

From closer, notice how the presence of a definite line (curved to match the circumference) helps to organize the composition.

Distance to wall: 2 feet (0.6m)

From this close position, the relative dimensions of the balustrade become distorted.

Continuous texture of leaves is another way of giving cohesion to the foreground edge of the picture.

Distance to wall: 1 foot (0.3m)

From only 12 inches (300mm), size distortion is very prominent.

For comparison, this photograph was taken from 2½ feet (0.7m) with one of the shortest focal lengths of non-fish-eye lenses – 14mm, giving a diagonal view of 114°.

Full-frame fish-eyes

These lenses are a hybrid development, designed to include the strong barrel distortion that gives fish-eyes their graphic interest, while maintaining a normal, rectangular picture frame. They do this by projecting a larger image circle; larger, that is, than the film frame. They have more general uses than their predecessors, and are particularly valuable at giving the maximum coverage possible within the full frame.

Full-frame fish-eye

This demonstrates the optical relationship between a true, circular image fish-eye and the more generally useful full-frame design. The latter projects a larger image circle, 46mm in diameter, so that it covers the picture frame of a 35mm camera entirely. The particular advantage of this is that most of the extreme distortion, which appears around the edge of the image, is cut out; only the corners are danger areas in this respect.

Areas of maximum distortion near circumference are excluded, giving less extreme effect than from a true fish-eye

Image circle

Full-frame fish-eye covers full 180° diagonally, but only central rectangular part of fish-eye image

Picture frame 24mm × 36mm

Full-frame fish-eye: Curved horizons

Performed with a full-frame fish-eye, the same exercise as on page 88 gives similar but less extreme results. What you can see, however, is that while the unusual circular picture frame in the previous photographs leads the viewer to expect curved distortions, the rectangular frames here create expectations of normal perspectives. As a result, the lesser distortion in these examples can seem more peculiar. Notice, however, that as we know sand dunes can be curved in outline, only the reference of the level-camera shot *below* and the cloud patterns show the degree of distortion in the two vertical images.

Cloud patterns are difficult to recognize in changes of camera angle

Camera level: horizon level, in the middle

Camera tilted up: horizon low, concave curve

Camera tilted down: horizon high, convex curve

Project: Coverage

Repeat the curved-horizon project from page 88. Experiment with coverage by photographing a very small, busy interior. The example shown here is one of the early space capsules, but a small room or under-stairs closet would serve as well.

Full-frame fish-eye: Coverage

At the cost of curved distortion, the best coverage inside a normal rectangular picture frame is with a full-frame fish-eye. This example, a photograph of the interior of John Glenn's Mercury Capsule, demonstrates some of the techniques that can be used to minimize distortion and give as realistic and natural a view as possible. The criterion in this case was to give the fullest coverage possible of a cramped interior, but at the same time to keep an acceptably straightforward treatment.

The interior of the capsule is partly curved, and in any case unfamiliar to most viewers. Consequently, even curved distortion here does not look out of place.

Viewpoint chosen so that as many lines as possible appear radial, and so stay relatively straight.

The image of a dummy head in the space suit's helmet would have been unacceptably distorted. The only solution was to keep it outside the picture frame.

At close distances, subjects in the center of the picture tend to appear overpoweringly large. Here, this tendency has been partly cancelled by positioning the camera so that the corners are occupied by the nearest parts of the interior, and the center by the most distant.

Changing viewpoint

As with any wide-angle lens, the strong perspective gives very different images when the camera position is changed. The added feature of curvature heightens this effect. Even though the giant figure of the reclining Buddha dominates each image, the relative proportions of the interior are altered substantially. In quite a different way, however, the curved lines introduced by the lens give a recognizable similarity.

Telephoto Lenses

Popularly, telephotos are synonymous with long focal length, although the word "telephoto" actually refers to a particular design of lens. The distinction is not normally important, but, for the record, the back-focus in a telephoto lens is shorter than that in a long lens of traditional design. In other words, the distance from the lens to the film is shorter, and so the physical dimensions of the lens can be smaller: a matter of convenience for hand-held shooting. As an illustration, the lens shown in use on page 161 is a 400mm telephoto, yet the distance from the lens elements to the camera is considerably less than 400mm.

With view camera lenses, the distinction is more practical. The longer focal lengths that are available in normal lenses are usually designed with greater covering power (see pages 106–7) for larger formats. For instance, 150mm is the standard focal length for a 4 × 5 inch camera, but the most easily available longer focal length is 300mm or 360mm – the standard focal length for an 8 × 10 inch camera. These are not telephotos, and so the bellows length would have to be doubled: a considerable inconvenience outdoors. Large format telephotos are not very common, but they need less bellows extension.

Two technical developments within the last few years account for the variety of telephoto lenses available. One is internal focusing, in which only the rear group of elements move to change focus. As these are considerably smaller than the front group in a telephoto lens, they can be moved without changing the length of the barrel. The advantages over the traditional helicoid system, in which the front part of the barrel moves forward for closer focusing, are that dust is not sucked into the lens in the same way, and the balance of the lens stays the same (try resting the front of a traditionally-designed telephoto on a support and then changing the focus).

The second development is faster telephotos; that is, bigger maximum apertures. It is the maximum aperture that sets the limit to the fastest shutter speed that can be used, and this can never be fast enough. Camera shake is a constant worry with a telephoto, so the advantages of a faster lens are obvious. However, this involves a lot of glass at the front, making such lenses heavy and expensive.

Focal lengths
First let us look at the strengths of telephoto lenses. The choice of actual focal length is even greater than for wide-angle lenses, ranging typically from 85mm to 800mm for a 35mm camera. As you might expect, all the effects that are characteristic of telephoto lenses increase in proportion to the focal length, and the big super-telephotos, which give the most extreme graphic results, also demand the most care in use. It is worth noting here that certain focal lengths are considered particularly useful for some specific types of photograph. These are listed below. This is not intended as a list of recommendations; they are, after all, a consensus of other photographers' ideas, and this is not necessarily what you may need to complement your own style of work.

The most objective quality of a telephoto lens is its magnification, and most of the reasons for using one probably depend on this. There are situations where a close approach is impossible (for example, keeping beyond the boundary line in sports matches, or the "threat" zone perceived by wild animals), and there are situations where the view of a subject is simply less satisfactory from nearby; it may be interrupted by foreground obstructions. The degree of magnification is easy enough to judge; when comparing the view between two focal lengths, just divide the larger by the smaller. In practice, you are likely to be interchanging a group of lenses, so there is a definite advantage in having some viewfinder indication of a longer lens when using a shorter focal length, as shown here.

The more subjective qualities of a telephoto image are isolation, compression of perspective, and presence. This last is the least definite, and occurs only with single subjects that are framed quite tightly.

Range of focal lengths

SUBJECT	LENS	REASON
Head-and-shoulder portraits	85mm, 100mm	Perspective – facial proportions more pleasing than with standard lens
Street photography	135mm, 150mm, 180mm	Magnification – allows unobtrusive shooting distance
Stage and theater photography	180mm, 200mm (if fast)	Magnification – close access limited
Sports	300mm, 400mm, 500mm	Magnification – from field, track boundaries
Special sport and news events	600mm, 800mm (if fast)	Magnification – closest possible view from journalists' stands
Wildlife	300mm, 400mm, 500mm, 600mm, 800mm	Magnification – animals shy of close approach

Magnification

The longer the focal length, the more the image is magnified. When a subject cannot be approached close enough for the image you want, or when a closer viewpoint would not give a good perspective, a telephoto lens performs its basic function. In wildlife photography, for instance, there is nearly always a limit to how close an animal can be approached. To reach out beyond this requires magnification. In this example, of large flocks of flamingos in Ngorongoro Crater, a 600mm lens gives 12 × the magnification of a standard lens (divide the shorter focal length into the longer), and 30 × that of the 20mm lens used in the comparison photograph *below*. Whatever other graphic effects a telephoto lens has, such as compressing the perspective and giving presence to the subject, it does one simple task well: it enlarges the image.

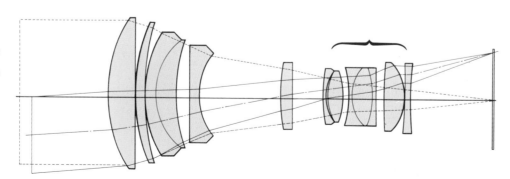

Tele-extenders

These are small auxiliary lenses that fit between the telephoto and the camera. They step up the magnification of the prime lens by bending the incoming light rays to the film less sharply, and have an overall concave construction. The usual types are a 1.4 × extender (sacrificing 1 *f*-stop of lens speed) and a 2 × extender (sacrificing 2 *f*-stops).

Pre-visualizing the frame

Practice makes it easier to judge what focal length to change to for any particular composition, but the view through whatever lens you normally leave on the camera can be a guide. Even if the focusing screen has no markings other than the central focusing circle, that alone can indicate the framing of a longer lens. More useful, however, is a grid screen.

Lens speed

Achieving wider maximum apertures can only be done by increasing the light-gathering power of the front group of elements. This in turn means bigger front elements, and a bulkier lens overall.

300mm 200mm 100mm 85mm 50mm

These are the relative frames for four common telephotos as seen through the viewfinder with a standard 50mm lens. Note that the 100mm frame is exactly half the size, the 200mm frame a quarter, and so on.

50mm

The central focusing circle on a normal SLR focusing screen can give an approximate idea of telephoto framing.

50mm

The grid lines etched on some focusing screens give a clearer indication of framing, even though you may need to use them off-center.

400mm 180mm

Also familiarize yourself with the framing of long focal lengths as seen through medium telephotos. As with all these examples, adapt to the range of lenses you normally use.

300mm f2.8 5lbs 1oz (2310g)

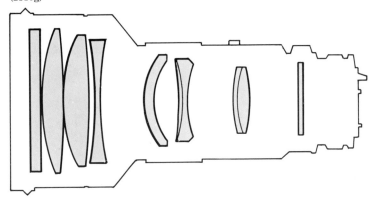

300mm f4 2lbs 1oz (945g)

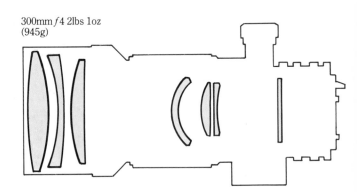

300mm f5.6 1lb 6oz

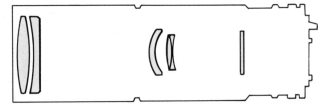

Isolation
By means of narrowing the angle of view, which reduces the elements in the scene, and compressing the perspective, which makes it possible to select a "clean" background, a telephoto lens can isolate an image. To do this effectively, first select the subject, move back far enough to give a suitable framing with a long focal length, and find a viewpoint that puts a fairly simple background behind the subject. This last is the key to success, as illustrated here. The church steeple and cross have been precisely centered against the corner of a modern building behind; the camera position needed to be accurate to within a few inches, even at this distance. Notice how the isolating effect is much stronger in the 400mm shot *right* than in the 180mm version *above*.

Project: Compression

First choose a row of same-sized objects and photograph them from a fairly acute angle. The examples on this page show typical results. Also, photograph isolated subjects against a slightly elevated backdrop; for instance, a farmhouse against a hillside, or yachts in a harbour against waterfront buildings. Look at the way in which the background appears flattened and larger.

Compression
The prime effect of a telephoto lens on perspective is to reduce the apparent differences in size due to distance. So, if objects of the same size are at different distances from the camera, a telephoto lens will make them seem more nearly identical. This is what has happened here in a 400mm shot of a row of tenement houses and balconies. The longer the focal length, the stronger this effect. Commonly, if a wide-angle lens were used closer to the buildings to fill the frame to the same degree, there would be a strong convergence of diagonals from right to left.

In the lower pair of photographs, this compression of perspective can be seen in different degrees. The picture *left* was photographed with a 180mm lens, the one *right* with a 400mm lens, both from the same camera position, and although theoretically the perspective is the same (because the viewpoint is unchanged), the overall visual impression is certainly different. One important difference is that there is less information in the 400mm shot about how the pillars on the side of the street recede from view. Wherever possible, make comparative shots yourself, using more than one telephoto, to be able to judge the nuances of different effects.

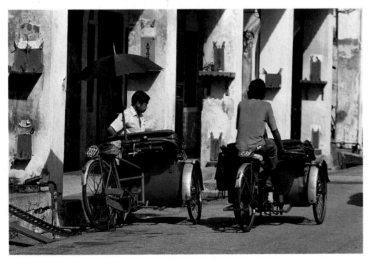

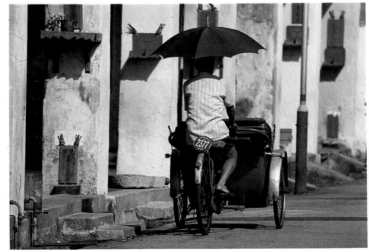

The practical problems associated with telephoto lenses are the shallow depth of field, camera shake, the ease of making a focusing mistake, and susceptibility to flare. (For flare, see pages 118–21.)

Project: Depth of field
Shoot pairs in different situations, one at maximum aperture, the other at minimum aperture. A tripod will almost certainly be necessary. Use the comparisons to become familiar with the depth your own lenses are able to achieve.

Project: Slowest safe shutter speed
A telephoto lens also magnifies camera shake. Shoot a series of identical shots, varying the shutter speed (and adjusting the aperture to compensate). Start at the reciprocal of the focal length, that is, $1/500$ of a second if you are using a 500mm lens, and move to slower speeds. From this, done several times, find the slowest speed at which you can be sure of a sharp picture. The next slowest speed is still usable, but only if you take several exposures for safety (see page 158).

Project: Isolation
This characteristic is not simply a function of the narrow angle of view, and needs practice to achieve whenever you want it. Choose subjects that will occupy a substantial part of the picture frame at a convenient working distance with your longest lens. Concentrate on selecting a background (by moving the camera position) which is least distracting. Vary the aperture to change the depth of field; although selective focus (see page 130) helps to isolate an object from its surroundings, it is not always necessary.

Presence
This quality is a little more elusive than objective effects such as magnification, but is real nonetheless. It derives to a considerable extent from the compression of perspective, and is enhanced by reproducing the picture large. In this example, of a truck travelling at speed along a Canadian highway, the effect of a 600mm lens is to project the viewer forwards and to give more of a sense of bulk to the object (the rear of the truck has much the same dimensions as the front).

Mirror Lenses

Mirror lenses can be used as alternatives to some of the long telephoto focal lengths, yet they have a very different construction and some different picture qualities. Also known as reflex and catadioptric lenses, their design is similar to that of some telescopes: a combination of lenses and mirrors, in two groups. The diagram *below* shows a typical section and light path of a mirror lens. The purpose of the two mirrors is to bounce the light rays back and forth within the lens, so effectively doubling the distance they travel. Optically, this is a convenient way of making a lens that is half the length of its equivalent telephoto design. And, as much of the weight of a lens is in the barrel and the glass, a mirror lens is light for its focal length.

The most common focal lengths for mirror lenses are between 300mm and 1000mm, and their main physical characteristic is their ease of handling. A typical 500mm mirror lens weighs in at around 25 oz (700 g); much less than a telephoto lens of the equivalent focal length.

This 500mm mirror lens weighs about the same as an ordinary 200mm telephoto lens. The light rays travel through the front of the lens, and are reflected off two mirrors as shown in the diagram *below* to effectively double the distance they travel.

Rotating collar mount

Internal filter mount fits behind lens elements

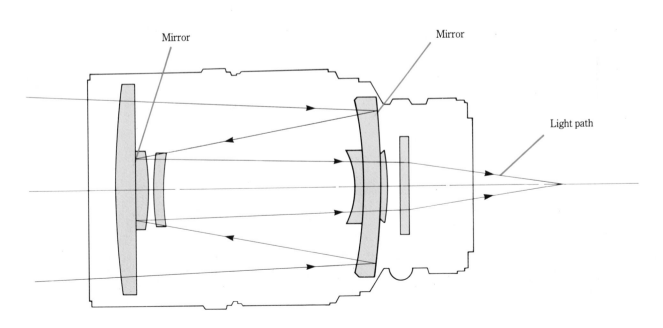

Mirror

Mirror

Light path

Project: The mirror lens "signature"

A telltale picture characteristic of mirror lenses is the ring shape of bright highlights, such as reflections of the sun on water. These small rings, by no means always unpleasant in appearance, are in fact miniature reflections of the rear mirror, the center of which is open to allow the light through to the film. Experiment with this by shooting backlit scenes against reflective surfaces – water, glass or chrome metal, for instance – and with night views that include small lights. A more subtle but consistent effect of this mirror construction is the mildly fringed, diffused treatment of areas in the image that are out of focus. Neither of these descriptions quite captures the special characteristic, but it is very recognizable.

Potential problems are the fixed aperture, aberrations and, paradoxically, the light weight. The reflex mirror design does not incorporate a variable aperture, so that altering the shutter speed is the usual way of varying exposure (by the equivalent full f-stops rather than half f-stops). With more effort, neutral density filters can be used in the internal drop-in mount.

Spherical aberration and astigmatism are typical faults in this optical system, making most of these lenses unsuitable when maximum sharpness and contrast are needed. The light weight of the lens coupled with its relatively thick dimensions, make it unusual to hold, and the balance is not to everyone's liking.

►In this backlit shot of a lake, taken with a 500mm mirror lens, the ripples in the water produce pinpoint reflections of the late afternoon sun. However, as they are out of focus, they record as bright rings, reflecting the construction of the lens.

▼The visual effect of the same mirror lens is more subtle in an image that lacks spectacular highlights, but is nonetheless distinctive. In the out-of-focus areas of the picture, a slight fringing can be seen, particularly alongside definite straight lines.

▼In a strongly angled photograph of the side of a car after a shower, the water droplets reflect the sun. As the mirror lens cannot be stopped down to less than its f 8 maximum aperture, only a narrow band of droplets appear sharply focused. The size of the characteristic rings increases as the focus is lost in front of and beyond this band.

Zoom Lenses

Zoom lenses are an alternative to regular, fixed focal length lenses rather than a supplement. Their principal advantage is that a single zoom lens can encompass a range of focal lengths that would otherwise require two, three or four normal lenses. The extent of this "replacement value" depends on how comprehensive a set of lenses you would normally carry, and what importance you attach to being able to select an exact composition.

As the focal length can be altered continuously over the range, there is rather more to this than just being able to change from, say, 35mm to 50mm to 70mm. The intermediate transitions allow a precision in the framing that is not normally available. However, although this is obviously useful, you should consider what little difficulty most photographers have in working with a set of fixed focal lengths. The choices in designing photographs are so varied, even with one fixed focal length, that the additional option of a zoom is by no means necessary. Many of the projects in volume II of this series, *Image*, demonstrate this.

Zoom lenses are optically complex, and the need for many elements (usually more than ten) makes them heavier than equivalent regular lenses, and slower. While one or more zoom lenses will be lighter in the camera bag than the equivalent set of regular lenses, they are heavier in the hand when shooting. Maximum apertures are small by ordinary standards. Nevertheless, a zoom lens overcomes the business of continually changing lenses.

Project: A range of composition
For this project, choose a fairly static subject, such as a landscape, and make as many different images as possible within the range of focal lengths. Stay in the same position. Compare the results with the focal length project on pages 74–5.

Focusing technique
On occasions when there is sufficient time, it is good practice to set the focus at the maximum focal length before zooming back to the length chosen for shooting. As zoom lenses tend to have relatively small maximum apertures, viewing is a little darker than with most normal lenses, and precise focusing thus marginally more difficult.

Framing choices

Compared with a set of normal fixed focal length lenses, a zoom lens encourages different composition decisions. The jump from one focal length to another is replaced with a continuous transition, and the framing choices can be fairly subtle. Unlike the focal length project on pages 74–5, the best use of a zoom lens is not normally a matter of aiming at one central point and zooming in or out. As you move the zoom control, it is important to reassess the composition. For instance, the best framing may move off-center up to a certain focal length, as shown *right*. There may also be different centers of interest at the longer end of the focal length scale.

Zoom ratios

Expressed here in diagrams, the zoom ratio is the difference in magnification between the minimum and maximum focal lengths; that is, the longer focal length divided by the shorter. The most common ratios are between 2:1 and 3:1. Lenses with longer ratios are more useful and desirable, as they replace a wider range of fixed lenses, but are understandably more expensive, and heavier.

Zoom ratio 2

Zoom ratio 3

Zoom ratio 4

Macro Lenses

Macro lenses have a number of design features to give better image quality at close distances and more convenient focusing. While any lens can be used for close-up photography (in conjunction with either extension tubes or bellows), the optical characteristics do not give the best performance at these scales. Simply extending the focusing range, as some lens manufacturers do with, for instance, macro zooms, is not the same as designing a lens specifically for the task.

In particular, the maximum resolution of a macro lens is in the close focusing range rather than at infinity (although for practical purposes image quality is good at conventional distances). The construction is designed for high contrast, for maximum correction of astigmatism (a common problem in close-up photography – see page 115), and for suppressing the aberration fluctuation caused by the big range of shooting distances. Most macro lenses can focus down to a distance that gives $\frac{1}{2}\times$ (0.5) magnification, and some down to $1\times$. For greater magnifications, use either extension tubes or a bellows extension. The former are available in different widths, and a set of three (typically around 35mm, 10mm, and 5mm) can cover most requirements. Bellows extensions allow greater magnification, and over a continuous range. Being rather less robust than extension tubes, they are probably more suitable for controlled indoor use.

For purposes of definition, there are three ranges of photography at shorter-than-conventional distances. The limits of each are practical ones of camera operation. Using magnification of the subject as the standard, close-up photography covers the range from about $\frac{1}{7}\times$ (0.14) to $1\times$. The lower limit is the point at which exposure begins to be affected by the lens extension (see light transmission on pages 110–11).

From $1\times$ up to about $20\times$ the range is known as photomacrography (not, incidentally, macro-photography, despite the accepted abbreviation "macro"). The lower limit is set by the fact that the lens is now nearer to the subject than it is to the film; at this point an ordinary lens should be reversed so that it faces the camera. Beyond $20\times$ is the province of photomicrography, for which the special optical and lighting systems of a microscope are more suitable. (See pages 170–5 for magnification.)

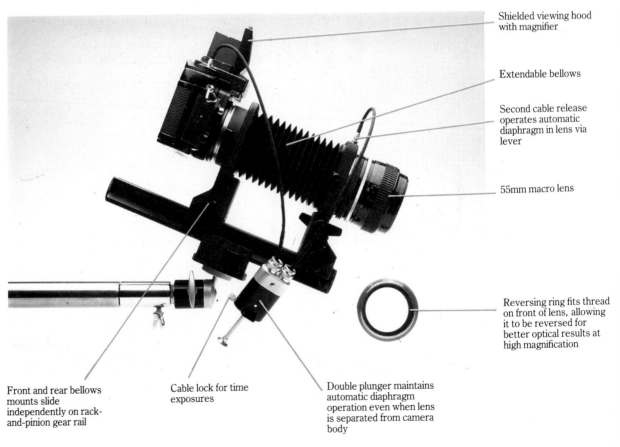

The basic equipment for macro shooting includes a bellows extension, a lens that will perform well at close focusing distances, and a double cable release (this last so that the automatic diaphragm stop-down can still be used, even though the lens is separated from the camera body). Optional extras are a waist-level viewing hood with magnifier and a ring that allows the lens to be reversed for better image quality at high magnification.

Shielded viewing hood with magnifier

Extendable bellows

Second cable release operates automatic diaphragm in lens via lever

55mm macro lens

Reversing ring fits thread on front of lens, allowing it to be reversed for better optical results at high magnification

Front and rear bellows mounts slide independently on rack-and-pinion gear rail

Cable lock for time exposures

Double plunger maintains automatic diaphragm operation even when lens is separated from camera body

Width of butterfly is equal to the width of the frame: 50mm.

Magnification 0.1×

To demonstrate the range of normal performance of extension tubes and bellows, take a subject that has plenty of structural detail, a relatively flat surface (to avoid depth-of-field problems) and which is not much larger than, say, a 35mm mount.

Note that the magnifications given here are for the images as they appear on each 35mm slide. For clarity, the three pictures have been enlarged on the page.

Magnification 0.5×

Magnification 5×

Special Lenses

Beyond the normal range of commercially available lenses are some which are specifically designed to solve special problems.

Flat-field lenses

One of the many aberrations that occur in lenses is field curvature. In order to refract light, a normal lens has a curved shape, yet the film is, for convenience, held flat in the camera. As a result, if this aberration remains uncorrected, a flat subject perpendicular to the lens axis will not produce a perfectly focused image. (This is treated in more detail on pages 114–15, but for now here are some practical implications.)

In most scenes there are insufficient reference points to show up this aberration, but in copying the problem is real. The closer the shooting distance, the more it becomes pronounced, and although increasing the depth of field by stopping down the lens can mask the effect, exact sharpness is a basic requirement in copy work.

Two kinds of lenses are designed to overcome this and produce a flat field. One is an enlarging lens – naturally enough, as both the negative and print lie flat. The other is a process lens, used for copying and making separations in the graphic arts industry. If you use an enlarger, make a visual comparison test between an enlarging lens and a normal camera lens of about the same focal length (most enlarging lenses are of the standard focal length for the format). Make an enlarged print with both lenses, at maximum aperture, of a negative or transparency that has good detail across the picture frame, focusing on the center. You should be able to see a noticeable difference.

Aspheric lenses

By far the easiest lens shape to grind and polish is a circular section. Unfortunately, as the top diagram *right* shows, the light rays passing through the outer areas of the lens are bent more steeply than those closer to the axis. The result is that the sharp image of each point of a subject is surrounded by additional, larger images. Naturally, the effect is worse at wide apertures, and fast lenses suffer from this when used fully open.

The manufacturing solution is to grind the front surface of the lens in different curves, as the second diagram shows. The refraction of the marginal rays is made less steep, and all meet at a common focus. The practical advantage of aspheric lenses is the elimination of flare and halos, particularly from points of light in the picture.

Unlike regular camera lenses which are normally used for three-dimensional subjects, enlarging lenses are designed to make images of negatives and transparencies, so both subject and lens are flat. The image shell of a simple curved lens element is itself curved, but by overlapping more than one image shell, enlarging lenses like these produce a flat image plane.

▼Aberration caused by spherical lens surface

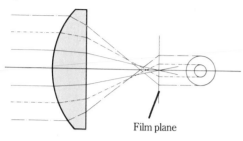

Film plane

▼Perfect intersection of rays due to aspheric surface

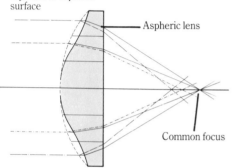

Aspheric lens

Common focus

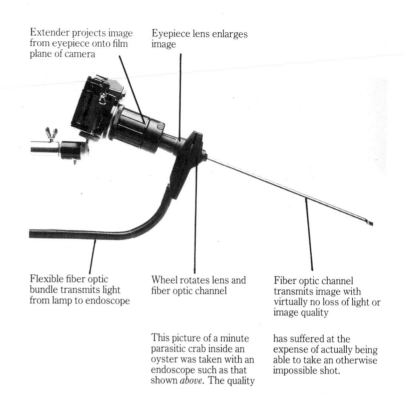

Extender projects image from eyepiece onto film plane of camera

Eyepiece lens enlarges image

Flexible fiber optic bundle transmits light from lamp to endoscope

Wheel rotates lens and fiber optic channel

Fiber optic channel transmits image with virtually no loss of light or image quality

This picture of a minute parasitic crab inside an oyster was taken with an endoscope such as that shown *above*. The quality has suffered at the expense of actually being able to take an otherwise impossible shot.

Endoscope

Miniature lenses and fiber optics allow close-up photography from very short working distances – only a few millimeters – and from viewpoints that would normally be inaccessible.. Endoscopes are available in rigid and flexible forms, and work on the principle of an extremely small lens, the image from which is transmitted unaltered along a fiber optic bundle to a lens that enlarges it onto an eye-piece or the focal plane of a camera.

There is no aperture diaphragm, but depth of field is normally very good. As most endoscope photography is conducted inside small, restricted spaces, such as the internal organs of the living human body, lighting is usually carried alongside the lens system, down a second fiber optic bundle. Image quality hardly compares with that from regular photographic lenses, but the ability to make images inside unusually restricted or inaccessible spaces is usually sufficient compensation.

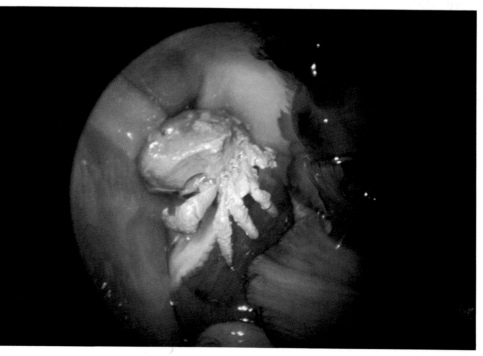

Covering Power

From a user's point of view, the choice of lenses depends first on focal length, and second on lens speed (that is, the maximum aperture). Other characteristics, such as aspheric elements, occasionally come into consideration.

There is another variable that concerns large-format users, and also features in certain special 35mm and rollfilm camera lenses. This is the covering power of a lens; the size of the image projected onto the film plane. Normally it needs to be just slightly larger than the picture area, but there may be reasons for wanting it considerably larger, such as shifts.

A lens projects a circular image. The margins are not a clean circular line, but are a little fuzzy and, as you might expect, the image quality deteriorates towards the edge. You can check this for yourself very simply. Take any lens and a small sheet of tracing paper, and choose a viewpoint that is in a darkened area looking out to a bright scene (for instance, in a doorway facing out to a garden). Hold the lens up so that you can see through it, and then hold the tracing paper between you and the lens. Move them relative to each other until you see an image sharply focused on the paper (the distance between lens and paper is the focal length). You should be able to see the soft circular edge to the image.

In the pair of photographs *opposite* this exercise has been duplicated by fitting a 35mm camera lens into a rollfilm camera so that the film area is bigger than the image. The image circle, as it is called, is about 48mm in diameter, very little larger than the diagonal on a 35mm picture frame. I say "about" because not all of the image circle is usable. Close to the edge of the circle the image quality deteriorates, and when the aperture is stopped down, the image circle becomes smaller.

We have seen, on pages 48–51, how view cameras need extra coverage in order to be able to function fully. The various movements make use of parts of the image that lie outside the image circle. Equally,

special lenses are available for some 35mm rollfilm cameras that allow shift movements (Canon make a lens for its 35mm SLR that incorporates swings as well). Typically, all of these lenses give an image circle with a diameter between a quarter and a third larger than the diagonal of the picture area. With a view camera, lenses are rarely supplied as standard, and the choice of lens normally depends entirely on the photographer's individual preference.

Small-format shift lenses, being purpose-made for the camera model and mounted with limited adjustments, cannot be moved beyond their effective limits. View camera lenses, however, can. The effects of extreme shifts are shown in the example here: one of the reasons why it is easy to make this kind of mistake is that the vignetting occurs first in the corners of the image, in just the parts of the viewing screen that are most difficult to see.

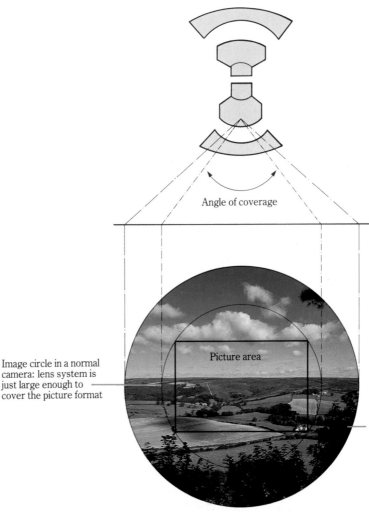

Angle of coverage

Picture area

Image circle in a normal camera: lens system is just large enough to cover the picture format

A shift lens, or a large-format view camera lens, gives wider coverage than needed normally. The extra quarter to a third diameter allows camera movements such as those described on pages 48–51.

Vignetting

In view camera photography the limits of covering power can usually be seen at full shift. The example *below* is a genuine mistake: the corners of a view camera image are difficult to see on the focusing screen,

Severe vignetting caused by shifting lens upwards to the maximum allowed on a 4 × 5 inch view camera. Although the 105° angle of coverage and 170mm (6.7 inch) image diameter of the 65mm wide-angle lens allow considerable movements, they were not enough for this amount of lens shift

and in this case the sky was a deep blue. An additional factor was that the scene was composed at full aperture but photographed at *f*32. This reduced the image circle, as demonstrated in the pair of photographs shown *right*.

At full aperture, a noticeable difference in brightness between center and edge

Image deteriorates and darkens at edge of image circle

*f*3.5

Center of image circle

Illumination even across image circle when lens stopped down

At smaller aperture, image circle is smaller, edge is fuzzy, and zone of poor image quality is thinner

*f*9

Perspective-correction Lenses

The explanation of covering power on the previous pages illustrates the principle of shift or perspective-correction lenses. This is that, as long as there is more usable image around the picture area than is needed, the lens can be shifted to bring a different part into view.

Most shift lenses have about ½ inch (11mm) of travel; that is, ½ inch or so on either side of the neutral setting. The shift mechanism can be rotated so that the shift can be made laterally as well as vertically. By far the most common use is in photographing buildings, so for the project with this lens design, follow the view camera project already described on page 56, choosing any reasonably isolated building.

Basic outfit
Fitted to a 35mm SLR, this lens allows shifts in one direction at a time, but the rotating mount permits a choice of direction. For accurate control, a tripod and cable release are essential, and a grid focusing screen shows precision of the vertical and horizontal lines in the image. A waist-level viewfinder can help composition. Fine-grained films are an advantage in detailed architectural and copy work, the most common uses of shift movements.

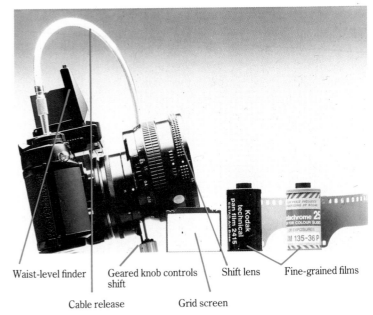

Waist-level finder Geared knob controls shift Shift lens Fine-grained films

Cable release Grid screen

Shift lens in use
The shift mechanism is not confined to the upward movement commonly used to correct upward converging verticals. In this example, the elevated viewpoint needed a downward shift to give an undistorted, reasonably composed picture.

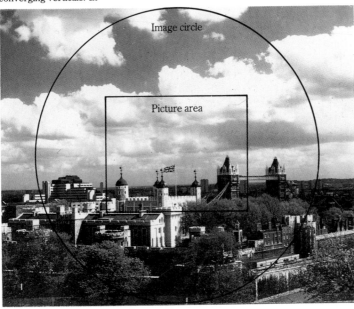

Image circle

Picture area

Zero shift movement
With a shift lens in its centred position, the picture area occupies the middle part of the image circle, which is larger in diameter than that produced by a regular lens.

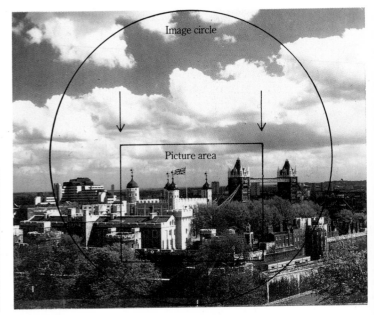

Image circle

Picture area

Downward shift movement
The effect of a downward shift to the lens is to use the lower part of the image circle (actually, as the image on the film is upside-down, it is the image circle that is lowered).

For the second exercise, use only a regular wide-angle lens (the shorter the focal length, the better). First find a viewpoint from which the building fills only about two thirds of the frame. Take the first picture by tilting the lens upwards so that the building is in the middle of the picture area. This is the uncorrected reference shot. Then level the camera and take the second picture. Although the building is now at the upper part of the frame and there is a lot of wasted foreground, at least the verticals are now corrected. Finally, make an enlarged print (to compensate for the smaller picture area being used) from this second exposure but crop in on the building. What you have just done in the enlarger is exactly what a shift lens does on the camera.

1

Camera tilted up to frame entire building. No shift movement

Tilt causes convergence of vertical lines. Building appears to slope away from camera

2

Still no shift movement: top of building cut from frame

Camera levelled so that lens axis is horizontal; center of picture is at camera height

All vertical lines now appear vertical and parallel

3

Lens shifted upward: entire building brought down into frame

Height of building in image now greater than in **1**.

Light Transmission

The amount of light that reaches the film can be adjusted by means of the aperture, but it also depends on the distance the light has to travel from the lens. The greater the distance between the lens and film, the less the quantity of light for making an exposure. Practically, this occurs when changing from one lens to another with a greater focal length, and during focusing. In some wide-angle lenses there is a sufficient difference between the distance from the lens to the center of the film and that to the edge of the picture, for the corners of the photograph to appear slightly darker.

As it travels, light weakens in proportion to the square of the distance; this is the inverse square law. In a camera, the light source is the lens. If the distance from the lens to the film is doubled, the light will be four times weaker, if trebled, nine times

weaker, and so on. It may help to think of the light rays spreading out in a cone, as in the diagram *below left*. As they spread, they cover an area that increases geometrically. Increasing the focal length does exactly this, and to make a telephoto lens that transmits the same amount of light as a standard lens, the diameter of the elements and the aperture must be proportionately greater. In practice, photographers are spared complications by the *f*-stop system, described on page 146.

Focusing, on the other hand, involves the photographer directly. The closest position for the lens relative to the film is when it is focused on infinity. To focus on anything nearer, the lens is extended, away from the film. Clearly, at some point there needs to be some compensation for the light fall-off. But what is an effective light loss?

In practice, the smallest alteration that most camera systems allow is ½ a stop. To be really critical, we could say that ⅓ of a stop light fall-off is significant. In focusing, this point is reached when the lens is extended by about 15 per cent of the focal length from infinity focus. At this extension, with whatever lens, the subject is reproduced at approximately ⅐ of life size and, effectively, this is the start of the range of close-up photography. As long as you use TTL metering (see pages 13–14), which reads the amount of light reaching the film plane (or an equivalent), there are no calculations necessary. The light fall-off is automatically noted. With any other external system of measuring light, however, you will need to calculate the lens extension and its effect on light fall-off. (See pages 170–5 on close-up photography).

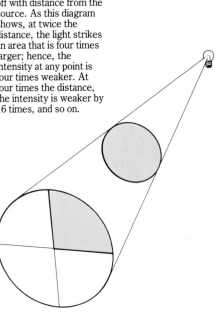

▼Inverse square law
The intensity of light falls off with distance from the source. As this diagram shows, at twice the distance, the light strikes an area that is four times larger; hence, the intensity at any point is four times weaker. At four times the distance, the intensity is weaker by 16 times, and so on.

This graph shows what is virtually a cross-section across a film frame, and shows in exaggerated scale how the light falls off towards the edges of the picture. In theory, there should be hardly any, but in practice even the best lenses fall short of perfection. Stopping down reduces the fall-off considerably. The performance shown here is typical of all fast standard lenses.

——— *f*1.4
- - - - - Theoretical limit
—·—·— *f*5.6

Picture corner Picture center Picture corner

As for variations in light transmission across the picture area, the most obvious effects are on wide-angle lenses, particularly if all of the image circle is being used. The panorama shot at the bottom of this page is evenly lit, but there is a significant fall-off from the center to the sides. This is an extreme case, because of the special construction of this camera, a Linhof Technorama (see page 65), but the principle is the same.

The graph on page 110 shows how the light falls off across the picture area with a regular lens. Especially important is that the fall-off is *less* at smaller apertures. You can demonstrate this for yourself simply: photograph an evenly lit white surface, such as the wall in the examples here. Make exposures at different apertures, including the maximum, with each of your lenses.

Using a panoramic camera, this 6 × 17cm transparency shows marked fall-off in illumination towards the sides. The 90mm lens has a coverage of 198mm, and is principally designed for a 4 × 5 inch format. The diagonal of the picture area is 7 inches (180mm), using almost all of the image circle.

An evenly illuminated white wall photographed with a 24mm lens shows clear differences in vignetting. *Above*, at the *f*2.4 aperture, the corners are obviously darker, while stopping down to *f*5.6 virtually removes the problem.

Automatic Focus Lenses

Although there are, in all honesty, very few occasions when automatic focusing is necessary, it is a convenience. Potentially at least, any camera function that can take care of itself without demanding attention frees the photographer a little bit more to concentrate on other things. In practice, automatic focus works well most of the time, but occasionally fails badly. As with any automatic system, it works on certain parameters that have been decided by the manufacturer. These in turn are based on the way that most people take photographs. If you shoot in a way that goes outside these normal limits, the focus may not be where you want it to be.

Currently, the usual autofocus system in 35mm cameras and lenses relies on phase detection. Typically, two small lenses inside the body project dual images onto a sensor linked to the camera's microcomputer. This compares the electrical signals from the two images with a reference signal. When the signals are in phase, the subject is in focus. As the diagrams show, the distance between the signals informs the microcomputer whether the lens is focused in front of or behind the subject, and the motor can then be triggered to move the lens element in the appropriate direction.

The lens elements must move physically, and this action needs a motor, powered by the batteries in the camera's body. Contacts at the rear of the lens and the front of the camera's mirror box transmit power and information. The autofocus sensor in the camera controls the motor movements. Reaction time is fast, and although a subject moving rapidly towards or away from the camera may overwhelm the ability of the autofocus system to react in time, at this rate of change in distance it is likely that you also would be unlikely to deal with it in sufficient time manually.

There are two significant problems with autofocus lenses. One is that the lighting conditions must be right. If the contrast in the central focusing rectangle is low, or if the light level is low, the autofocus will not work. Either the lens will shift focus backwards and forwards without stopping, or the viewfinder display will give a warning. Under these circumstances, you will need to focus manually, and this will cause some delay in taking the shot.

The second problem is the point in the picture that is chosen for focusing. Clearly, not everything can be in exact focus (extended sharpness due to good depth of field is a different matter), and autofocus lenses judge a small central triangle, which is also engraved on the focusing screen. This is fine if you place the subject that you want to be in focus in the middle of the frame. If, however, you place it off-center, the autofocus system has no way of distinguishing this, and will still focus right in the middle, which is as likely to be the background as anything else. The answer is to use the focus lock. First frame the subject centrally, apply enough pressure to the shutter release to operate the autofocus, then swing back the off-centered composition you want. Press the release fully.

Project: Autofocus

This project assumes that you own an autofocus camera and lens. If not, there is no important reason for you to borrow or hire one. First, test the low-contrast and low-light capabilities of the system under normal shooting conditions. The camera will display any failure to focus in the viewfinder, so there is no need to shoot any film. Find low contrast scenes by judgement. For low light levels, make a note of the meter reading – this will prepare you if you need to change over to manual focusing on future occasions.

Then practice using the focus lock on off-centered compositions. At least until you are thoroughly familiar with the lens, pause between the first pressure on the shutter and actually triggering the shutter, and check visually that the image is focused as you intended.

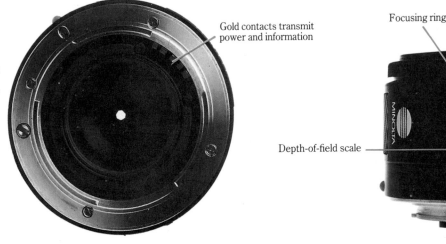

A 50mm autofocus lens, such as the one shown here, will take just ¼ of a second to focus on any distance from 3 feet (1m) to infinity. The lens is powered by a motor in the camera body.

Gold contacts transmit power and information

Focusing ring

Distance scale

Depth-of-field scale

The natural composition *below*, with the geese at the bottom of the frame and the family feeding them near the right edge, leaves the middle of the picture empty. The autofocus lens focuses on the distance. To correct this, the shot is temporarily re-framed *right*. Halfway pressure on the shutter release brings the autofocus into operation, focusing on the man. Maintaining the pressure on the shutter release keeps the autofocus locked. The camera can then be moved to the original composition *below right* and the family will be in focus.

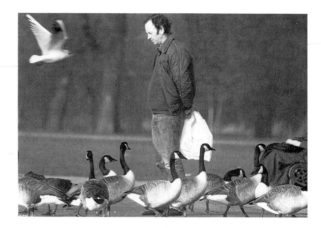

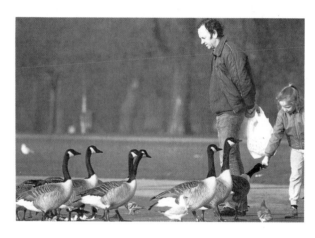

Focus frame

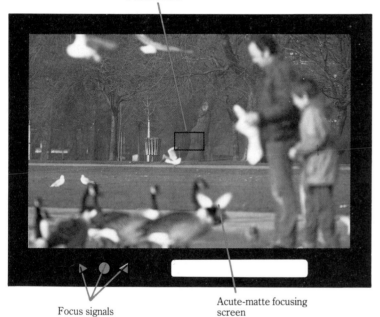

Focus signals

Acute-matte focusing screen

Reference signal

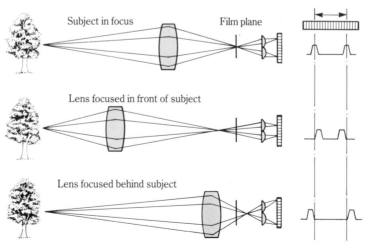

Subject in focus

Lens focused in front of subject

Lens focused behind subject

Film plane

Phase-detection autofocus
In this system, used by Minolta, two separator lenses each project an image from the center of the subject onto a charge-coupled device. This compares the signals from these with a reference signal, and indicates when they match. In other words, when both are equal to the stored reference signal, the image is in focus.

Aberrations

There are a number of potential faults, or aberrations, in camera lenses. They are potential in that there are solutions, or partial solutions to most of these, and they are mainly the concern of the lens manufacturer rather than the photographer. A fair working knowledge of lens aberrations will, however, help you in choosing a lens, in avoiding compositions, lighting and other conditions where the faults are shown at their worst, and in correcting some of them. As the table shows, the effects of some aberrations, such as diffraction, can be lessened by the way you use the lens.

In practice, altering the aperture is the main user control. Most aberrations are countered by stopping down, although diffraction, which is especially a problem in close-up photography, is improved by opening up to a wider aperture. In most situations where image quality is paramount, there has to be a compromise; in general, the best performance of most lenses is at an aperture of 2 stops less than the maximum.

Note from the last column of the table – effect – that aberrations can be made less obvious by avoidance. Coma shows up critically in images of points of light near the edges of the picture and it might not be difficult to alter the composition so that they are centered instead.

Spherical aberration
This is caused by the spherical curve of most lenses. Light rays through the edges of a lens focus closer than those that pass through the lens axis. Depth of focus obviously helps, and stopping down improves this aberration. The real solution, however, is to make an aspheric surface for the lens (see page 105).

Coma
Coma is an off-axis fault, in which points of light towards the edges of the picture focus at different distances when passing through different areas of the lens and appear extended, like a tear-drop or a comet tail (hence the name). It occurs in telephotos,

Aberration	Cause	Where common	Ways of improving	Effect
Spherical aberration	Spherical glass surfaces	Cheaper lenses, large-aperture lenses	Aspherical surfaces or floating elements Stop down	Unsharpness, especially in close focus Focus shifts when stopped down
Coma	Variation in magnification with aperture	Off-center highlights	Symmetrical design Stop down	Tear-drop shaped images of off-axis points of light
Astigmatism	Non-symmetrical refraction	Cheaper lenses	Stop down	Vertical and horizontal subjects focus at different distances
Distortion	Oblique light rays bent by edges of lens	Non-symmetrical lenses	Symmetrical design De-emphasize through composition	Non-radial lines curve out (barrel) or in (pincushion)
Field curvature	Focal plane curved because lens surfaces curved	Wide-angle lenses, large apertures	Manufacturer overlaps different image shells to approximate flat plane Stop down (improves depth of focus)	Focus position varies from center to edge
Diffraction	Wave nature of light	Small apertures, so especially common in close-up	Do not stop down fully	Loss of resolving power
Axial chromatic aberration	Dispersion of light	Especially a problem with long lenses	Achromatic or apochromatic design	Coloured fringes to highlights Focus shifts with colour
Lateral chromatic aberration	Dispersion of light	Especially a problem with long lenses	Very difficult: fluorite or similar (ED glass) – but these cause focus shift with temperature change Mirror lens	Coloured fringes to highlights
Vignetting	Light travels further to edge of film frame than to center.	Wide-angle lenses	Stop down	Uneven illumination – darker towards corners

retrofocus and other non-symmetrical designs of lens. Stopping down helps.

Astigmatism

This occurs only at the edges of the lens where oblique light rays do not converge on the film plane as points, but as two lines. These lines are at right-angles to each other and consequently cause vertical and horizontal lines in the subject to be imaged at different focal positions.

Distortion

The aperture stop of a lens prevents oblique light waves from passing exactly through the center of the lens and, as the surfaces of the lens at its edge are not parallel, the light is bent. This does not affect the sharpness of the image, but it does distort its shape, causing straight lines to bend inwards or outwards on the image. If the shape is compressed, it is called barrel distortion; if stretched, pin-cushion distortion. Symmetrical lenses are not normally subject to this distortion, but telephoto and retrofocus designs are to some degree.

Field curvature

As explained on pages 104–5, the focal plane of most lenses is not flat, but slightly curved, concave to the lens. While usually not noticeable, in copying flat subjects it causes out-of-focus edges if the center is focused, especially in close-up work. Stopping down helps by increasing the depth of field, and certain lens designs can eliminate it. Differential movement of lens groups during focusing is effective.

Spherical aberration
The shape of a typical lens means that the angles at which the light rays are refracted are slightly different in the outer zones than in the center. The result is that the image from any sharp point tends to be spread, reducing sharpness. Stopping down helps to reduce the problem.

Coma on a regular, spherical 35mm lens used wide open at $f1.4$ causes drop-shaped images of points of light.

▲Field curvature
A close view of the keyboard of a desk-top calculator, photographed at full aperture ($f1.4$) with a 35mm lens, clearly shows the inward curvature near the edges and corners. A regular camera lens like this is not suitable for accurate copywork.

▶ Both barrel distortion (*top right*) and pincushion distortion (*below right*) occur close to the edges of the picture, where the relative positions of the lens and aperture diaphragm cause the light rays to bend away from their true path, as shown.

Optimum aperture
Diffraction is the one aberration that increases with reduction in aperture. Unfortunately, it is sufficiently important to merit major attention. Most of the other aberrations are lessened by stopping down. The optimum aperture lies at the crossover point on the graph.

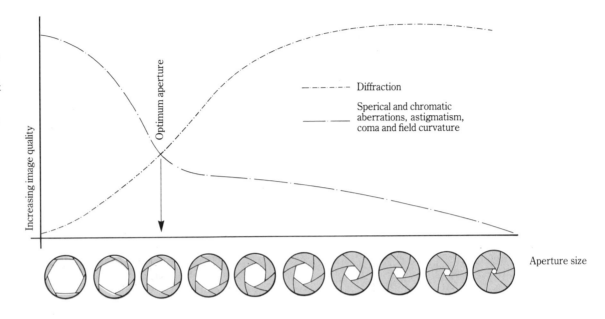

Increasing image quality

Optimum aperture

– · – · – Diffraction

——— Sperical and chromatic aberrations, astigmatism, coma and field curvature

Aperture size

Diffraction caused by *f*27 aperture at 4× magnification has appearance of unsharpness with a hint of colour fringing

At *f*11, diffraction is much less severe

Diffraction

Sharp edges in the light path cause slight spreading, which in turn causes unsharpness. The aperture blades in a lens do this, the more so at small apertures. The solution is not to stop down the lens fully.

Chromatic aberration

The different wavelengths of light travel at different speeds through the lens, and are refracted at slightly different angles. Blue focuses closer to the lens than red, with the other wavelengths in between. As a result, the focus is spread, and the resolution suffers. There are types of this fault. In axial chromatic aberration, the focus is spread along the axis, as shown in the diagram *top right*. In lateral chromatic aberration the magnification varies with the wavelength across the image plane, affecting the outer edges of the image.

Vignetting

As explained more fully on pages 106–7 and 111, wide-angle lenses may produce images which are slightly darker away from the center, particularly if the entire projected image is used to make the picture. Stopping down to a smaller aperture improves this fault by utilizing only the central part of the lens and projected image.

Flare

Although one of the major causes of poor image quality, most of the immediate origins of flare are in the use of lenses, and can be avoided by good photographic technique. This is dealt with on pages 118–21.

Chromatic aberration
Lenses refract different wavelengths more or less sharply, with the result that they focus at different points behind the lens. Blue, for instance, focuses more closely than red, with the result that in this type of lens fault the image is less than perfectly sharp.

Blue focus Red focus

Colour accuracy
Check the accuracy of the colour transmission of the lens by holding it, at full aperture, against a white light source. Compare the colour casts; there should be no visual difference.

Lens coatings
Check the multi-coating on a lens by holding it at an angle to a light source. The different layers can be seen in a series. A blue reflection indicates a single coating, green two coatings, brown, violet or amber, three coatings.

Flare

Flare is any light entering the lens that does not contribute to making the image. It might be caused by the sun shining straight into the lens, or by a bright part of the scene lying just outside the picture frame. In appearance, it can take a variety of forms, from a pattern of bright shapes superimposed on the picture to a subtle lowering of contrast across the image.

To an extent, flare can be reduced by the lens manufacturer, and one of the most effective means is to coat the elements. The way this works is by means of what is known as destructive interference. Several layers of coating, using materials such as silicon dioxide, are common; each layer is of a precise thickness to correspond to particular wavelengths of light. Peaks in the waves of light that are reflected from inside surfaces meet the troughs in the waves of light of similar wavelengths, and cancel each other out.

To inhibit flare further, the inside of the lens barrel is painted matt black. In time, this paint may flake off and expose bright areas; if you have old lenses, examine them carefully with a flashlight.

There are two main sources of flare, and there is a lot that you can do to reduce their effect. One source is an intense single light shining directly on the lens; the other is bright surroundings. Both are made much worse by dirt or grease on the front element of the lens.

Project: Bright sun

Of all flare effects, by far the most common and obvious is that from direct sunlight. The two worst conditions are when the sun is only just outside the picture frame and, as you might expect, when the sun is visible in the picture. Practice shooting under these conditions, making paired pictures with and without shading.

An ordinary lens shade is not as useful as you might imagine under these circumstances. Fit the camera to a tripod, and compose an outdoor scene in which the sun is just out of the frame. Then stand in front

Proprietary filter holder has rectangular shade which clips onto screw-on ring mount

Adjustable professional lens shade features bellows which extend or retract to match the field of view of different lenses

Standard lens shade of 35mm cameras is screw-on circular design

▼Basic circular lens shade is a compromise between ease of fitting (it screws onto the lens) and full shading. A rectangular shape that crops right down to the limits of the picture area would be better, but impossible to align accurately because of the screw. A variety of shapes is usually available to match, more or less, the angles of view of different focal lengths.

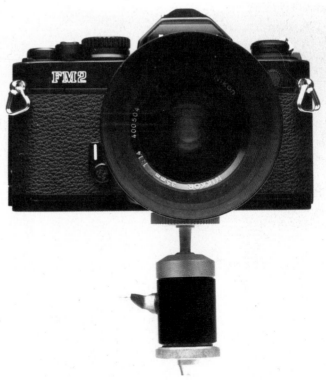

of the camera and see how much the front of the lens is actually exposed to direct sunlight. You will see that a regular circular shade will do little to hinder the amount of light striking the lens. Much more effective is your hand or a piece of card. Hold either slightly in front of the lens until its shadow just falls on the whole front lens element, and no more. Alternatively, if you are looking through the viewfinder, bring your hand into view, covering the sun, and then withdraw it until it is just out of the frame. The further forward you can hold your hand, the more precisely it will shade the lens from the sun.

▶This filter holder for the Cokin range incorporates a clip-on rectangular shade. This is more efficient than a circular design, although it shades only one angle of view and so is less effective with telephoto lenses.

▼With a single, point light source such as the sun or an undiffused artificial light, an effective method of shading is simply to hold a black card in front of the camera. If the camera is on a tripod and you can stand in front of it, judge the position of the shade by watching the shadow-line on the lens – the line should just touch the bottom edge of the front element.

▶The most efficient of all lens shades is an adjustable bellows design. The angle of view that it shades can be altered to match the picture area. For longer telephoto lenses, additional masks slide into the front.

▶Simple and largely effective, particularly with direct sunlight, is simply to use the flat of your hand. Place your hand so that it appears just out of the frame when looking through the viewfinder.

You can expect to see three kinds of flare effect, as shown in the paired examples on these pages. One is a bright fogginess close to the edge where the sun's image is. Another, less obvious on its own but very noticeable when compared with the shaded shot, is an overall weakening of the density in the shadows, causing reduced contrast. The third, which depends very much on the focal length of the lens, is a small reflected shape (or even a small group), caused by reflections between the surfaces of the separate lens elements.

The examples here are taken with wide-angle lenses. With longer focal lengths, the visible effect is usually just an overall fog, but more severe in most cases.

Fogging close to light source (the sun)

Overall lightening of shadows causes reduction of contrast

Green internal lens reflection

Major internal reflections, exaggerated by slightly dirty front lens element

Flare reduced to acceptable proportions by cleaning front lens element and by moving camera position slightly to obscure part of sun's disc

Filters and Mounts

The range of basic filters (excluding those that produce special effects) is considerable, but comprises these five groups:

- Filters which enhance contrast by absorbing ultraviolet rays
- Filters which alter tonal values in black-and-white photography
- Filters which reduce the quantity of light
- Filters which alter the colour temperature of light
- Filters which alter colour.

Full treatment of filters is given in volumes III and IV on *Light* and *Film*, but here we concentrate on the forms in which they are available and the types of mount. Filters are most commonly available as thin gelatin (a wide range but damageable), glass that screws directly on to the lens, and plastic that fits in a special holder.

1 Oversize plastic holder that screws onto the front of a lens, using an interchangeable set of screw mounts. It accepts its own range of plastic rectangular filters in two sets of grooves. These can be rotated or shifted; a feature useful with some special effects designs.

2 Screw-fitting glass filter for shooting with daylight-balanced film in fluorescent light.

3 Smaller, regular version of the most widely used patented system, in design identical to **1**. Shown here with a graduated filter, one of the most useful for altering the balance of light from one part of a picture to another.

4 Semi-transparent tape for mounting gelatin filters behind lenses, inside the camera body. This position eliminates the risk of filter flare, and is mainly used in large format photography.

5 Gelatin filter. Normally available as squares (this is the common 3 × 3 inch – 75 × 75mm – size), they are available in the widest range of colours. Being thin, they have virtually no effect on optical performance unless they are scratched. There are very few secure mounting methods, although gelatin filters can easily be cut to shapes that will fit, for instance, under a plain glass screw-in filter. They damage easily.

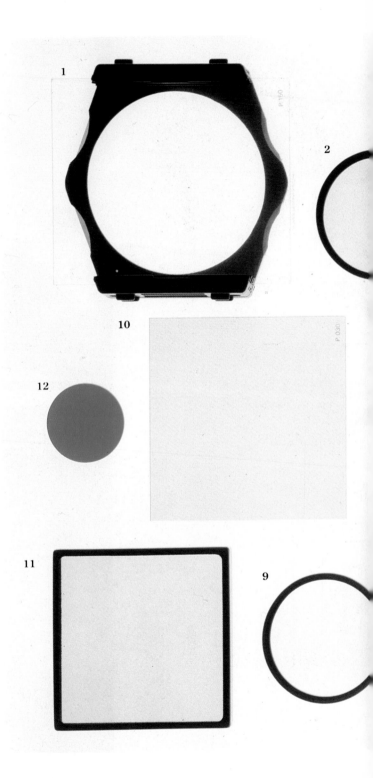

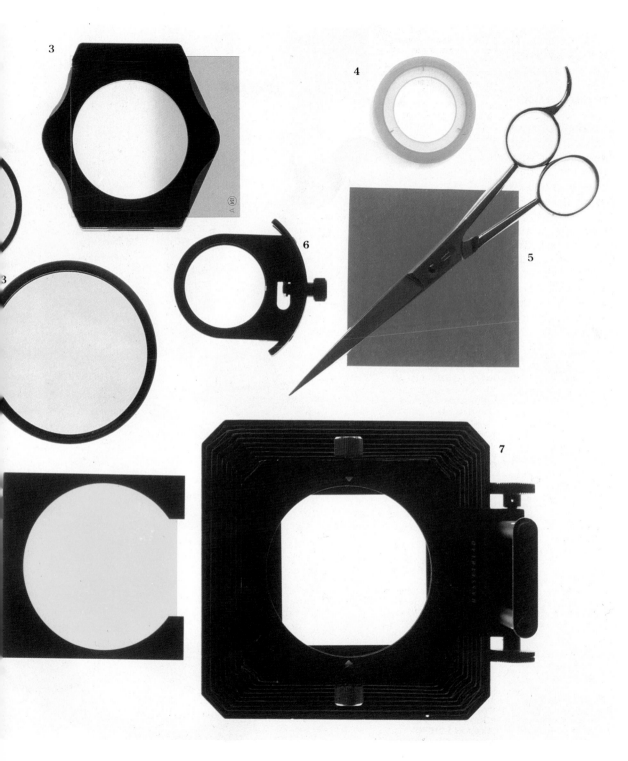

6 Internal lens mount. This model fits inside a 600mm telephoto behind the rear lens group. The small knob is for locking and unlocking. The small glass filters are interchangeable.

7 Bellows lens shade that has a slit which accepts 3 × 3 inch (75 × 75mm) gelatin filters. Adaptor rings enable it to be fitted to the majority of 35mm camera and rollfilm lenses.

8 Metal sleeve holder for gelatin filters to fit in the bellows lens shade **7**.

9 Screw-on glass light-balancing filter (a camera manufacturer's equivalent of Kodak's 81 series).

10 Light-balancing square plastic filter for use in the patented plastic holder **1**.

11 Optical flat. This example, a polarizing filter, is made of relatively thick glass that is free of optical distortion, bound in a metal frame. Expensive.

12 Glass correction filter for photomicrography: a plain disc that fits in the microscope convertor.

13 Polarizing filter in rotating mount, with small handle. The polarizing effect depends on the angle of the view to the light source, so that rotation is an essential control.

Effects filters

Whereas the prime function of most filters is to make corrective adjustments to the light transmitted by the lens, the purpose of effects filters is to alter the picture substantially. They are valuable only if used sparingly and intelligently but are not, under any circumstances, responsible for producing "creative" images, manufacturers' claims notwithstanding.

There is some overlap between effects filters and basic filters. This is in areas where there is a consensus on what are considered acceptable alternatives to an image, and include the use of a polarizing filter and a neutral graduating filter. Many filter effects are very specific – for instance, the use of shaped masks – and only a selection is shown here. Although they can be fun to use occasionally, I feel that most photographers are probably better off without them.

1 Petroleum jelly. Smeared lightly on a plain glass filter, it can diffuse or obscure parts of the image, selectively if wanted.

2 Slit-scan filters. Must be used with moving film, preferably motorized. The effect is to stretch the image of a moving subject.

3 Weak neutral graduated filter. The soft dividing area between the clear and dark halves conceals the transition, except at very small apertures with a wide-angle lens. Very useful for darkening skies. Many landscapes, particulary on cloudy days, contain such a high contrast between land and sky that details in both cannot be captured together without the help of this type of filter. Graduated filters can be used together to intensify the shading or in opposition to leave a bright horizontal strip.

4 Strong neutral graduated filter. A double-intensity version of the weak graduated filter. These filters can be raised or lowered in the holder to coincide with the horizon line in the picture.

5 Amber-coloured graduated filter. In addition to darkening the sky area, the warm tone can be used to create or intensify the colour of a sunset or sunrise. Must be used sparingly.

6 Fog filter. Also graduated, this design is half clear and half diffused. If the diffused area is kept uppermost, it can give the effect of fogginess in a landscape; that is, the foreground will be relatively clear, the background increasingly misty.

7 Double-image mask. This mask is rotated a half-turn between two exposures on the same frame of film. The effect is to butt the two halves together; if the camera is locked on a tripod, the background of a scene would appear continuous, but other subjects can be moved between the two exposures.

8 Prism filter. Prism edges polished into a glass filter produce multiple images, partly ghosted. Several prism configurations are available; this is a parallel series of steps.

9 Split-field close-up lenses. Half the circular mount is empty; half contains part of a close-up lens. The effect is to focus half the image very close when the prime lens itself is focused at a much greater distance. Difficult to use effectively, as the soft line between the two halves is almost impossible to conceal, but they give their best effects with a wide aperture. Different strengths are available.

10 Polarizing filters. Used alone, they can reduce reflections in daylight from non-metallic surfaces such as glass and water, and to darken the image of a clear blue sky at right angles to the sun. The same control of reflections is possible with artificial light that is covered with a screen of similar polarizing material. Two polarizing filters crossed, as here, cut all light except a deep indigo. Certain plastics, such as the small square shown here, exhibit a brilliant play of colours if placed between two polarizers. These filters are in screw mounts, and can be rotated to alter the polarizing effect.

11 Piece of stocking. Stretched over the lens, it gives a specific quality of diffusion, useful for atmospheric effects. Other thin materials produce different results.

12 Coloured gelatin filters. Although these two Kodak Wratten filters are designed principally for black-and-white photography and post-production, they can be used to add overall colour effects (normally more useful one at a time in multiple exposures rather than to give a single overall view). The yellow 16 and magenta 32 combine to give a primary red.

CAMERA HANDLING

A camera works best when it acts as an extension of the photographer's eye. If you are not entirely comfortable with the way it operates, the equipment can be something of a barrier between what you see or imagine and the picture recorded on film. Many potential photographs can only be realized if you take the opportunity as it presents itself, and shoot immediately. Even in situations where there is no hurry, the equipment can delay the process of seeing and constructing an image if you need to stop for long in order to work out settings, choice of lens and so on.

In either case, the important thing is to preserve continuity of vision to keep the flow of the photography from the idea to the exposure. The process begins and ends with images – the first in the eye, the second on film – and the place of the equipment, however essential, is intermediate. The more you can absorb the camera operations in a natural way of working, so that they come as a matter of course, the more smoothly the picture-taking will go. The key to this, as you might expect, is complete familiarity with all of your equipment. For this, nothing is better than regular use.

The subject of this last section of the book is efficient use; being able to create predictable results with each camera and lens control. There are two principal conventions in photography – sharpness and a recognizable level of brightness – and these depend on the four essential controls: focus, shutter, aperture and metering. The sharpness of an image is affected by whether it is focused sharply, how deep the focus is, and whether the shutter is fast enough to freeze movement of both the subject and the camera. The brightness of the image is a matter of exposure, managed by the shutter and aperture acting together and measured by a meter, usually built into the camera.

The degree and extent of sharpness, and the level of exposure, depend very much on how you visualize the photograph (on your personal preference, that is), but still the essential camera-handling skills are those of being able to meet the conventional standards whenever you need to. Think of a sharp, normally-exposed negative or transparency as the basic standard. To be properly equipped, you should at least know how to produce that under most conditions.

Focus

Focus is inextricably linked to sharpness. Practically everybody has such a well-developed intuitive sense of what is sharp in an image that you may imagine there is little to say about it. However, recognizing sharpness in a picture is one thing, but achieving it in all conditions requires a command of certain techniques, and some of these need plenty of practice. Probably the worst technical error you can make in photography is an unfocused image; the margins of error that we are prepared to accept as viewers are remarkably narrow, and much less than, for instance, those acceptable in satisfactory exposure. You cannot salvage a picture that is out of focus.

Sharpness is not an objective quality. Instead, it is a personal assessment made intuitively on the basis of several factors. The two principal ones are resolution and contrast; both can be measured objectively, but each can be independent of the other. In fact, in some ways it would be easier to manufacture a higher resolution lens with less contrast.

Resolution is the ability of a lens to distinguish detail. A basic method of assessing this is in terms of the number of distinct parallel lines in one millimeter that can be recorded; the more sophisticated modern method is modulation transfer function (MTF), which is a measure of the change in spatial frequency (the number of light waves per millimeter) when light passes through a lens. Contrast is the difference in brightness between adjacent areas of tone; the bigger the difference, the greater the contrast. High resolution and high contrast together create the sensation of sharpness.

In the vast majority of situations facing the camera, there is absolutely no doubt what to focus on, just as most photographs have distinct subjects. To a large extent this is the nature of the way people take photographs, first choosing an object and then making it the center of interest. Nevertheless, one condition that makes for some difficulty is when the subject is chang-

ing position. If the depth of field is limited, as it is with a telephoto lens used wide open, the margin for error is very restricted. Moving subjects need experience and technique, but any practice that you put into accurate focusing with them will enhance the speed at which you can focus on easier, static subjects.

Project: Focus on movement
Choose a situation and location which present you with a moving target that is approaching (either directly or diagonally). The easiest, though probably not the most interesting, might be close to a road with constant traffic. Something a little more worthwhile should not be too difficult to find, however. Make sure that there is a succession of moving targets, so that you can take plenty of repeat shots and improve your timing.

The first step in this project is simply to make one completely accurate exposure. If the subject is moving fast, you may be surprised at how difficult this is. A basic method is to focus in advance and shoot as the subject moves through the focus point. You may find at the first few attempts that you have a tendency to let the subject move into and then a fraction beyond best focus. This is why practice is essential, to get a feel for the timing. After this, work on making more than one sharply focused shot in an approach sequence. The measure of your success is the number of good shots that you can make in a set distance.

Follow-focus
Although follow-focus (turning the focusing ring to keep the image of the subject constantly sharp) is often touted as the basic method of dealing with an approaching subject, in fact it is difficult and rarely suitable. You are likely to lose shots if your focus starts to drift. This sequence of a cyclist is one of the few situations where it can work. The three conditions that

make follow-focus suitable here are that the movement is predictable and repeated (different cyclists following the same path), the distance travelled by the cyclist is very short, and the camera is on a tripod.

Key techniques here are to have a known starting point for the focus (the base of the tree on the left), and to practise on the first few cyclists. Be warned: it is not so easy.

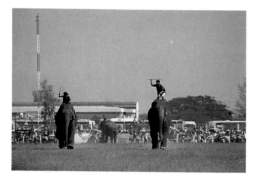

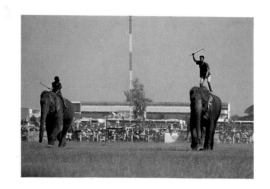

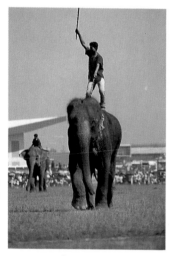

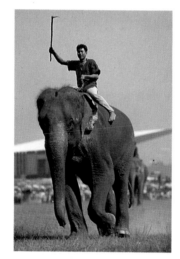

Continuous refocusing technique

The key to making a sequence of well-focused shots as a subject comes towards you is to break the focus after each shot. If the subject is moving at speed and over a considerable range of distance, you will be very unlikely to keep it in focus simply by trying to match the rate of the approach by slowly turning the focus ring on the lens. Instead, quickly catch the focus and then focus forward a short distance (step **1** in the diagram). Let the subject move into focus and shoot when it reaches the sharpest point (step **2**). Immediately after shooting, focus forward again, and wait for the second opportunity (step **3**).

This is the technique used here. Try it in any similar situation; you should find that because the apparent rate of approach is slow to begin with, the first few shots will give you useful immediate practice for the more difficult, but more important, frame-filling shots at the end of the sequence.

The limits of shooting are set by the focal length of the lens; the furthest point is the position where the subject can be identified, the nearest is where the subject fills the frame. In this example, shot with a 400mm lens, the format was changed from horizontal to vertical half way through.

Project: Selective focus

This is a fairly loose exercise, to practise whenever you are working with a telephoto lens at a wide aperture. In situations like those shown here, there is no alternative to having some parts of the picture frame significantly out of focus. The exercise is experimenting with where to place these unfocused elements, noting the different effects they have on the design of the picture. They can, for instance, act as a kind of frame, or as a colour or tonal wash; they can help to make the main subject stand out, and they can enhance the sense of depth.

Selective focus
Two treatments of a similar subject show that it is possible to use the out-of-focus parts of an image to perform different functions. In both cases, a long telephoto (600mm) was used at full aperture, and it was inevitable that only the animals could be sharply focused. In the picture *top* the out-of-focus foliage makes a kind of casual frame, which conveys exactly the impression of a shy animal glimpsed fleetingly through a chance gap. This effect would not, of course, be the same if everything were sharp.

In the picture *right* this framing was chosen as an alternative to including an uninteresting horizon. Here, the wash of colour created by the strongly unfocused foreground helps the unity of the photograph by limiting the setting to a single hue. Also, the direction of increasing focus does much to move the viewer's eye upwards through the frame.

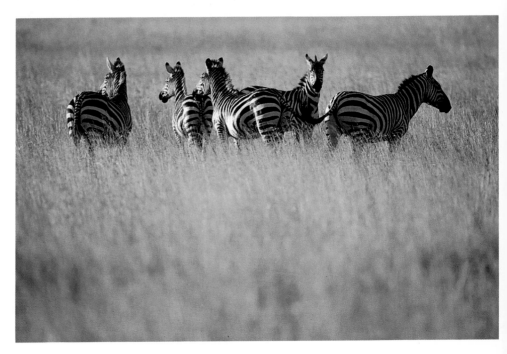

**Adding dimension
with selective focus**
While the most common
reaction to scenes that
have some foreground
obstructions is to change
viewpoint or focal length
to eliminate them, they
can perform valuable
functions. In this
example, the unfocused
tree-trunks are included
in the horizontal picture
to involve the viewer
more in the scene.
Unfocused, they
establish the dimension
of the setting, and imply
that the viewer is
standing at a certain
distance from them and
the village. A small but
important element in this
is the feeling of
casualness in the lack of
focus; the picture is that
much looser and less
organized than the
second version in which
the foreground is
eliminated. Neither
image is objectively
better; simply the
impressions differ.

Project: Best focus

One of the most common uses of a wide-angle lens is to photograph scenes with full overall detail. Used like this, there is an expectation of good depth of field, but if the aperture is at its maximum it may not be immediately obvious where to focus. This is partly a depth of field exercise, but to be done at full aperture. Take scenes such as those shown here and focus in two different positions: close to and far away. If the depth of field is insufficient, accurate measurement of distance is irrelevant; work visually and subjectively.

Choosing the point of focus

When the depth of field in a picture is not all that you would like it to be, choosing where to focus becomes even more critical. The circumstances in this example of a floating market in Thailand were low light and a minimum shutter speed set by the movement of the boats. Ideally, the whole length of the waterway should have been in focus, particularly as the lens is a wide-angle 24mm (we are less accustomed to seeing selective focus in a wide-angle shot than in a telephoto image). With this not possible, the most satisfactory setting is one which keeps the foreground sharp. Try this for yourself with any similar view in depth, using full aperture. Vary the focus setting. You may notice that with a wide-angle lens there is a temptation to assume that the whole image is focused in distant scenes. At full aperture, particularly with a fast lens (f2 and wider) this is not necessarily so.

Loss of focus starts here

Virtually sharp

Focus here

Focus here

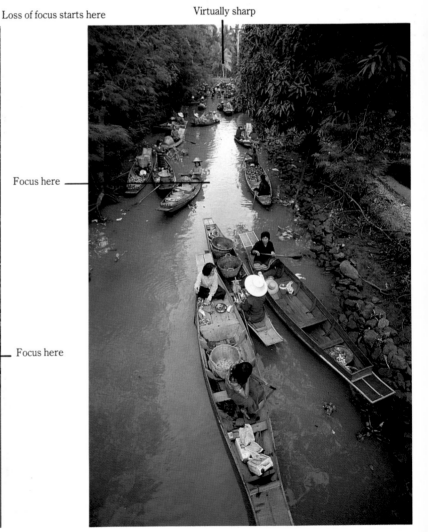

Project: Focus sequence

This is a valuable demonstration of the extremely fine tolerances in accurate focus. Shoot a close portrait, as in this example at maximum aperture, ideally with a telephoto lens. Focus on the eyes for the first exposure and then take a second shot with the smallest discernible movement that you can make with the lens focusing ring. Make another small movement for the third shot.

A face is the ideal subject for this project because viewers are especially sensitive to the sharp focus of the eyes (there is virtually no other psychologically satisfactory point of focus in a portrait). See for yourself on the developed photographs, using a loupe, how easy it is to distinguish a slightly unfocused image – and how unacceptable it is.

Ultimately, sharp focus is judged subjectively on the appearance of the image, but most camera focusing screens contain aids. Most common is the split-prism, which separates two sections of the image until they are properly focused. Surrounding the central split-prism circle in this example is a microprism "collar". This pattern of small prisms scrambles the image when it is unfocused. (For a full run-through of viewing aids see pages 176–7.)

There is a slight, almost imperceptible, difference in the focus of these two portraits. In the picture *far left*, the point of focus is exactly on the eyes; in the print *left* it is just behind. At this scale of reproduction there appears to be virtually no difference, but in any greater enlargement, the slightly misplaced focus would be sufficient reason to reject the shot. Enlargements of the eye from three different frames in the sequence *below* show this; **1** is accurately focused, **3** is obviously out of focus, but **2** is a borderline case, and could be reproduced satisfactorily at only a small enlargement.

1 **2** **3**

Shutter Speed

The shutter has two functions, which often conflict. One is to regulate the amount of light; a duty it shares with the aperture. The other is to freeze the image sharply. These functions become opposed when the image is moving and the light level is relatively poor. Even though the aperture usually allows some adjustment and a faster film can be substituted, there are occasions when the only practical way of giving enough exposure to the film is to slow down the shutter speed, and this may result in a speed too slow to freeze the movement.

Freezing

Put at its simplest, the first basic skill in using the shutter is being able to judge the slowest shutter speed that will do the job. In most situations this depends on how active the subject is, but at the slower shutter speeds camera shake sets the limit (see hand-holding on pages 96–7).

One thing you can see from a glance around the examples on these pages is that there are several variables. All of the following affect the required shutter speed:

- How fast the subject is moving.
- Its angle of movement to the camera: head-on, side-on, or diagonal.
- The distance from the camera.
- The focal length of the lens.

In addition, the following set limits to the speed that is actually possible:

- The need for good depth of field, and so for a small aperture.
- The acceptability of graininess from a high speed film.
- The amount of acceptable blur.
- The amount and direction of light.

This seems to have the makings of a complicated sum, but it can be simplified at one stroke. What is ultimately important is how much the image moves inside the frame. The only practical measure of this is experience, because the circumstances hardly ever arise where you would have time to make calculations. The table and diagram are an initial guide, but what you must practise is assessing movement as you see it in the viewfinder.

Projects: Slow-speed techniques

Find situations which have repeatable movement; that is, the same subject performing the same action a number of times, or a succession of similar subjects in the same location. You cannot confirm the safe slowest shutter speed without looking at actual results, so shoot at two or three different speeds. Examine each developed frame critically under a loupe. You may find that certain small amounts of motion blur are acceptable provided that the overall image is basically sharp (see pages 142–3 for more detail on motion blur).

Where possible, vary the focal length that you use. This is equivalent, for the purposes of this exercise, of moving closer to or further away from the subject; it alters the size of the image in the frame, and consequently the apparent movement. Keep a note of the speeds you shoot with, at least until you have developed a confident eye for judging the shutter speed necessary. There is no better way of assessing the results, even if this method seems to be rather laborious at first.

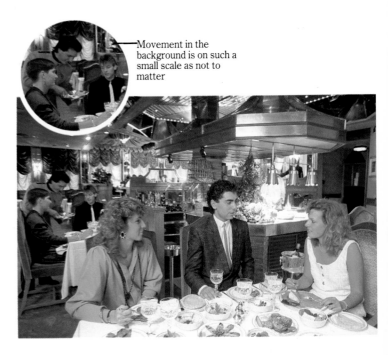

Movement in the background is on such a small scale as not to matter

Slow-speed techniques
It is possible to shoot successfully well below the slowest safe shutter speed. A typical situation is this restaurant interior – a planned photograph. To record the existing lighting, very little photographic lighting could be added, and graininess set the limit on the speed of film that could be used. Given the need for some depth of field, the shutter speed had to be 1 second, making a tripod essential. The first important thing to note is that only the movement of the three foreground figures counts; the people behind appear too small in the frame to matter. The other thing is that in any movement there are natural pauses, and by taking sufficient shots, the odds of a sharp picture are lengthened to a near-certainty. A larger number of shots, timed for natural moments of least movement, gave a reasonable percentage of non-blurred exposures.

Distance and direction

The distance between the camera and the subject and the angle of motion are the major factors in the least shutter speed needed to freeze movement. Provided that you do not change to another lens, the apparent movement of a distant object will clearly be less than that of something nearer, just because the image will be smaller in the picture frame. Equally, the greatest apparent movement is perpendicular to the view – that is, across the picture. The least apparent movement is when the subject is approaching the camera directly; then, the only important movement is in the parts of the subject, such as the arms and legs of a runner.

If you have a reference shutter speed, the effects of distance and direction are easy to work out. In the diagram *above* we assume the moving object to be a running person; at a distance of 16 feet (5 m), without panning the camera, $\frac{1}{2000}$ of a second would be a safe shutter speed to freeze the movement with a standard lens. At twice the distance – 33 feet (10 m) – the figure is twice as small in the viewfinder, and the shutter speed needed is twice as slow: $\frac{1}{1000}$ of a second.

The relationship with direction is similar. If the running figure is moving at 45° to the camera instead of right across the picture, it seems to be approaching at half the speed, and so needs a shutter speed twice as slow.

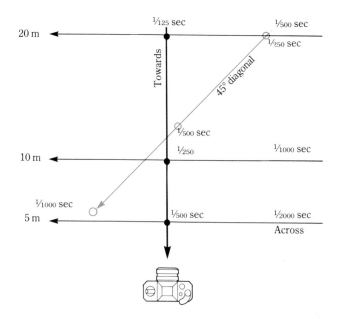

Focal length
Because the size of a moving subject determines its apparent movement across the picture frame, focal length affects the minimum shutter speed. A longer focal length magnifies the image, and at the same time magnifies the movement. In this example, a photograph of a peregrine falcon in flight, changing to a shorter focal length makes the shot possible. The most suitable lens – 400mm in focal length – was too slow at $f5.6$ to allow the $\frac{1}{500}$ of a second shutter speed necessary. An $f2.8$ 180mm lens, however, could be used, provided that the resulting photograph was enlarged. In effect, lack of graininess has been sacrificed for sharpness.

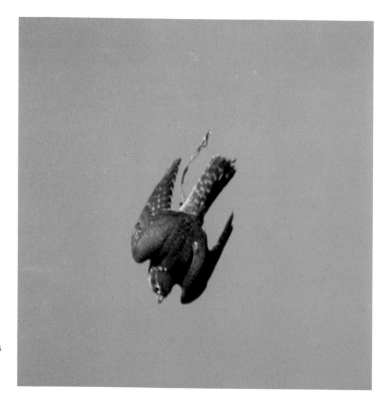

135

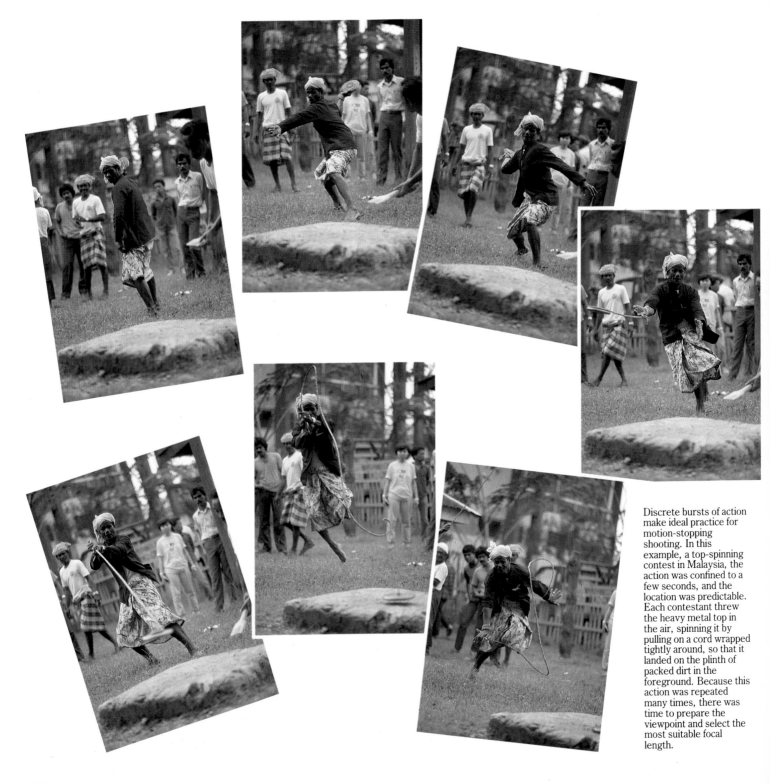

Discrete bursts of action make ideal practice for motion-stopping shooting. In this example, a top-spinning contest in Malaysia, the action was confined to a few seconds, and the location was predictable. Each contestant threw the heavy metal top in the air, spinning it by pulling on a cord wrapped tightly around, so that it landed on the plinth of packed dirt in the foreground. Because this action was repeated many times, there was time to prepare the viewpoint and select the most suitable focal length.

Lighting direction
The shutter speed needed for any subject is also affected by the quality of the lighting. Assuming that the subject reflects light in an average way, the exposure latitude will be fairly narrow if it is lit from the front or from a little to one side: say, within half a stop on transparency film. If, however, it is backlit, you have the choice of treating it as a silhouette, basing your exposure on the bright background. This is exactly the case with the two examples here: in the first picture, these hill-tribe women carrying roof thatching are lit frontally by the remains of a sunset, and need an exposure of $1/30$ of a second at $f3.5$. The exposure actually given was $1/60$ of a second at $f2.8$, tolerating some underexposure in return for a just-usable shutter speed. The second photograph was made as they continued walking, but from behind, turning the camera to face the sky. As a silhouette, no detail within each shape was needed, and the exposure could be $1/125$ of a second at $f4$. The diagram *right* shows the approximate relationship between the lighting directions.

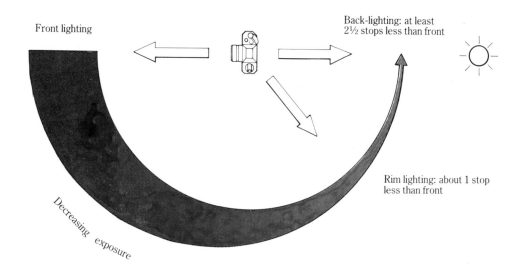

Front lighting

Back-lighting: at least 2½ stops less than front

Rim lighting: about 1 stop less than front

Decreasing exposure

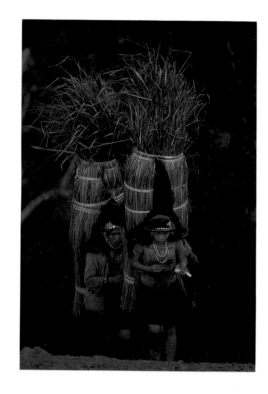

Anticipation

We can now move on to the critical matter of timing. What constitutes the best moment at which to shoot depends so much on the individual circumstances and on your own sense of appropriateness that there is no actual method that has any value.

Interestingly, whatever criteria you choose for the best moment to shoot, the timing is nearly always extremely critical. Even if you are dealing with relatively slow movement, such as a person walking, the differences between the best moment and the next-to-best is likely to be a matter of milliseconds only. This means that if you wait until it looks good in the viewfinder, you will probably miss capturing it on film. The key to good timing is anticipation, and this means thinking about what is likely to happen in any one sequence of events.

Having the judgement and reaction to be able to catch an exact moment is a distinct talent, but like most talents it can be improved upon with practice. Remember that we are not attempting to establish what the best moment is – that is a matter entirely for your own judgement – but rather how to anticipate the way a scene unfolds in front of the camera. Usually, there is a fairly logical progression. Here are two different examples where the moment of shooting has a special importance.

Projects: Sequences

Imagine a situation in which the potential for a good picture exists, but because of the interplay between different elements, it all depends on something being in just the right position. This is the ideal example of the "best-moment" shot. Under normal circumstances, you might only shoot at that moment, but for this project, shoot before and after, at the less perfect moments. You will then have a sequence of pictures to examine and assess. Among all the different possibilities, I have chosen two specific examples. In one, the moment is absolutely predictable, in the other, uncertain.

In the sequence of the aircraft, the picture can be imagined in advance. The camera is set up on a tripod and the shot composed so that the parked aircraft is centered at the bottom of the frame. The runway is directly behind, so the larger transport aircraft will fly into the shot as it lands. The only uncertainties are how high and how large it will appear; both of these can be resolved by watching any previous aircraft landing. The focal length chosen just allows the full length of the transport aircraft to fit into the frame. For the purposes of demonstration, a motor-drive was used to get a full before-and-after sequence, but the only important exposure is the central one. Try this exercise yourself with any similarly moving object: a car, perhaps. Work at shooting to this kind of tolerance.

Given the lighting conditions, film and lens, the fastest possible shutter speed was 1/250 of a second, only just satisfactory for the amount of movement. As in applying the brakes in a car, there are two periods of delay in shooting: your reaction time and the mechanical delay between the signal from the shutter release and the shutter blinds opening. Here, the shutter release is pressed for the crucial third frame when the nose of the aircraft was half way between the frame edge and its position in the previous picture.

In the second example, the moment is not predictable, and it is not always possible to know when the best opportunity presents itself. Basically, the painted shop front shutter is graphically appealing, but not on its own. What was felt to be necessary was a figure, ideally coming out to avoid a back view. The main difficulty here is that someone walking in gives about one or two seconds' notice as they approach the shop, but someone coming out appears in the doorway only a fraction of a second before they take the first step (considered the "best moment" here). In this case, the last shot was what I wanted, but I might have settled for one of the previous frames. Who knows; if I had waited longer, a more interesting figure might have appeared. In these situations, you start to think of diminishing returns: how long is the potential of a picture worth in waiting time? Will the time be better spent moving on to other things?

This sequence, waiting for the last shot, took place over about ten minutes.

A moment's inattention misses this figure entering.

A clear view of a man leaving, but another passing vehicle obstructs the view.

Fairly good timing, but back of figure.

Best so far, and good enough.

First attempt, but the front of the parked car is irrelevant.

Slight change of position, and reframed. Unfortunately, passing car spoils the shot.

Panning

When there is continuous movement and it happens across the field of view (it usually does; head-on views are a special case), the usual technique is to follow it with the camera. The name for this is panning, and there is normally nothing complicated in keeping the target in frame. However, the conditions of the picture may well change and the extra complications in panning are the control adjustments that you may need to make simultaneously.

Panning is usually associated with telephoto lenses (there are very few occasions when you will be close to something moving past you without the distance between you and the subject changing very much), and these are, as we have already seen, a little more difficult to hold and operate than short focal lengths. Hence, if you are anticipating a panning sequence rather than reacting to a sudden opportunity, it is an advantage to use a tripod. This frees at least one hand to operate focus or exposure controls.

A word about the tripod head. Ideally, there should be enough friction to support the camera and lens without putting any strain on your hands, with enough free play in the important direction to allow the target to be followed without drag. As most panning sequences involve horizontal movement, it usually helps to loosen the rotating axis fully, keeping the friction on the other movements. One danger in tripod panning is that if the tripod itself is not level, the vertical and horizontal lines in the picture will become increasingly askew as the camera is rotated. If you can prepare the set-up and know the route that the moving subject will follow, check the levelling first with a dry run. There will be too much to do when you are actually panning the subject to correct tilted verticals.

Another reason for checking out the path of the pan is that it may involve changes in focus and exposure, and also some obstructions. For focus shift under these conditions, refer back to pages 128–9. Any changes in lighting along the target's route will require adjustments to be made to the exposure controls; preferably the aperture, as the shutter may need to be at a certain speed to cope with the movement. If you can leave this to the camera's automatic exposure system, so much the better, but this is not a good idea if there are any big differences in contrast between the subject and its background. In the case of the aircraft shown *opposite*, for example, automatic exposure would result in an image that was too dark. The alternative is manual adjustment, but this is only practical if you do not need to hold the focusing ring throughout the pan.

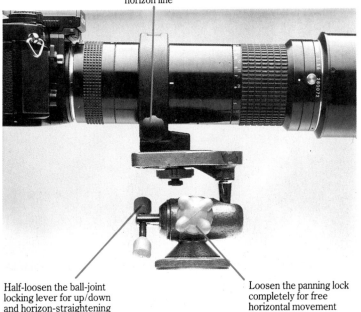

If your lens has a friction-locking collar like this, loosen it slightly to allow left-to-right correction of verticals and the horizon line

Half-loosen the ball-joint locking lever for up/down and horizon-straightening adjustment

Loosen the panning lock completely for free horizontal movement

◄ A ball-and-socket head gives the greatest freedom of movement in panning, although this freedom means that you must support much of the weight of the lens and camera with your hands. Limit the free play in order to exercise more control.

► The three axes on a pan-and-tilt head operate separately, so the panning technique is a little different from that needed for a ball-and-socket head. Ideally, you should have full panning (horizontal) movement and some up/down tilt movement to make minor adjustments. The left-to-right movement that justifies vertical and horizontal lines should be levelled and *non*-adjustable.

Level the left-to-right adjustment, and lock

Half-loosen the up/down tilt adjustment

Level the tripod before anything else

Loosen the panning lock fully

Diagonal approach
The subject here is the same as on page 138: a transport aircraft coming in to land. Whereas in the previous sequence the camera was locked off, in this example it is on a loosened tripod head following the right-to-left movement. In any diagonal movement, the focusing is the critical control, so that the exposure should be either preset (as here) or on automatic.

Panning blur
One technique that can be introduced deliberately into a panning sequence is slight intentional blur. More extreme uses of blurring are dealt with on pages 142–3, but the method used here is to select a shutter speed that is just fast enough to keep most of the subjects sharp – in this example, $\frac{1}{125}$ of a second with a 400mm lens. Remember from page 134 that it is the apparent movement in the frame that counts, and that the idea of panning is to keep the subject in more or less the same position. As a result the blur chiefly affects the background, which is conveniently streaked in the direction of movement. The aim of this technique is to help the sense of motion.

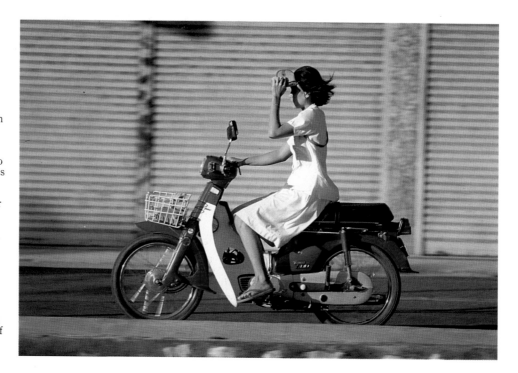

141

Blurring

The sharply frozen image will always remain the reference standard in photography, but there is still room for experiment. Unsharpness due to motion blur has a very different appearance from that caused by lack of focus and is to many people more acceptable. It is not so much soft as streaked and, if nothing else, it communicates movement.

On occasions, the benefits of strengthening the impression of movement may overcome the drawbacks of blurring details. If and when you decide to use motion blur deliberately, consider just how important is the information content of the picture, because this is what you will reduce.

There are guidelines for this, but personal taste enters so strongly that they are questionable. The very elimination of identifiable detail may make the image more intriguing, or it may reduce it to just a pattern of streaked tones and colours. There is nothing intrinsically wrong with going to this latter extreme, but if you do, you should realize that the abstract design must then be strong enough to carry the picture on its own, without the help of a recognizable subject.

Project: Fireworks

A few subjects only sensibly reveal themselves on film by means of motion blur. One is a firework display. Even to the human eye, it is the rapid movement of points of light that convey the impression of lines and patterns (just as the rapid sequence of still frames in a movie appears to be continuous action). A sharply frozen photograph would look like nothing more than bright points. Unless there is a lot of drifting smoke illuminated by the explosions, the shutter speed will have no significant effect on the brightness of the picture; it will simply determine the length of each streak. Use speeds of between ½ a second and a few seconds and, of course, a tripod. A wide-angled view simplifies the problem of framing the display. With a telephoto, as used here, loosen the tripod head slightly, following the rocket trail upwards, and when it reaches its highest point, quickly lock the head and open the shutter.

Project: Time and motion

Any subject that has distinct blocks of tone or colour, and an outline that is easy to recognize, can be degraded by blurring without losing its identity. As an example of this, I have taken a bullfight, which contains heavily stereotyped forms: black bull, matador, red cloak. A sharp, high-information-content version is included for reference.

For your own project find an equivalent

A typical firework burst, photographed with a 180mm lens at 1 second on ISO 64 film.

situation – equivalent, that is, in the recognizability of the images, and in the isolation of the subject. Some contrast with the background is often an advantage in the ultimate clarity of the image, and a bland, featureless background is at least predictable in contrast to the subject.

With the bullfight, the motion-stopping shutter speed is ½₅₀ of a second or ⅕₀₀ of a second. To introduce blur, speeds of ¼ of a second and 1 second were used. One advantage of working at these speeds is that the aperture can be very small, and so the depth of field great enough to cover any likely changes in focus during the exposure. The principal drawback with an SLR is that the viewfinder is blind during the exposure, making it quite difficult to follow movement. In these examples, the exposures were made at moments when it was expected that the action would take place in one spot.

The results, of course, are unpredictable, but that is part of the entertainment of using motion blur. As with many techniques that display strong visual signatures, its interest soon palls with repeated use.

Project: Free shooting

As part of any regular photography, such as in the street, try shooting a variety of moving subjects at long exposures. The cleanest streak trails will be when the subject is light against a dark background, but try the opposite as an experiment. Also try both panning with a long exposure to create more sharpness in the main subject than in the setting, and keeping the camera steady so that movement is blurred against a sharp background.

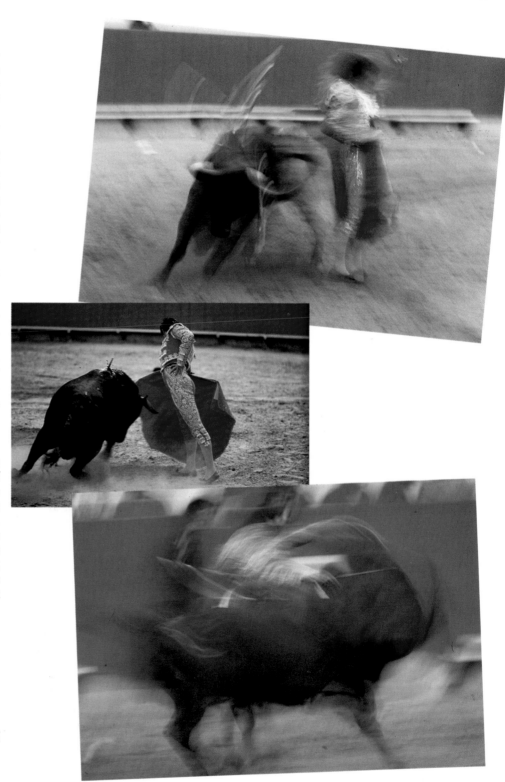

The motion-blurred shots here were photographed at ¼ of a second (*top*) and ½ second (*right*) with apertures respectively of *f* 22 and *f* 32. Conveniently, they were shot later in the afternoon, when the bull-ring was in shadow and the light levels too low for sharply frozen pictures with the *f* 5.6 telephoto lens. The comparison picture (*center right*) was photographed at ½₂₅ of a second at *f* 5.6.

Artificial Movement

We can extend the technique of lowering the shutter speed to introduce motion blur. As this type of streaking connotes movement, adding it to a static subject can be a useful, if specialized, technique for creating activity in a picture.

In artificial movement, what moves is the camera, or at least some parts of it. The easiest movements are panning from side to side, tilting up and down, rotating on a tripod head, and simply moving it irregularly by hand. In addition, the zoom control on a zoom lens will make radial streaks. More specialized methods are to operate the control on a shift lens during exposure, or to use any of the front or rear standard movements on a view camera.

All this makes a significant shift to the image, which is important given that the most manageable shutter speeds for this kind of picture are between about ¼ of a second and 2 or 3 seconds. These may be

long times from the point of view of exposure, but they are quite short for moving the camera physically. For this reason, shifting the entire camera without any angular movement has very little effect at normal shooting distances. For instance, racking up the center column of the tripod during an exposure would allow only several inches of travel in a couple of seconds. The only occasions on which this can have a significant effect are in close-up photography and, by extension, when duplicating.

In fact, for controlled experiment, copying an existing photograph has considerable advantages. The best mechanism for this is a rack-and-pinion mount of the type used as a base for extension bellows; these are available for photomacrography. The principal drawback is that extra image space is needed for the movement, so that the duplicate must be made at greater than 1:1 magnification. If the original photograph has

a black background, however, the copy can be made at almost any scale, even at a considerable reduction.

Moving the camera may bring into view unwanted parts of a scene, even at normal scales, and some masking may be needed. For example, in the shot *opposite* of the curved car tail light, the time exposure was made of a single light against an unlit background (the vehicle was lit by flash at the beginning of the exposure). The surroundings, therefore, were carefully blacked out, and the shot made at night.

The zoom technique is nearly always effective, however you perform it, but it is already very much a photographic cliché. If you ever feel the need for it more than twice during your entire life, you are probably over-using it. Note from the examples here that a slight pause at the short focal length end of the zoom scale helps to establish the identity of the object.

Random movements
Both of the original scenes here were lights against a night sky. The picture *right* was an oil refinery, the one *far right* the illuminated rigging of a sailing ship. In each case, the camera was deliberately shaken during a long exposure (of about 1 or 2 seconds).

▲Zoom blur
Various combinations of zoom movement and long exposure give different degrees of recognizability in this sequence of shots of a stationary car. Theoretically, it is possible to detect the trick, as the background and road are streaked to the same degree.

▶Rotation blur
A suggestion of movement is introduced into this rear shot of a car by streaking just one part of the image: the tail light. After an initial flash exposure to record details, the camera was rotated off-axis with the shutter open and the tail light illuminated. Dry-runs were made while adjusting the camera angle and the length of the rotating arm until the trace of the tail light made a suitable curve.

Aperture

The lens aperture diaphragm shares with the shutter the control of the amount of light reaching the film. Also in common with the shutter, there is a second major function; in the case of the aperture this is control of the depth of field.

In order to make camera operation relatively easy, there is a reciprocal relationship between shutter speed and aperture. Just as shutter speeds are graduated in steps that double or halve the time (and so the exposure), the main steps in the aperture control are separated by the same amount. Each stop down from the widest aperture halves the area of the circular opening. In practice, one stop down to a slower speed accompanied by one stop down to a smaller aperture makes no change to the exposure.

35mm

105mm 58mm

20mm

Different focal lengths
In appearance, the same aperture settings for different focal lengths is not the same. Here the setting is $f5.6$; it will give exactly the same exposure at the film plane through each of these lenses. However, as the longer focal lengths placed the lens further from the film, the aperture must be correspondingly longer to compensate for the light fall-off described on pages 110–11. Note that this view is from the front; the view through the rear of the lenses gives a different impression.

Aperture diaphragm
The mechanics of the aperture diaphragm have remained remarkably consistent, unlike different designs of shutter closure. A set of curved blades close and open in synchronization to give different sizes of an approximately circular aperture. Each main step doubles or halves the area of this opening, so doubling or halving the exposure. These steps are f-stops, and are calculated by dividing the focal length of the lens by the effective aperture (the effective aperture is slightly larger than the physical diameter of the diaphragm, because the front elements of most lenses converge, thereby reducing the size of the light beam that will actually fill the size of the aperture). The standard numbering sequence of f-stops proceeds in steps that halve the illumination, and is as follows: $f1$, $f1.4$, $f2$, $f2.8$, $f4$, $f5.6$, $f8$, $f11$, $f16$, $f22$, $f32$, and so on. In this sequence, the numbers are increased by the square root of 2.

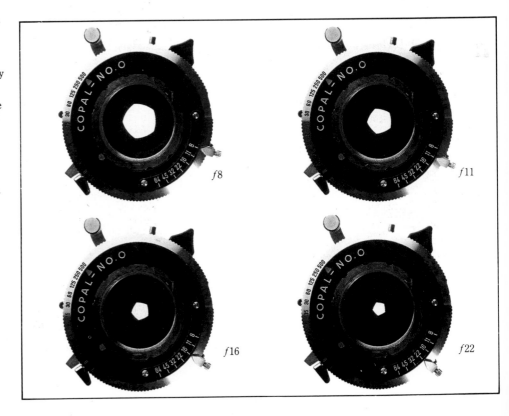

$f8$

$f11$

$f16$

$f22$

Depth of field scales
Depth of field can be calculated from tables (often supplied by the lens manufacturer), but in practice this is slow and tedious. The convenient and most usual method is to read the depth of field scale on the lens. Of the three different designs here, the one *below right* is the most common: an engraved scale which marks the near and far limits for each *f*-stop. In

the scale *bottom*, on a Hasselblad lens, two pointers are linked mechanically to the aperture control, again marking the near and far limits. The scale *below*, on a Sinar view camera, employs a different principle. View camera focusing is done by extending or contracting the bellows, as there is normally no focusing lens mount. The scale in this case is on a circular metal strip around the geared

knob that moves the rear standard. It is rotated to set it at zero when the bellows are racked to focus on the furthest point. The rear standard is moved to focus forward to the closest point in the scene. The scale then indicates the *f*-stop needed to ensure adequate depth of field, and the focus point is reached by turning the point until the mid *f*-stop mark is opposite the reference point.

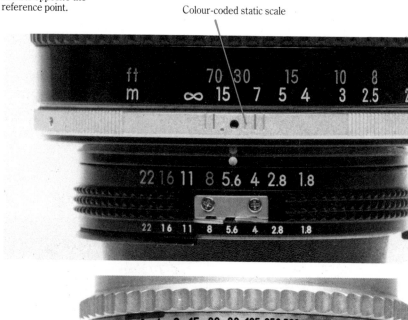

Colour-coded static scale

Reference point

Zero setting on rotating ring scale

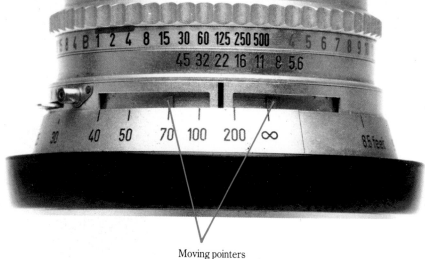

Moving pointers

Less depth

In a photograph, the image is critically sharp in one plane only. If in a portrait you focus on the eyes, then the nose will be slightly less sharp, as will the ears. Slightly less depth of field may well be sufficient, however; the limits in front of and behind the point of focus determine the depth of field.

Like sharpness itself, depth of field is not a quality that can be measured exactly and objectively. It depends ultimately on what you are prepared to tolerate as unsharpness. In an attempt to rationalize this, lens manufacturers use the term "circle of confusion". Even a sharp point can be resolved by a lens at best as a very tiny circle. Below a certain diameter, it looks like a point, and this is known as the permissible circle of confusion. Clearly, the larger you allow this to be, the greater the depth of field can be.

Depth of field, then, is the zone of acceptable sharpness that extends in front of and behind the point on which you focus. To make it shallower, you could widen the aperture, move closer to the subject, or use a longer focal length lens. Stopping down, moving further away or using a shorter focal length will increase the depth of field.

The depth of field that you will actually need depends on how you define your subject. A broad, deep scene, with a high information content usually justifies full depth of field. In contrast, the pair of pictures *opposite* show a situation that needs less rather than more.

The subject, the bird, is partly obscured by the surrounding grass. With a telephoto lens the potential depth of field is restricted, but even so, at $f16$ in the top picture, the image is a confused mess. With the aperture fully open to $f4$, the depth of field only just covers the visible parts of the bird, but this is enough. The shallow depth of field now makes nearer blades of grass almost invisible. The slight degradation of the image caused by the out-of-focus foreground grass is more than compensated for by the increased recognizability of the principal subject.

Depth of field
Even at this plane of focus, the image of a sharp point is a very small circle. Points in front of and behind the focus subject register on the film as larger fuzzy discs. When these appear sufficiently large, the image looks unsharp.

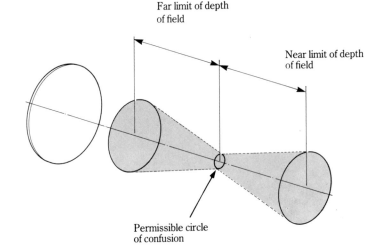

Far limit of depth of field

Near limit of depth of field

Permissible circle of confusion

In conditions similar to those of the bird pictures *opposite*, identification of the image depends on the sharpness being restricted to the head of the monitor lizard. Even in colour the broken hues create a blending effect that does little on its own to separate the greys of the animal from the dull greens of its surroundings.

Shallow depth advantage
These two pictures were taken within seconds of each other with the same 600mm lens and from the same camera position. In the upper picture, the ƒ16 aperture details more than is wanted, but the ƒ4 aperture used in the lower picture opens up the view by throwing the foreground so far out of focus that it behaves more in the way of a mild diffusing lens than as an obstruction.

The closer the working distance between the camera and subject, the less the depth of field. Close-up photography, therefore, is often characterized by images like these, in which there is a strong visual separation between a subject and its background; a useful quality in this instance, as it helps to define the orchid against what would otherwise be a distracting setting of vegetation. Notice how the depth of field at the same shallow aperture (ƒ5.6 on a 200mm lens) is less when the camera is moved closer; the definition of the pale diagonal blade of grass behind is much weaker.

More depth

On the whole, you are more likely to need good depth of field than shallow focus. Perhaps I should rephrase that: the need is for overall picture sharpness, and in most circumstances depth of field is the way of achieving it. If you are using a view camera, with the tilt or swing movements described on pages 48–51, this is a more efficient means of redistributing the sharpness. With a regular, fixed-bodied camera, the aperture is your only control. The absolute limit is set by the minimum aperture of the lens, which in the case of fast lenses is often not particularly small. However, this smallest aperture may create new problems due to diffraction (see pages 114–17) and there may be occasions when it is difficult to decide between the unsharpness resulting from the depth of field limit and a different kind of unsharpness due to diffraction.

The price of good depth of field is a slower shutter speed. In principle, a tripod solves this problem, but movement in the scene (people, cars, the wind moving branches) can set a practical limit. Also, if the light levels are poor, stopping down may require such long exposures – in the seconds – that the film begins to suffer from reciprocity failure (loss of sensitivity and colour shift).

For all these reasons, the depth of field that is possible may not be enough, or it may have to be distributed very carefully. Now, as we have seen on pages 146–7, the limits of the depth of field are neither distinct nor objective, so there is some latitude depending on how much softness you are prepared to tolerate.

Project: Depth of field

For this, find a location with similar characteristics to the rooftop example here; an elevated camera position which gives you a shallow view down onto a row of objects stretching from near to far. Alternatively, a long line of anything – trees, houses or fencing, for example – which can be photographed from a shallow angle at ground level. If possible, use two focal lengths of telephoto lens. Long focal length lenses allow only a limited depth of field, and so are ideal for demonstrating the effects. Use a tripod for best results.

First, focus successively on the farthest and nearest points in the scene and get a feel for the amount of travel in the focusing ring. If you work often enough with certain lenses, you will begin to be able to judge intuitively whether or not the maximum possible depth of field will cover the scene. Now, despite what is said about depth of field scales on page 147, they are not a great deal of use on a telephoto lens, particularly a long one. A look at the size of the scale on, say, a 300mm lens should convince you that it is useless for making measurements. Instead, use the viewfinder. Locate a point in the scene that appears to be about a third of the depth from the foreground. Check this by moving the camera's focusing ring quickly from near to far; the point you have selected should feel to be at the mid-point of travel on the focusing ring.

Make a series of exposures, at four different focus points: the nearest part of the view, about a third of the way into the scene, about half way in, and at the farthest point. Do this for at least two aperture settings; then change to any focal length of lens and repeat the exercise, making a note of the points you focused on. Examine the results under a loupe.

In an image, sharpness falls away from the point of focus towards and away from the camera. In this example, this loss of sharpness is from lower left to upper right because of the camera angle.

Focus here

Focus here

Both 400mm f 8

Near focus

Far limit of depth of field

Focus here

Near limit of depth of
field is out of frame, and
wasted

Far focus
Far limit of depth of field
is out of frame, and
wasted

Focus here

Near limit of depth of
field

Focus one third in

Shot at a single aperture,
f 9, with a 105mm lens,
this sequence of
photographs shows the
importance of where to
focus. If the depth of field
extends out of the frame,
as it does when the focus
is near or far, it is
wasted. Sharpness is lost
elsewhere for no benefit.
If you want the maximum
depth of field, the
optimum focus is
approximately one third
of the way into the scene.
Depth of field scales on
telephoto lenses are
inadequate for making
this kind of
measurement; the only
practical method is by
judgement through the
viewfinder.

Focus here

Depth of field covers
entire view at *f* 9

Exposure Basics

The subject of exposure measurement can be made into a thorough and complex topic, but here we will deal with it in the simplest and most direct manner possible.

The most convenient way of taking readings is the one immediately to hand, even if it is not theoretically the most accurate. As most photographers use an SLR with TTL metering, that is the method to become proficient in. Using the center-weighted metering system in most SLRs, the following techniques are available:

● Direct reading, no compensation. This is ideal for average lighting conditions and when you want an averagely exposed result.

● Direct reading with compensation. With experience, this can work remarkably well. The principle is to take the reading, then judge how much darker or lighter than average you want the result. This technique is used in the examples shown here.

● Aiming off, to exclude unwanted areas from the metering area.

● Substitute readings. Aim the camera at a different view which, in your judgement, is the same brightness as the part of the picture you want to measure. This is useful when the subject is too small for the camera's TTL metering area.

● High/low readings. Aim off to read the bright part of a scene and then the dark part. Average the two readings.

● Spot readings. Fit a telephoto lens and use the camera like a spot meter. Good for reading small areas.

Apart from these methods, which in most conditions are sufficient if not always ideal, incident readings and spot readings can be taken (see pages 29–32 for light meters). Incident readings are extremely useful if you have the time: they measure the light, not how it is reflected from a subject.

We will concentrate, however, on what you can do with the basic center-weighted TTL reading in the camera. First, you should familiarize yourself with exactly what area in the frame your camera is measuring. It varies from make to make (see pages 13–14). The camera's instruction booklet should tell you, but the information packages of even some of the top models omit the details, and you will need to check it.

Remember that the TTL reading you get is the one that will reproduce the metered area as an *averaged* tone. Look at the area and decide if that is how you want it to appear. You will obviously not want white snow or a black fur coat to appear grey, and will need to compensate according to your judgement in a number of situations.

As a rule of thumb, the contrast range that negative film can record satisfactorily is about 7 stops, but for transparency film it is only about 5 stops. If the brightness range of the scene exceeds this, something has to go. With transparency film, try always to hold the highlights; washed-out bright areas usually look worse than underexposed shadow areas.

If in doubt, use more film. Professional photographers, who must do all they can to guarantee the shot, frequently bracket exposures, shooting darker and lighter frames as well as the exposure that they judge to be the best.

For simplicity, the basic metering situations have been subdivided into nine, and examples of each are discussed.

Project: Metering

Locate your own examples of each of these nine different metering situations, and use the recommendations here for calculating the exposure. Then, in order to have a basis for comparison and a means of assessing your accuracy, make exposures above and below the prime exposure. In other words, bracket each shot, ·½ a stop over and ½ a stop under. It is essential that you keep a written record of your exposure measurements for this project.

Metering familiarization
Choose a scene which, through the viewfinder, is divided sharply between two contrasting tones. Move the camera around, taking readings, until you find the edges of the metering area. In this example, also featured on the following pages, the central 12mm circle engraved on the focusing screen of a Nikon conveniently marks the area from which 80 per cent of the measurement is taken. Other averaging TTL systems may not be so precisely marked, but the purpose of this exercise is to familiarize yourself with the metering bias. Once you know this well, you can aim off to take readings from parts of the scene, or take substitute readings of a completely different view.

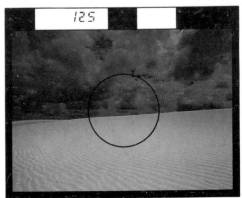

Lighting situations
In a simplified form, most scenes in front of the camera fit one of these stylized conditions. High contrast conditions are the main source of exposure difficulties. Each of these situations is dealt with in detail on the following pages.

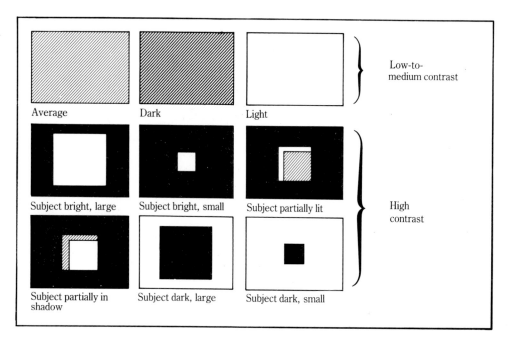

Low contrast, average subject
This is about as close as you can expect to come to an even tone in normal shooting conditions. The contrast is low to the point of drabness. There are no particularly bright or dark areas to worry about, and no reasons to want any other than an average reproduction. An average TTL reading is ideal. Incident and spot readings would be the same.

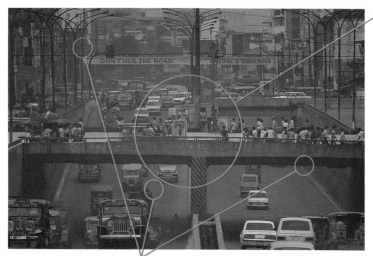

Even at a glance, it is obvious that the central metering area is completely typical of the entire scene. Reproduced as an average exposure, it will look like this, and the only possible variation is whether to suggest a bright cloudy day (add ½ a stop) or an approaching storm (reduce ½ a stop). Typically, average scenes like this offer the least latitude in exposure.

A random selection of spot readings shows consistency to within ⅓ of a stop. There is no reason for taking any measurement other than the camera's average TTL reading.

Low-to-medium contrast, dark subject

Apart from the skyline, the contrast in this scene is also below average, and the center-weighted area will give a typical reading. However, this is a pre-dawn scene, and there is good reason for wanting it to look dark, as a night view should. Hence, the indicated reading should be reduced by 1 or 2 stops. The same compensation would apply to, say, a black automobile, or a close portrait of very dark skin.

The moderately bright sky just above the horizon is the only anomaly in this otherwise low contrast scene.

The key spot reading in this scene is coincident with the camera's metering circle.

The camera's TTL reading is accurate for the entire scene, as long as the metering circle does not include the sky.

Low contrast, bright subject

Again, contrast is low, but an average TTL reading, if followed, would make this headstone appear grey rather than white. Compensate by increasing the exposure by about 1½ to 2 stops. More exposure than this will cause the texture of the stone to disappear.

Within the area of this inscribed headstone, any reading will give the same result. The three circles represent different aiming points for the camera's TTL metering circle.

High contrast, subject bright and dominant

The first step is to identify the subject – that is, from the point of view of exposure. Exclude the deeply shadowed frame and sky from the reading by aiming off so as to meter only the pale buildings. The indicated reading would give a fairly dense exposure. For a more average, if slightly less richly coloured version, compensate by increasing the exposure by ½ to 1 stop.

As a dense black shadow, this area of the picture plays no part in the exposure calculations, and does not need to be measured.

The dark blue sky should not influence the exposure measurement.

This brightest face of the building is the key tone. Any exposure calculation must hold this tone as a just-readable white. Too much exposure would give it a washed-out appearance.

Although a straightforward TTL reading would be overly influenced by the sky and shadow, aiming the camera slightly off will give a usable reading of the essential parts of the scene. This will still need compensation to avoid underexposure.

High contrast, subject bright and small

A reading of the darker part of the gold bank sign would be accurate, but only possible to make with a spot meter, a spot reading alternative in the camera's TTL system (available on a few models), or by changing to a long telephoto. Failing any of these, make a substitute reading of some other surface that seems to be of average reflectance and is in the same sunlight, and then bracket.

The key tone naturally is within the small area of the subject. A spot meter reading would be ideal; allowance would then be made to avoid underexposure

The area occupied by the subject is too small for the metering circle, even if the camera is aimed off in order to make the reading.

High contrast, subject partially lit

Any direct TTL reading here, center-weighted or spot, has no value. Take a substitute reading of another sunlit area and bracket. In this actual example, many other photographs had been taken in full sunlight before, when the basic setting was familiar – $\frac{1}{250}$ of a second at $f5.6$ with ISO 64 film. As the highlights are more important for outlining the shapes of the figures than for showing their own detail, the exposure given was deliberately 1 stop over – $\frac{1}{125}$ of a second at $f5.6$.

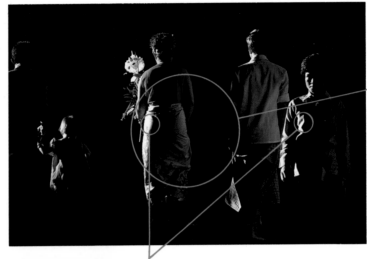

The metering circle in this case is useless.

The key tones are these rim-lit highlights outlining the figures. Not only are they too small even for a spot meter reading, however, but the movement leaves insufficient time. A substitute or incident reading would be the only reasonable alternative.

High contrast, subject partly in shadow

Here the bright areas have priority, but the shadow areas also need to be held. Spot readings of the brightest and darkest parts would be ideal, but if only the TTL measurement is available, you could take a direct center-weighted reading and reduce the indicated exposure by about 1½ stops, bracketing for safety.

The brightest part of the scene needs to be held. Too much exposure would wash it out.

A snap judgement from the TTL reading would be to reduce the indicated exposure by about 1½ stops.

Ideally, this large shadow area should be sufficiently well exposed to show some detail – about 1 or 1½ stops above the threshold of dense shadow.

High contrast, subject dark and dominant
This high contrast scene actually allows considerable latitude for interpretation. Nevertheless, the objective ideal would be an exposure that leaves some tone in the foggy sky, and shows the barest hint of detail in the silhouetted bell. One method is to aim the camera so that the metering area takes in the light sky and dark bell in equal proportions. This is essentially a quick method of approximating a high/low reading. Again, where there is uncertainty, bracket.

The contrast range between these two extremes is 6 stops.

Given that the metering circle covers both dark and light areas about equally, a straightforward TTL reading would, in this case, probably be accurate (but bracketing would be advisable). On the whole, an incident reading would be safer.

High contrast, subject dark and small
There is no point attempting any kind of reading of the boat, or of a substitute dark area. The most easily available reading is of the bright sunlit water. Take this reading and compensate by adding about 2 or 2½ stops. Less exposure will give you more texture and colour to the water but may absorb some of the outline of the boat. More exposure will tend to introduce flare and a greyness to the boat's silhouette.

The contrast range between subject and background is 8 stops.

The easiest practical method here is to read the background and then open up the aperture by 2 to 2½ stops so that it is just held below the point of being washed out.

Hand-held Shooting

Most photographs are taken using hand-held cameras. The photography looked at here is, more specifically, the kind where you work out of a shoulder bag, prepared for immediate shooting, without any form of preparation or setting up of the shot. Street photography falls under this heading.

Selecting the camera bag, and what goes in it, is extremely important and worth some thought. Ideally, it should have everything you need for a trip of, say, a few hours, but at the same time be light enough and comfortable enough to be carried easily. There are two examples on the following pages, but your own selection may well be very different, and adapted to suit your needs.

Facility with your equipment simply increases the number of picture opportunities that you can make use of. How quickly you can react to a scene that may last only for a few seconds is one important factor. Another is the slowest shutter speed that you can reliably shoot with on each lens. You can improve both with practice.

Project: Improving your slowest shutter speed

In part, this exercise has cropped up before on page 97 for telephoto lenses. The purpose of that project was to discover the slowest safe shutter speed at which you could use a particular focal length (not counting subject movement). This will vary according to the focal length, and the first step is to know what that speed is for each of your lenses.

The purpose of this project is twofold: first, to lower that slowest safe speed, and second, to learn how to shoot below it with some confidence of success. Most recommendations on the slowest speed to use are over-cautious. Experience and careful holding will allow you to shoot at slower speeds than you imagine would be possible. Make a regular practice of pushing your own limit by means of standing in a stable position, holding your arms in to your body, and breathing steadily. At the lower limit, whatever it is, you should find when holding the camera to your eye that even though the image shakes, there are brief moments when it is steady enough to shoot. Taking a few exposures will improve the odds of one being sharp.

The importance of making this improvement should be obvious: it broadens the conditions under which you can shoot. As a guide, the following is what I consider to be safe hand-held speeds:

Lens weight	Guaranteed sharp	Guaranteed one in a few shots	Possible with several shots
400mm	$\frac{1}{250}$	$\frac{1}{125}$	$\frac{1}{60}$
180mm	$\frac{1}{125}$	$\frac{1}{60}$	$\frac{1}{30}$
55mm	$\frac{1}{60}$	$\frac{1}{30}$	$\frac{1}{15}$
20mm	$\frac{1}{30}$	$\frac{1}{15}$	$\frac{1}{8}$

Slow-speed shooting
Once you are familiar with the slowest shutter speed at which you can reliably shoot for a particular lens, you can work at the bottom limit by taking several exposures. As in these two pictures, some frames will show camera shake (*far right*), but others will be sharp (*right*). With experience, you can usually tell at the moment of shooting whether or not the camera has been steady enough. Learn to watch the apparent movement in the viewfinder. Holding the camera up to your eye for a length of time, particularly with a long lens, will worsen the amount of shake; when this happens, lower the camera, rest for a few seconds, take a deep breath, and start again.

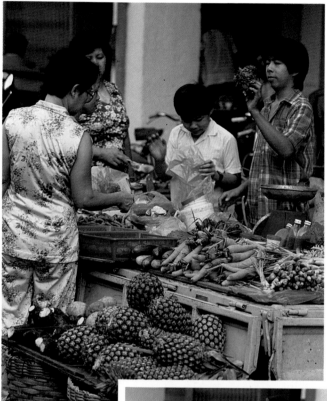

Project: Two-format shooting
The natural format for most photographers is, not surprisingly, horizontal, since 35mm cameras are designed to be held that way. In types of shooting that require quick reactions, such as street photography, it is much easier to shoot like this. Nevertheless, it is not really the best reason for determining the format of a picture, and there is a danger of missing a good vertical shot for the sake of convenience. Make it a practice to look for vertical compositions of pictures which you would normally shoot only horizontally.

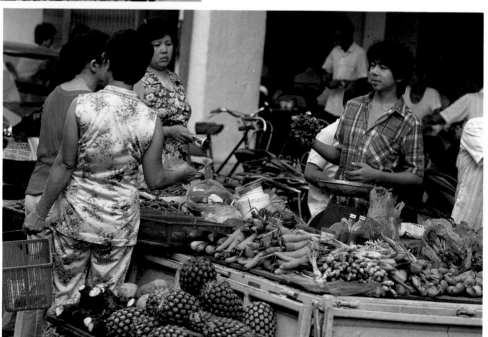

Horizontal/vertical
Particularly in street photography, when shots often have to be taken quickly, the natural reaction is to use a horizontal format. Most scenes, however, can be composed either horizontally or vertically to a satisfactory standard. Make a practice of shooting both. Here the horizontal picture is rather better organized, but the vertical is adequate.

Camera bags for street photography

If you practice hand-held photography regularly, you will work out, over time, your ideal set of equipment and ways of carrying it. Most photographers have idiosyncrasies in this area, and the contents of camera bags are rarely similar. Here are two, not necessarily typical, but not unusual either. The bag *below*, made to the photographer's own specifications, is designed to carry two 35mm SLR cameras and about half a dozen lenses, including a long telephoto. In use, one of the cameras is normally carried outside the bag. As equipment goes, this is probably on the side of being comprehensive. Everything shown here weighs 20 lbs (9 kg). The camera bag *opposite* is at the minimum end of the scale of equipment, and is arranged to be easy to carry. Here, there is only one camera (and so only one type of film available for immediate use) and two lenses, one of which is a zoom to take the place of three regular focal lengths. Used by a woman photographer, the bag is actually a leather handbag, chosen in preference to a custom-made camera bag precisely because it does not advertise the cameras, making it very effective for street photography. For the same reason, the bulkier bag *below* is designed as discreetly as possible; camera bags that really look like camera bags are no advantage in candid photography, either professional or amateur.

Street map

Notebook and pen. The main reason why professional photographers keep notes is not to record camera and lens settings, but for caption information. If a picture is to be sold to a publisher, accurate information is an essential requirement

105mm f 1.8 fast short telephoto: a portrait and low-light lens

Hand-held light meter, used principally for its incident-reading capability. A valuable exposure check in difficult metering situations.

Neutral graduated filter, mainly for use with the wide-angle lenses to darken skies

Mesh cloth has several uses, including padding the interior of the bag, as a cushion for resting camera on available supports, and for general cleaning and wiping.

Cokin 52mm filter holder

Swiss army knife has enough tools and attachments for some emergency repairs

Small, robust flashlight

Marker for numbering film cassettes

Spare meter batteries for cameras

Principal camera, with motor-drive and medium telephoto (180mm f 2.8), loaded with regular daylight film – in this case professional Kodachrome

Film pocket. Here, six cassettes of professional Kodachrome 64, one of medium-high speed ISO 200 film, one of high-speed P800/1600 (designed to be rated at any of four different speeds by the photographer, and push-processed)

24mm f 2 wide-angle lens in zipped leather pouch. An alternative to divided compartments in a camera bag is to protect each lens individually. Although sometimes a little slower for access, this allows lenses to be dropped into the bag without being careful that they are in a certain place

Two essential filters in the most common 52mm screw-mount size: a magenta correction filter for average fluorescent lighting, and an 80B blue correction filter for tungsten light. Both for use with daylight film

Second camera, fitted with 35mm f 1.4 lens and loaded with high-speed film

55mm f 3.5 macro lens does double duty as standard focal length and for close-ups

400mm f 5.6 telephoto, the longest lens here, fits easily into a separate lengthwise zippered pocket. When not in constant use, it is wrapped in cloth bag

Camera bag support
Provided that you can find a high enough surface, a soft camera bag allows very slow shutter speeds, and is particularly useful with a telephoto lens. Move the contents around to shape the bag as a bed for the lens, and press the camera down onto it for extra stability. By shaping the bag even more carefully, it is possible to position the camera so that the view is properly framed without having to hold it yourself; add a cable release and use shutter speeds of a second or more that would normally require a tripod.

Rest the weight of the lens here

An internally-focusing lens is best; changes in focus do not push the lens barrel forward

Push the front of the lens beyond the bag so that no straps or folds obscure the view

Notebook for captions

Spare meter batteries for camera

Small, basic SLR fitted with 35–70mm zoom and autowinder

Second lens is 105mm f 1.8 portrait telephoto

Polarizing filter

Marker pen doubles for notes and numbering film cassettes. Cans are unboxed to save space and time, and marked to identify film type. Pocket contains three cassettes of professional Kodachrome 64, enough for limited shooting

Neutral graduated filter for occasional use, held by hand in front of lens

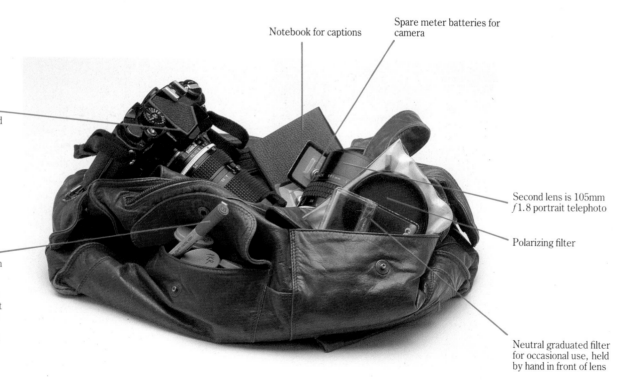

Tripods

However proficient you become at hand-held shooting, a solid, locked camera support is still the most secure method. It is essential for certain conditions: low light levels and small-aperture shooting that call for shutter speeds below the safest hand-held speed, with large format cameras and with macro set-ups that require exact positioning. In addition, it is an advantage when you want precision in the composition or in the placement of subjects. For instance, a loosely locked tripod head in portrait photography makes it possible to shoot without having to spend the whole time looking through the viewfinder. This will let you talk to the subject, often necessary to help create the right atmosphere.

The normal support is the tripod, which can be used in most situations. There is a surprisingly big difference in stability between a tripod used well and one set up inefficiently. A few principles are worth remembering:

• Low is more stable than high.
• Make sure that the floor or ground surface itself is stable. Sand shifts, as do loose floorboards.
• Adjust the legs so that the platform (the immediate base for the tripod head) is level. Do not rely on levelling by means of the tripod head only.
• If you can, place the center of the erected tripod under the center of gravity of the camera and lens. If this is not possible, place one leg so that its line is under the center of gravity (normally forward).
• Shelter the tripod from wind.

You can test the stability of your support by gently tapping the end of the lens. Look for visible movement of the equipment, and repeat this when looking through the viewfinder. It is possible to add stability by lowering the center of gravity and increasing the base area. The two easiest methods of lowering the center of gravity are to lower the height (by shortening the legs or by spreading them at a greater angle) and to suspend a weight from the center (a camera bag works well, but beware of it swinging).

Maintain the tripod in good condition. Prime weaknesses to watch for are loosening of the joints at the top of the legs (this increases the risk of torque, or twisting) and corrosion and dirt inside the leg telescope adjustment. Regularly tighten the joint nut or screws, and occasionally take apart and clean the leg sections. For loosening a stiff joint, use WD-40 or similar anticorrosive penetrating spray lubricant.

Maximum stability
To make the best use of a tripod, follow this sequence. Remember that the thickest sections of the legs are the strongest, and that the adjustable center column, if there is one, reduces the stability considerably. It raises the camera above the stable point where the legs meet, so only use it after you have reached the maximum height with the legs alone. If any leg needs to be shorter than its maximum extension, close the thinner sections first.

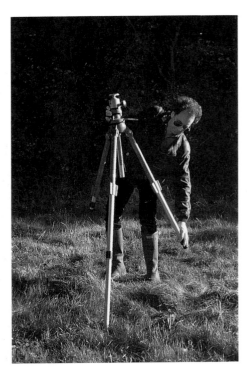

◄First extend the leg that will point downhill on a slope. If you want full height extend this leg fully. Holding the tripod approximately straight, extend the other two legs in turn. With each, extend the thickest section fully before the next. Tighten each collar firmly.

►Make fine adjustments to the thinnest section of the uphill legs only to level the tripod platform (not the head at this stage). Use a spirit level if possible (some tripods incorporate one), or judge the levelling by eye.

Long, heavy lenses always need good tripod management, which professional photographers take seriously, particularly at major news events which leave no room for mistakes. Here, a platform on top of a heavy-duty tripod allows this photographer to align three telephoto lenses for shooting at different focal lengths and with different film speeds.

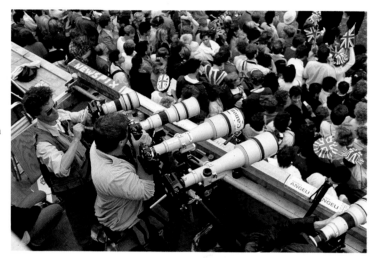

▶If you need still more height, raise the center column and lock. An angled center column is particularly unstable, making a levelled platform critical.

▶Finally, fit the camera and adjust its position on the tripod head. Now you have a fully extended tripod in its most stable configuration. The exception to this set-up is with a long heavy lens that places its center of gravity out from the center of the tripod; in such a case, place one leg so that it points along the lens axis.

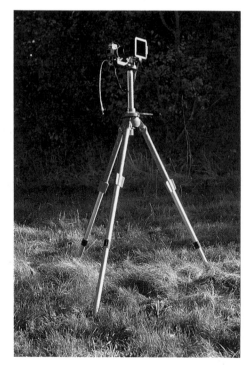

In awkward camera positions, it is often better not to place all three tripod feet on the floor. By shortening one leg, you may be able to put it on a raised surface, such as a shelf, step or window-ledge. For this kind of shot, it helps if the legs can be splayed at angles wider than normal. Some makes of tripod have adjustable stops for this purpose; others, like the ones shown here, have a fully adjustable leg-locking bar. If you have another person to help, first loosen all the movements on the tripod for maximum free play, hold the camera firmly in the position you want, and then place and lock the legs.

To hold a heavy camera in a potentially unstable position like this, a fully adjustable tripod is essential. This model features continuously adjustable leg angles by means of leg locking bars. Stability can be increased by adding clamps to the legs (this is a valuable technique for use with any make of tripod).

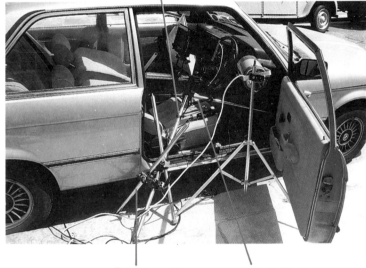

Collars lock at any position by tightening screw

Extra clamped leg increases support area of base

Leg locking bars

Raised surfaces have the big advantage of needing only a short tripod extension. With a heavy lens like this 600mm, this short tripod can be conveniently left attached and folded back when not in use by loosening the tripod head. Used like this, the camera and lens are carried on the back seat of the car and can be set up for shooting very quickly – in less than half a minute.

Heavy equipment, and long lenses in particular, benefit from the extra point of support of a second tripod. Without this, there is a danger of rocking along the axis of the lens, even if the support point is under the center of gravity.

Center of gravity here

Loosen center column locking collar and tripod head, screw head to camera body and gently allow tripod to fall into place. Then lock

First position and lock lens on this tripod head

Secondary, stabilizing tripod

Heavier principal tripod for main support

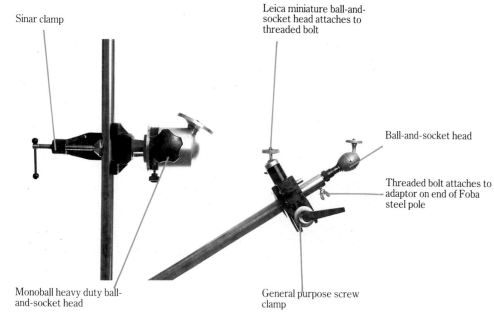

Sinar clamp

Leica miniature ball-and-socket head attaches to threaded bolt

Alternatives to tripods are various clamps and screw-fitting systems. The advantages are the small space they occupy when positioned, portability, and ability to make use of existing structures. In the studio these structures can be lighting supports and pole-and-clamp systems. On location, railings, balustrades and furniture are among countless possibilities.

Ball-and-socket head

Threaded bolt attaches to adaptor on end of Foba steel pole

Monoball heavy duty ball-and-socket head

General purpose screw clamp

Motor-drives and Triggers

Motor-drives are no longer considered a luxury; nor are they specialized for just a few high-speed applications. The prime advantage of a motor-drive (and of the simpler power winder) is that it frees the photographer's attention and hands from preparing the shutter and film for the next shot. In practice, there are relatively few occasions that justify continuous motor-drive shooting at full speed. If you have a motor-drive or power winder, your chief priority should be to become more efficient at using it in bursts under normal shooting conditions.

Continuous/single-shot mode

A true motor-drive, as opposed to a power winder, has a choice of triggering modes. In one, the motor-drive fires the shot as soon as the camera is ready for the next exposure, in a continuous series. In the other, the motor-drive's release must be pressed each time for a new exposure. The difference is shown in the diagram *right*. In continuous triggering, the rate of fire is faster than you could manage in a single-shot mode, but the moment of triggering is predetermined. Now, in many action sequences the timing of the best moment is at a much smaller fraction of a second than the ¼ to ⅙ second cycles that are typically available. Consequently, single-frame firing is more accurate for certain moments.

▼ The diagram *below* shows the frame-by-frame timing of the sequence *opposite*. Note that this happens in bursts as the photographer thinks that a good moment comes up. To do this, the technique used is a very common one among professionals; the motor-drive, with a capability of above five frames per second (top speed usually depends on freshness of batteries), is set on "continuous" rather than "single-shot", but is mainly triggered one frame at a time by light pressure on the release. This method preserves both options: the maximum number of frames in short bursts, and the precise timing that is only possible with shots triggered individually.

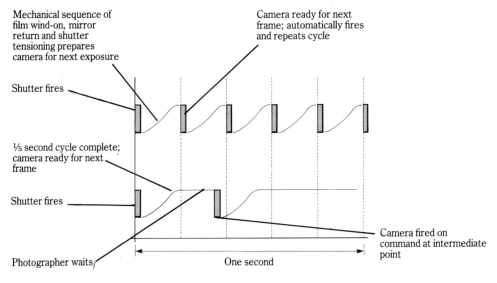

Mechanical sequence of film wind-on, mirror return and shutter tensioning prepares camera for next exposure

Shutter fires

Camera ready for next frame; automatically fires and repeats cycle

⅕ second cycle complete; camera ready for next frame

Shutter fires

Photographer waits

One second

Camera fired on command at intermediate point

The reconstructed frame sequence for these photographs shows that most of the shooting occurs in two bursts, at the maximum continuous-mode rate.

This typical use of a motor-drive for a sequence of shots illustrates some of the practical influences. The essential purpose is rapid shooting; a means of taking the maximum number of pictures in a limited amount of time. The conditions for this sequence were a major news event (a Royal Wedding at Westminster Abbey, London) where, typically, there were fixed camera positions allocated to photographers. Under these conditions, there was a restricted "window" for shooting, not only in terms of the camera angle but in time. Each arrival at the Abbey would be in a worthwhile shooting position for only a few seconds. A motor-drive maximized the shooting opportunities.

Within the time frame there is usually considerable unpredictability. The best moments for shooting are determined in this kind of situation by expression and stance. These happen in an instant. A professional celebrity like Nancy Reagan can usually be relied upon to play to the media, as she does.

Here, nine pictures were the most that could be taken in the time available. One important decision is when to change to a new roll of film. It is never possible to predict exactly how many frames you will need for the next sequence of shots, but within several frames of the end of a roll you should begin to think seriously of rewinding and loading a fresh film. Essentially, this is a decision that balances the importance of not missing a shot against the extravagance of wasting film.

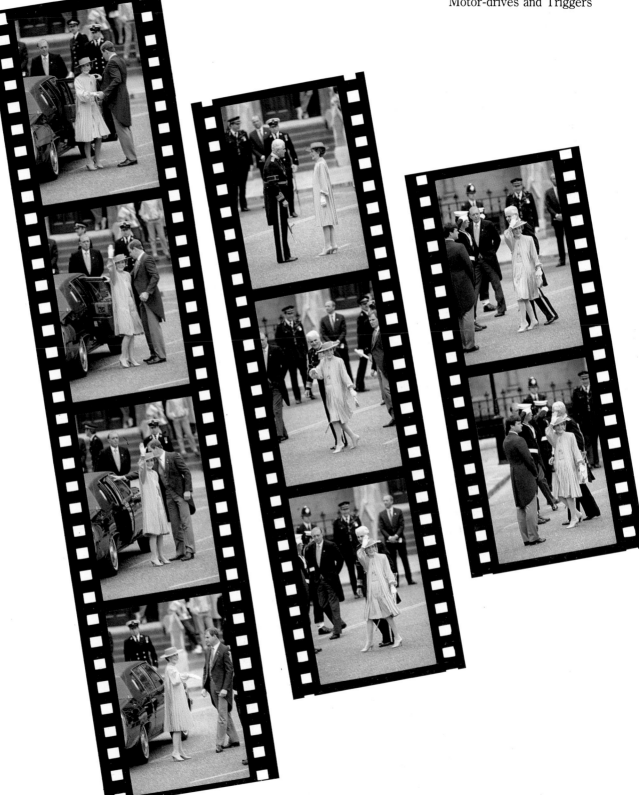

The ancillary advantage of motor-drives and power winders is that the triggering of the shutter and film wind is electrical. As a result, all that is needed to fire the camera is the closure of a contact, and there are very many ways of doing this. Here, a simple extension lead plugged into the motor-drive's remote outlet is the basis for a variety of triggering methods. Additional leads can be attached to the contacts, and these can be connected by means of a simple throw-switch, radio control, pressure switch, or such exotic techniques as the mercury switch shown *opposite*.

The non-electrical alternative is a cable release. It has limited possibilities for remote operation: an air-bulb release, or a servo motor that mechanically presses the plunger. (This would have to be custom-built – not impossible, but awkward, and without film rewind and retensioning of the shutter. Moving the rewind lever would require a more complex action and more power).

▶ **DIY remote triggering**
The idea of this example is to demonstrate the flexibility of triggering systems. There is virtually no limit to contact-making devices. The one used here, for a trip-switch in wildlife photography, is a mercury switch. These are available quite cheaply at electrical hobby outlets. The starting point is an extension lead connected to the camera's motor-drive remote outlet, exactly as shown *left*.

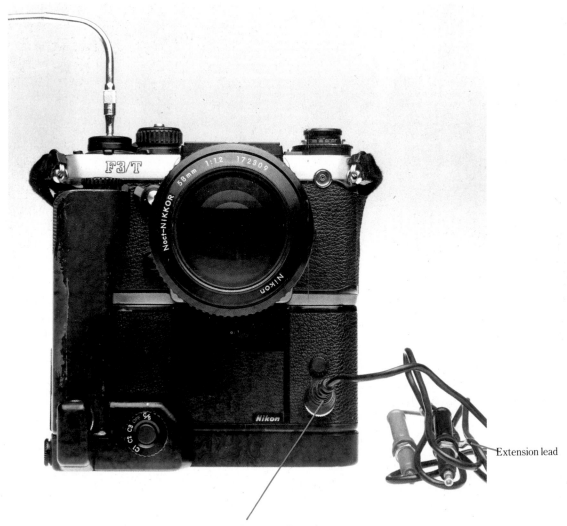

Extension lead

Remote outlet socket

1 The contacts at the ends of the remote leads are attached to a second set of leads fitted with miniature grips.

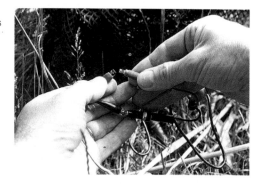

2 The miniature grips at the other ends are clamped to the contacts on the mercury switch. This consists of a small sealed glass bottle containing mercury and two interior contacts. When the bottle is tipped, the mercury flows and connects both contacts.

3 A rubber band secures the grips to the mercury switch, preventing accidental separation.

4 All of this is placed in a plastic bag to protect it from moisture which would short the circuit. The bag is sealed with rubber bands.

5 The remaining exposed connections are sealed with insulating tape.

6 The switch is camouflaged with a patch of camouflage fabric.

7 A twig is placed on the ground to form a tie-off for the trip thread, and the switch is secured to the twig so that if the twig is bent, the mercury will close the contacts and fire the camera.

8 Finally, a strong thin thread is tied to the twig, pulled across the trail that the animal is expected to take, and secured firmly to a stone or bush on the opposite side.

Magnification

Macro and close-up photography (see pages 102–3) are performed at extremely short distances, so there are a few special technical aspects to consider. Regular camera systems are designed for use at normal distances – generally between about 3 feet (1m) and infinity – so that apart from some special equipment, macro and close-up work needs some special optical precautions. The principal ones are:

● Exposure. Magnification involves light loss, so that either the film needs more exposure, or the illumination must be stronger, or both.

● Depth of field. This diminishes as the magnification is increased. The traditional answer of stopping down the aperture does not work very well at these scales, because diffraction increases strongly.

● Optical quality. Regular lenses are optimized for normal distances. Either special macro lenses are needed for best image quality, or a regular lens should be reversed. Diffraction is an additional problem.

Supplementary close-up lenses

Optically, these do not give quite the same quality as a prime lens used at an extension, but for modest magnifications they are quick and convenient to use. Also, no allowance needs to be made for exposure. The magnification varies with the point of focus of the prime lens.

Lens focal length	Lens-to-film distance (mm)																	
	50	60	70	80	90	100	110	120	130	140	150	160	170	180	190	200	210	220
35mm	1⅓	1½	2	2⅓	2⅔	3	3⅓	3½	3⅔	4	4⅓	4½	4⅔	4⅔	5	5	5⅓	5⅓
50mm	—	½	1	1⅓	1⅔	2	2	2½	2⅔	3	3⅓	3⅓	3½	3⅔	4	4	4	4⅓
55mm	—	⅓	⅔	1	1⅓	1⅔	2	2⅓	2½	2⅔	3	3	3⅓	3½	3⅔	3⅔	4	4
60mm	—	—	½	⅔	1⅓	1½	1⅔	2	2⅓	2½	2⅔	3	3	3⅓	3⅓	3½	3⅔	4
80mm	—	—	—	—	⅓	½	⅔	1⅓	1½	1⅔	1⅔	2	2⅓	2⅓	2½	2⅔	3	3
90mm	—	—	—	—	—	⅓	⅓	⅔	1⅓	1⅓	1½	1⅔	1⅔	2	2	2⅓	2½	2½
105mm	—	—	—	—	—	—	—	⅓	½	⅔	1	1⅓	1⅓	1½	1⅔	2	2	2
120mm	—	—	—	—	—	—	—	—	⅓	⅓	½	⅔	1	1⅓	1⅓	1½	1½	1⅔
135mm	—	—	—	—	—	—	—	—	—	—	⅓	⅓	½	⅔	1	1	1⅓	1⅓
150mm	—	—	—	—	—	—	—	—	—	—	—	—	⅓	½	½	⅔	⅔	1
180mm	—	—	—	—	—	—	—	—	—	—	—	—	—	—	—	⅓	⅓	½
200mm	—	—	—	—	—	—	—	—	—	—	—	—	—	—	—	—	—	⅓

▲ **Quick exposure guide**
To correct the exposure in close-up or macro work, read off the lens-to-film distance against the lens focal length. Then open the lens by the number of f-stops indicated. For example, with a lens-to-film distance of 150mm and a focal length of 60mm, increase exposure by 2⅔ f-stops.

▼ **Instant exposure scales**
These two scales have been worked out for 35mm and rollfilm formats, and are extremely simple to use. First compose the photograph and adjust the focus. Then aim the camera at the scale below, moving it or the book until the figures appear sharp (do not alter the focus). When the large arrow is close up against the left edge of the frame as you look through the viewfinder, the last figure you can see on the right is the extra exposure.

6 × 6cm format (for 6 × 7 cm, use shorter side)
f-stop increase
| 4 | 3 | 2 | 1⅔ | 1⅓ | | 1 | | ⅔ |

Exposure increase
| 16.0 | 8.0 | 4.0 | 3.2 | 2.5 | | 2.0 | | 1.6 |

35mm format
f-stop increase
| 4 | 3 | 2 | 1⅔ | 1⅓ | 1 | ⅔ | ⅓ |

Exposure increase
| 16.0 | 8.0 | 4.0 | 3.2 | 2.5 | 2.0 | 1.6 | 1.3 |

Lens extension: reproduction ratios and magnification						
	50mm lens		100mm lens		200mm lens	
Extension (mm)	Reproduction ratio	Magnification	Reproduction ratio	Magnification	Reproduction ratio	Magnification
5	1:10	0.1×	1:20	0.05×	1:40	0.025×
10	1:5	0.2×	1:10	0.1×	1:20	0.05×
15	1:3.3	0.3×	1:7	0.15×	1:13	0.075×
20	1:2.5	0.4×	1:5	0.2×	1:10	0.1×
25	1:2	0.5×	1:4	0.25×	1:8	0.125×
30	1:1.7	0.6×	1:3.3	0.3×	1:7	0.15×
35	1:1.4	0.7×	1:2.8	0.35×	1:6	0.175×
40	1:1.2	0.8×	1:2.5	0.4×	1:5	0.2×
45	1:1.1	0.9×	1:2.2	0.45×	1:4.4	0.225×
50	1:1	1×	1:2	0.5×	1:4	0.25×
55	1.1:1	1.1×	1:1.8	0.55×	1:3.6	0.275×
60	1.2:1	1.2×	1:1.7	0.6×	1:3.3	0.3×
70	1.4:1	1.4×	1:1.4	0.7×	1:2.8	0.35×
80	1.6:1	1.6×	1:1.2	0.8×	1:2.5	0.4×
90	1.8:1	1.8×	1:1.1	0.9×	1:2.2	0.45×
100	2:1	2×	1:1	1×	1:2	0.5×
110	2.2:1	2.2×	1.1:1	1.1×	1:1.8	0.55×
120	2.4:1	2.4×	1.2:1	1.2×	1:1.7	0.6×
130	2.6:1	2.6×	1.3:1	1.3×	1:1.5	0.65×
140	2.8:1	2.8×	1.4:1	1.4×	1:1.4	0.7×
150	3:1	3×	1.5:1	1.5×	1:1.3	0.75×

50mm lens on 35mm camera, focus ∞				
Add supplementary lens:	+½ diopter	+1 diopter	+2 diopters	+3 diopters
Reproduction ratio	1:40	1:20	1:10	1:6
Magnification	0.025×	0.05×	0.1×	0.17×
50mm lens on 35mm camera, focus 3 feet (1 m)				
Reproduction ratio	1:20	1:10	1:6	1:5
Magnification	0.05×	0.1×	0.17×	0.2×

▼ **Close-up exposure increase**
If you have worked out the reproduction ratio or magnification, increase exposure in accordance with this table.
R = reproduction.
M = magnification.
E = exposure increase.
F = exposure increase in *f*-stops and **X** = decrease in flash to subject distance. The latter is an alternative to **F**.

R	M	E	F	X
1:10	0.1×	1.2	⅓	1.1
1:5	0.2×	1.4	½	1.2
1:3.3	0.3×	1.7	⅔	1.3
1:2.5	0.4×	2	1	1.4
1:2	0.5×	2.3	1⅓	1.5
1:1.7	0.6×	2.6	1⅓	1.6
1:1.4	0.7×	2.9	1½	1.7
1:1.2	0.8×	3.2	1½	1.8
1:1.1	0.9×	3.6	1⅔	1.9
1:1	1×	4	2	2
1.2:1	1.2×	4.8	2⅓	2.2
1.4:1	1.4×	5.8	2½	2.5
1.6:1	1.6×	6.8	2⅔	2.7
1.8:1	1.8×	7.8	3	2.8
2:1	2×	9	3⅓	3
2.2:1	2.2×	10.2	3⅓	3.2
2.4:1	2.4×	11.6	3½	3.5
2.6:1	2.6×	13	3½	3.7
2.8:1	2.8×	14.4	3⅔	3.8
3:1	3×	16	4	4

TTL readings
Measuring the light that actually reaches the film plane clearly removes all the problems associated with calculating lens extension and exposure factors. Most 35mm SLRs are equipped with this facility for continuous light sources, although the lower limit of sensitivity may not always be sufficient (in such a case, increase the film speed setting temporarily until a reading registers, then make allowance for the difference between this film speed and that of the film you were using). Flash TTL metering, on the other hand, is at the time of writing relatively unsophisticated, being normally confined to use with dedicated flash units. This reduces flexibility in choosing flash sources. The solution, if you want to use mains-operated flash units, is to use a booster attachment with a hand-held flash meter. With the system shown here, the booster augments the sensitivity by degrees that can be calibrated, and has a receptor that can be placed in the viewfinder eye-piece or, as here, directly on the film gate.

▶**Close-up field kit**
Close-up photography generally demands considerable additional equipment, and although only one or two focal lengths are really needed, the extra equipment necessary to extend the lens and to provide extra illumination makes for a heavier camera bag than in normal photography. The array shown here is comprehensive for a field trip – probably more than you might actually need. It includes a TTL-metered flash system of two dedicated flash units with appropriate connecting leads, and a non-automatic pre-set flash system, using two small units designed to be mounted at the front of the lens in a calibrated position (for which the *f*-stop is already known from prior testing).

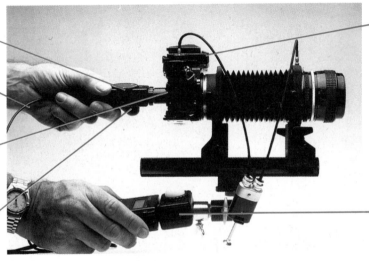

Dial for calibration

Cable attaches booster to meter

Shield covers shutter opening, fires film plane reading

Booster has own battery, amplifies light signal to exposure meter. Its measuring range is the equivalent of EV -6.3 to EV17 at ISO 100

Shutter is locked open for reading

Flash meter allows accurate TTL reflected light readings when using studio flash units (i.e. non-dedicated)

Tripods for field use
For outdoor close-up work, the majority of natural subjects are close to ground level. A pocket tripod (as shown packed in the bag *opposite*) is one alternative. Another, *right* is a regular tripod that has settings to allow the legs to be opened wide. If there is a center column, the depth of this below the tripod head will set the limit of how low the camera can be positioned. However, reversing the center column so that the tripod head is underneath will position the camera next to the ground if necessary.

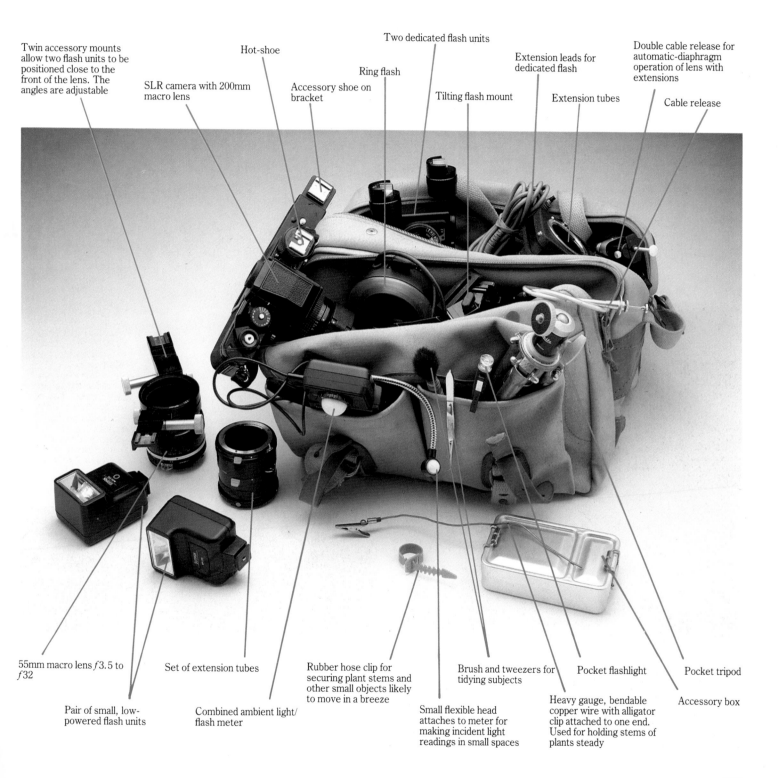

Twin accessory mounts allow two flash units to be positioned close to the front of the lens. The angles are adjustable

Hot-shoe

Two dedicated flash units

Ring flash

Extension leads for dedicated flash

Double cable release for automatic-diaphragm operation of lens with extensions

SLR camera with 200mm macro lens

Accessory shoe on bracket

Tilting flash mount

Extension tubes

Cable release

55mm macro lens f 3.5 to f 32

Set of extension tubes

Rubber hose clip for securing plant stems and other small objects likely to move in a breeze

Brush and tweezers for tidying subjects

Pocket flashlight

Pocket tripod

Pair of small, low-powered flash units

Combined ambient light/flash meter

Small flexible head attaches to meter for making incident light readings in small spaces

Heavy gauge, bendable copper wire with alligator clip attached to one end. Used for holding stems of plants steady

Accessory box

Working through a real example will serve better than the theory of close-up photography to demonstrate the practicalities. Use this as a guide for your own project; most of the steps will apply, even though the set-up will be different.

As you can see, this is a large-format photograph, but do not be put off because it seems to bear little relation to 35mm equipment. A 4 × 5 inch view camera was used to make it easier to add the landscape after the principal photography was done; an exercise in special effects work which we will not go into here, as it involves quite

different techniques. Nevertheless, apart from the swing movements used to align the plane of sharp focus with the gambling chip, there is nothing here that cannot be performed with a 35mm SLR (and some extension bellows for 35mm cameras include this facility). As the depth of field in a 35mm format is much greater than in a 4 × 5 inch, movements are, in any case, less necessary. For comparison, the equivalent 35mm set-up is shown *below*.

Note the use made of ordinary unspecialized lighting: two small flash lights. One of the beauties of close-up photography

is that at this scale very small light sources can be used, and can also be improvised. Tungsten-balanced film was used, with an 82C light bluish filter to compensate for the low temperature of the light. The small illuminated light box underneath the chip was used only for ease of focusing and does not feature in the final lighting effect.

As the subject in close-up photography is much smaller than the camera, lens and bellows, it is usually easier to lock the equipment into a convenient configuration, and then make the most of the adjustments to the subject. Hence the vertical set-up.

◄ The final result is a greatly enlarged (2½×) view of a casino chip, made to appear monolithic by the choice of lens (wide-angle) and the later addition of a landscape. The techniques involved in combining the two images of the chip and the landscape use silhouette masks made on line film, but were performed quite separately from the close-up photography shown here.

▼ **35mm equivalent set-up**
The camera configuration needed to shoot the same image with a 35mm SLR includes a bellows extension and a 28mm lens reversed for optimum image quality.

This focal length, roughly the equivalent of the 90mm lens used on the view camera, is needed to give a strong perspective effect (required for the monolithic impression).

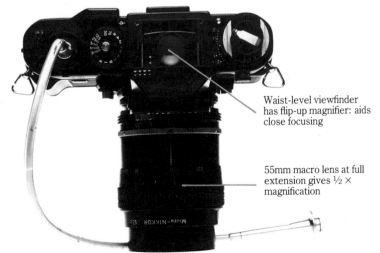

Waist-level viewfinder has flip-up magnifier: aids close focusing

55mm macro lens at full extension gives ½ × magnification

1 Placing the chip on the camera's focusing screen helps in judging the ideal magnification, which in this case will be 2½×. A strong perspective is needed for the final effect, so a wide-angle lens is fitted. As the magnification will be greater than life size, the lens is reversed.

2 With the camera mounted securely pointing downwards, the chip is positioned with a miniature clamp and claw grip (the base of the chip will not appear in the shot).

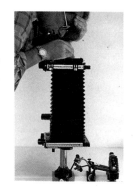

3 The back of the camera is extended until the chip appears at the right size and in focus. A loupe makes focusing much easier.

4 To align the plane of sharp focus with the face of the chip, both front and rear panels of the camera are swung (see pages 48–51). This is, of course, only practical when the subject is flattened in one plane. The chip is ideal for this.

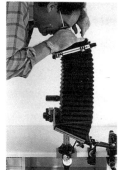

5 A final check is made for focus and to make sure that the angles of the two camera swings are accurate. With these movements, the only depth of field needed is sufficient to cover the thickness of the chip. The aperture is set at f11.

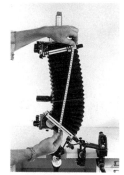

6 The extension is measured. Note that the measurement is made from the center of the lens. In fact, two measurements are made: one to each side of the film plane to see if there is a significant difference.

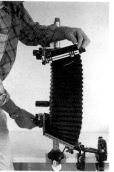

7 Ordinary flash lights are positioned on clamps to light both the front face and the edge of the chip.

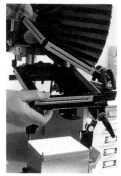

8 The lens shade is fitted and adjusted precisely. This is particularly important in close-up photography because the lights, as here, must usually be placed very close to the subject (for maximum illumination).

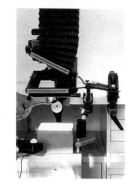

9 The light level is measured, using a hand-held incident meter fitted with a small, flexible probe. The reading for the film used is 45 seconds at the f45 aperture already set up.

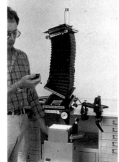

10 The exposure is made, using a stop watch. Allowance for the bellows extension and reciprocity failure gives an exposure of three minutes (see table on page 170). The room lights are turned off for the exposure.

Viewing Alternatives

The viewing screens and finders supplied with the camera may not necessarily be the best for you. It is often possible to substitute alternatives, or to add finders for different purposes. The available range of focusing screens for your particular camera is always worth investigating: most 35mm SLRs have a large variety. In some models, screens can be interchanged easily; in others, a different screen can be specified when you order the camera, and it will be fitted by the manufacturer or distributor.

Interchangeable viewfinders

Some professional SLR models allow the standard pentaprism viewing head **1** to be removed easily. This in itself allows waist-level viewing (ambient light normally makes it necessary to shade the screen with your hand if you do this). Alternative finders are available as specific aids to different types of photography.

The actionfinder/speedfinder **2** gives an enlarged view that is projected back a few inches. Its advantage is that the image can be seen very clearly before the camera is pressed right up to your face; it can also be used in underwater housings or if snow goggles are being worn.

The waist-level finder **3** is a collapsible hood that shields the screen from light, and also incorporates a pop-up magnifying glass. It is a useful aid to composition, but easier for a horizontal than for a vertical shot.

The magnifying head **4** is adjustable to the user's eyesight, and gives a right-angled view, useful for critical focusing, as in close-up work.

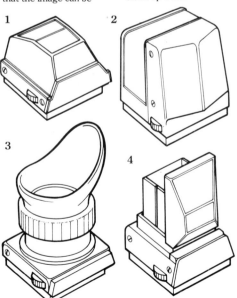

Plain ground glass screen

This is the simplest focusing screen design of all, and so has the least limitations. Like all 35mm SLR screens, it is backed with a Fresnel lens to give the appearance of even illumination across the screen area. Compared with an unadorned ground glass screen, such as is normally fitted to view cameras, a faint pattern of concentric rings from this Fresnel lens makes focusing marginally less easy, but this is more than offset by the extra brightness that it gives to the viewing image. The center circle on this Nikon F3 screen measures ½ inch (12mm) and marks the area from which 80 per cent of the exposure measurement is made (see pages 13–15). Focusing technique with this screen is simply to judge the apparent sharpness of detailed parts of the image – for instance, the eyelashes or edge of the pupils in this case. This screen is particularly useful for telephoto lenses, through which the focusing range is great. It is a little less easy to use with wide-angle lenses.

Grid screen

This design is essentially a plain ground glass screen, as *above*, with a vertical and horizontal grid overlaid. Its principal use is in types of photography where it is important to maintain verticals and horizontals accurately, and so is ideal for architectural work and copying. If you have any difficulty in keeping the horizon line level (not uncommon with extreme wide-angle lenses), this screen will help. An ancillary use is to give a quick indication of the framing with a longer lens: a quarter of the grid shown here is nearly eight times less in area than the full frame, so that if you were using a 100mm lens, this section would give roughly the framing that you would get with a 250mm lens.

Cross-hair screen

Extremely accurate focusing is essential in photomacrography and photomicrography, and for this a normal matt screen finish is often a disadvantage (the ground glass screen reduces the critical accuracy of focusing). Instead, this cross-hair screen is very finely ground, and has a clear central spot ⅙ inch (4mm) in diameter, in the middle of which is a cross-hair reticle. The clear area gives the brightest possible view, while the reticle helps maintain the eye's focus in this plane.

Micrometer screen
In copy photography and certain kinds of close-up photography, it is important to be able to make measurements and to determine reproduction ratios. The vertical and horizontal scales are graduated in 1mm steps.

Microprism spot screen
A microprism screen is a lattice-like arrangement of small prisms which have the effect of scrambling any image which is out of focus. In principle, small focusing movements produce very obvious changes, and as this part of the screen is clear (as opposed to ground), the image is very bright. Hence, microprism screens are particularly useful for low light levels. They work best, however, if the image has a fairly detailed structure. The size of the microprism spot varies among different makes, and a full-frame microprism is available for some cameras.

Split-image rangefinder and microprism collar screen
This is the standard design of screen that is fitted to most 35mm SLRs by the manufacturer, the reason being that it contains three methods of focusing: a plain ground glass surround and two aids. The central spot has two opposed prisms which separate the image when it is out of focus, as shown here. When the two halves match, the image is in focus. The microprism collar around this gives another indication of focus.

The problem with this design is not only that the viewing image is fussy, but that the split-prisms will only work for a limited range of focal lengths. In a standard focusing screen the prism is angled for use with lenses close to 50mm focal length. When focusing at smaller apertures, or with wide-angle and telephoto lenses, the refraction of the prism is too great and the image is blacked out. It is possible to buy focusing screens for certain cameras with prisms designed to work with wide-angle and telephoto lenses.

Ultra-bright telephoto screen
The standard rangefinder prisms and microprisms are usually unsatisfactory for long focal lengths, giving a half-black image.

Plain matt is the most preferred screen finish for telephoto lenses. In this example, a small central spot is specially ground for a brighter image.

177

Panoramic Sequences

Provided that you take an organized approach, a panoramic sequence is relatively straightforward to perform. The first step is to plan the view; its shape and extent will then give you a fair indication of how many features will be needed, and this in turn will determine which focal length to select.

Distortion is a major concern with any panoramic sequence. Look at the wide-angle distortion project on page 85, where using a short focal length causes distortion at the edges of the frame. As these are precisely the points in a panoramic sequence where the different images must match, you can see that this will not work with a normal scene. As a general rule, the longer the focal length the less the distortion. The angular movement between frames is very small with a telephoto lens, making accuracy particularly important.

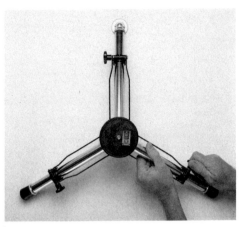
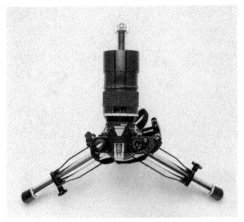

1 Level the tripod. Unless the tripod has a built-in spirit level, remove the tripod head and place a two-way spirit level on the platform. Adjust until the bubbles are centered.

2 Fit the tripod head, and the camera. Put the spirit level on the camera – ideally in the accessory shoe holder if there is one – and adjust the head until the camera is level.

▼The most straightforward method of assembling a panoramic strip is to have identically sized prints made from each frame of the film. Illustrated here is the first step, in which the prints are laid out on a sheet of clean, white art board. The overlap between each is deliberate, to avoid the risk of leaving any gaps between pictures, and you should allow for this when shooting. Inevitably, there will also be some slight vertical differences, also. To finish the panorama, carefully cut the underlying prints at the overlapping border, trim the top and bottom edges of the strip so that they are both horizontal, and paste down the final assembly.

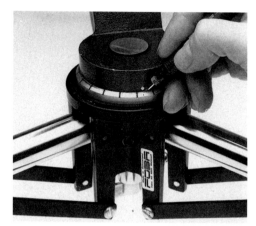

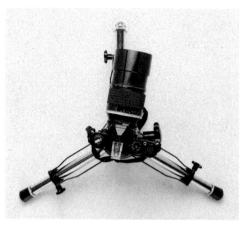

3 Rotate the camera by means of the pan movement on the tripod head. Do a dry run to work out the framing of each picture in the sequence. Mark each position with a fine-tipped pen.

4 Make the first exposure at the far left of the sequence, using the marks on the pan head as a guide. Continue, frame by frame, as far as the right limit.

▼To demonstrate the importance of using the right focal length, make a short panoramic sequence with a wide-angle lens. Here, a 24mm lens was used with a 35mm camera, and the stretch distortion at the edges of each frame are immediately obvious. Although the area covered is very wide, the assembled prints cannot be matched. In general, a moderate telephoto lens is the best choice for a panorama.

Cleaning and Repair

Cleaning

If you use camera equipment seriously and regularly, it will get dirty. Cocooning the camera to the point where you avoid shooting in exposed conditions for fear of losing its pristine condition is pointless; cameras are made to be used, not admired. A regular cleaning programme should be a natural part of the photography, however. The equipment will not clean itself, and you should constantly inspect everything. Additionally, if you expose the equipment to conditions that you know are damaging, do a special cleaning immediately you have finished. The most common conditions to be careful about are:

● Anywhere near sand. However benign they appear, beaches probably cause more camera damage than any other location. If sand gets inside any part of the camera or lens mechanism, it must be removed immediately. It can wear or even jam moving parts, and has a tendency to work itself deeper into the mechanism. In contact with the emulsion, it scratches. Never put any equipment directly onto a sandy surface.

● Windy, dry conditions. Wind often carries dust and other airborne particles. The remarks above for sand apply here. The extra danger is that if the equipment is exposed, it will attract dust. Although grain-for-grain it is less damaging than sand, dust penetrates more easily. Check by turning the focusing ring on the lens barrel and the rewind lever on the camera in silence: you will be able to hear a slight scraping if there is dust inside.

● Salt spray. If there is any on-shore wind close to the sea, there is a danger of salt deposits from fine spray. These deposits are greasy and should be removed with lens cleaning fluid or denatured alcohol, applied with a clean soft cloth. Salt water is more corrosive than fresh water, and is also more highly conductive (a danger for printed electrical circuits).

● Water. A light shower should do no harm to a modern camera, provided that you wipe it down afterwards. A more serious wetting, however, is a different matter. Strip the camera down as far as possible (for example take the back off, prism and lens off, and separate the motor-drive or power winder) and see how far the water has penetrated. If it is inside the mechanism, treat it as a repair and give it to a professional repair shop. Otherwise, dry it down and, if possible, play hot air on it from a hair dryer.

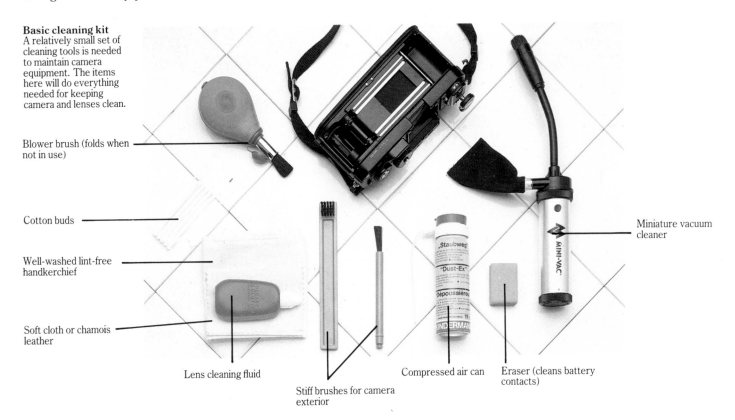

Basic cleaning kit
A relatively small set of cleaning tools is needed to maintain camera equipment. The items here will do everything needed for keeping camera and lenses clean.

Blower brush (folds when not in use)

Cotton buds

Well-washed lint-free handkerchief

Soft cloth or chamois leather

Lens cleaning fluid

Stiff brushes for camera exterior

Compressed air can

Eraser (cleans battery contacts)

Miniature vacuum cleaner

Cleaning
Develop a set procedure for your particular equipment, based on the one illustrated here.

Body
1 Separate all easily-removable components and blow dirt and film scraps from inside the body: film compartments, area around the mirror, and under prism head, if removable.

2 Work around crevices and corners of the outside with a toothbrush. Avoid the lens, mirror and screen.

3 Loosen particles in delicate areas with a soft brush, use the blower a second time on all areas and work a lightly moistened cotton bud around crevices.

4 Wipe all parts with a soft, lint-free cloth and use an anti-static gun or brush on the interior.

5 Operate all moving parts and listen for scraping dust particles.

Lens
1 Treat the lens barrel like the camera body. Then remove the ultra-violet filter and blow on the lens surfaces to remove loose particles, before brushing the lens with a camel-hair brush.

2 Use the blower once more, and wipe gently with a clean soft cloth (not the one already used on the camera body), using a circular movement, spiralling outwards from the center of the lens. Replace the cleaned ultra-violet filter.

Repair

While few people would dispute that camera repair ought to be left to the manufacturer or professional repair shops, if the damage is preventing you from taking an important shot, there is a case for DIY repair.

Essentially, what we are talking about here is emergency repair; the kind that is necessary just to keep the camera going until you are able to hand it in for professional repair. The risks are great, particularly with equipment that has a large proportion of electronic functions, and you should assess the strong possibility that your temporary emergency repair may make the ultimate professional job more difficult and expensive against your need to continue shooting.

If you are mechanically minded, however, and are prepared to learn the basics of how your equipment works, there is no reason why you should not attempt *simple* repairs. No manufacturer will give you access to a technical repair manual, but many physical repairs due to obvious damage are relatively simple. If, incidentally, you ever do such serious damage to a piece of equipment that it has to be written off, keep it and dismantle it so that you can learn something of the way it functions.

Having said this, there is no doubt that the best method of avoiding having to undertake emergency repair is to have a spare piece of equipment. This is not really practical with lenses, but is a sensible precaution with camera bodies.

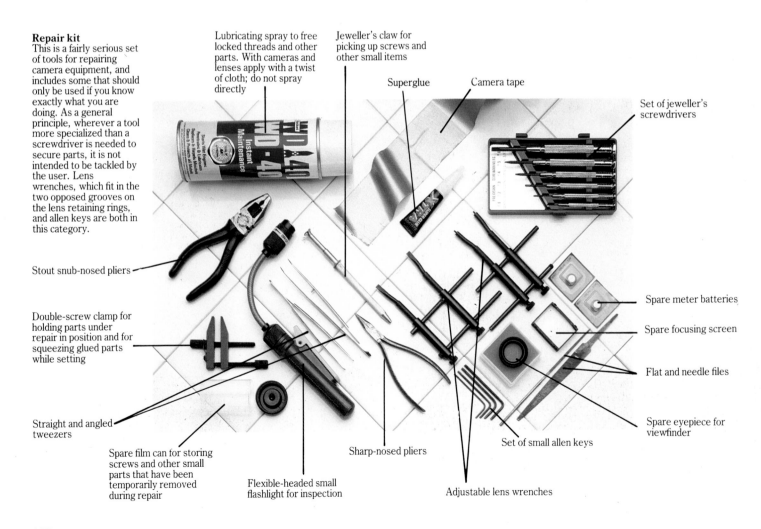

Repair kit
This is a fairly serious set of tools for repairing camera equipment, and includes some that should only be used if you know exactly what you are doing. As a general principle, wherever a tool more specialized than a screwdriver is needed to secure parts, it is not intended to be tackled by the user. Lens wrenches, which fit in the two opposed grooves on the lens retaining rings, and allen keys are both in this category.

Lubricating spray to free locked threads and other parts. With cameras and lenses apply with a twist of cloth; do not spray directly

Jeweller's claw for picking up screws and other small items

Superglue

Camera tape

Set of jeweller's screwdrivers

Stout snub-nosed pliers

Double-screw clamp for holding parts under repair in position and for squeezing glued parts while setting

Straight and angled tweezers

Spare film can for storing screws and other small parts that have been temporarily removed during repair

Flexible-headed small flashlight for inspection

Sharp-nosed pliers

Adjustable lens wrenches

Set of small allen keys

Spare meter batteries

Spare focusing screen

Flat and needle files

Spare eyepiece for viewfinder

◄A set of jeweller's screwdrivers, both regular and cross-head, can be used for basic dismantling. As a rule, never open anything unless you are familiar with what is inside and what you are doing. The greatest danger is with springs and other parts that are held under tension. Removing a protective plate may release this tension; at best this may leave you uncertain about how to re-assemble, at worst the part may fly off and become lost.

▲For parts that have accidentally been bent out of shape (here the external linkage for the automatic diaphragm stop-down lever on a Nikon), use sharp-nosed pliers padded with a soft cloth or piece of chamois leather. Hold the piece of equipment firmly, and be gentle.

▼Superglue is one of the most versatile tools in a repair kit, but use it with extreme caution. It is very unforgiving of mistakes and must be used quickly. Apply with a small sharp implement rather than the tube (inadvertent pressure may squirt too much onto the part being repaired); a sharpened matchstick is ideal. Keep a bottle of removing solvent nearby in case of mistakes. Here the glue is used to re-fit leatherette covering which has come loose.

Although superglue can be used for more drastic surgery, bear in mind that, once set hard, it is virtually impossible to remove and, although you may have made the camera usable, it may be beyond complete restoration.

▼Gaffer tape is extremely strong, and can be used to bind broken parts as well as sealing light leaks. If, for example, the prism head is damaged so that the connecting lugs are broken, it can be bound firmly to the body with cross-wrapped thin strips.

Packing and Storage

Packing

Although a shoulder bag is ideal for carrying cameras when you are shooting, it is not necessarily the best method for transporting them. Most professional photographers travel with their equipment securely packed in hard cases, then transfer what they need for a day's shooting to a soft shoulder bag. This combination is necessary if the equipment is to be handled by other people, as check-in baggage on aircraft, for example. Also, if the environmental conditions are potentially damaging, you may consider continuing to work from a protective case. Back-packing in mountains or photographing from a boat would fall into this category.

The criteria for choosing a case are that it should offer maximum protection, be a convenient size, and be reasonably light (weight restrictions on aircraft are a constant problem for most photographers). Appearance is at the bottom of the list.

Secure padding inside is essential. One method is to carve compartments for specific items of equipment into a block of foam (make sure that it is closed-cell foam) which fits the case precisely. Another, for when the selection of equipment varies from trip to trip, is to wrap each piece individually in padded material. Always fill up the entire space, using foam blocks or cloth if there are gaps. This prevents equipment shifting around during transit.

Storage

When not in use, camera equipment needs care in a slightly different way, and if you are likely to be leaving it packed away for a couple of months or more, you should follow these standard procedures:

- Remove all batteries. They all leak a little, and over a period of a few months, the gas, salt or liquid that they emit can corrode the contacts and compartment inside the camera. There is no need to throw them away; just store them separately.

- Clean the equipment thoroughly before storing it. Deposits that you might think harmless, such as from a fingerprint can, given enough time, damage glass. Pay particular attention to the lens surfaces, instant-return mirror, viewing screen and prism.

- Release the tension of springs. The shutter, mirror mechanism and automatic diaphragm system all operate under tension in most cameras. Before packing, fire the shutter and do not wind on, lock the mirror up and open the lens diaphragm to full aperture.

- Remove film from the camera. Apart from the fact that film should either be developed or cold-stored for its own good, it is likely to distort if left in the camera. This might jam the wind-on mechanism.

- Protect the equipment from dust by wrapping and sealing it, ideally in plastic. Include a sachet of silica gel desiccant to absorb residual moisture. However, as the lubricants and some of the materials (such as the leatherette covering) emit fumes, it is a good idea to unwrap and air the equipment every month. For the same reason, store lenses separately from the camera body: the lubricants for the focusing mechanism (and for zoom mechanisms) give off more fumes than any other part of the equipment.

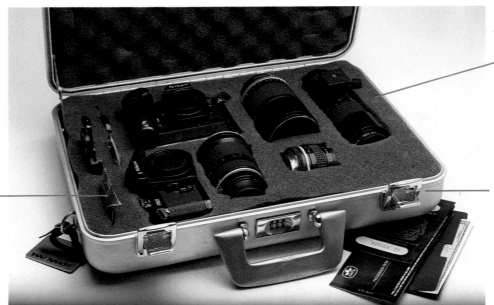

Aluminium case
Models such as this Halliburton are designed for good protection against physical damage, and appearance. Disadvantages are that they are not always completely waterproof (here, the combination lock admits water) and they are vulnerable to scuffing.

Filters and other thin items fit into slits carved with a knife

Close-cell foam block is intended to be carved with a knife

Moulded aluminium case has rounded corners for extra strength

ABS cases
These are among the most functional of hard case designs, and will seal so efficiently that they will float in water. Here the equipment is shown with a variety of individual padding. An alternative would be a carved foam block.

Bubble-laminated plastic wrap

Foam sheet secured with rubber bands makes a simple padding

Rubber O-ring makes an airtight gasket seal when lid is closed. Pressure purge in base of case unscrews to equalize pressure (necessary after an airline flight)

Closed-cell foam block fills empty spaces in case

Padded general purpose soft case, sealed with velcro tabs

Indented closed-cell foam block in lid

Press-seal plastic envelope

Shoe-cleaning mitts from hotels make soft bags for small equipment

Small plastic cases for bits

Synthetic ABS moulded case is one of the toughest and most rugged available. In combination with gasket seal and interior padding, it offers a completely waterproof and dustproof protection

Zipped soft leather lens cases

Soft synthetic outer covering backed with waterproof lining. Square sheet with velcro tabs at corners can be folded to wrap around a variety of equipment, from camera bodies to lenses

Nylon stuff-sack from camping suppliers

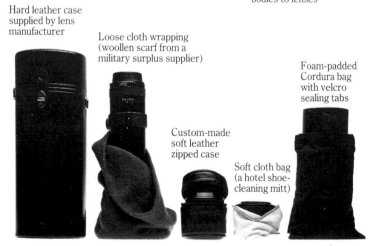

Hard leather case supplied by lens manufacturer

Loose cloth wrapping (woollen scarf from a military surplus supplier)

Custom-made soft leather zipped case

Soft cloth bag (a hotel shoe-cleaning mitt)

Foam-padded Cordura bag with velcro sealing tabs

Lens cases
Unless your camera bag has individual padded compartments, lenses need some physical protection. This can vary from purpose-made to improvised.

Glossary

Aberration General term for the failure of a lens to focus a sharp, accurate image. Aberrations, which include astigmatism, coma, field curvature and diffraction, may have very different causes. Compound lens designs is one of the principal methods of reducing aberrations.

ABS plastic Plastic compound used for camera cases and bodies. Properties include high impact strength and good tensile strength, rigidity, heat-resistance and chemical resistance.

Accessory shoe Fitting on the body of a camera that is designed to accept accessories and portable flash units. *See also* **Hot shoe.**

Achromat Lens corrected for chromatic aberration in simple lenses to give the same focal length on two wavelengths.

Adapter ring Mount that allows the attachment of lenses and filters, etc, with different diameters or design.

Additive colour The method of producing different hues by combining light. Three primary colours added together in equal proportions gives white light.

Aerial perspective The visual effect of depth in a scene created by atmospheric haze, which makes the more distant parts of the view appear lighter in tone, paler in colour and have less contrast.

Amphibious camera Camera designed to operate when completely submerged under water, with gasket-like seals fitted to all compartments that can be opened.

Anastigmat Lens that has been corrected for astigmatism.

Angle of view The maximum width of a scene that a lens will project onto the picture format, measured as the angle from the lens. It varies with the focal length of the lens and the film format.

Aperture Central opening in or in front of a lens that restricts the amount of light passing through. In most lenses it is adjustable in size and more or less circular.

Aperture-priority camera Camera that incorporates an automatic exposure system in which the photographer selects the aperture and the camera meter adjusts the shutter speed accordingly.

Apochromat Lens corrected so as to focus three wavelengths of light together at one point.

Area light Diffused photographic lighting in the form of a box that encloses the lamp, fronted with a translucent material. The effect is similar to that of indirect daylight through a window.

ASA Speed rating for film and other photographic emulsions devised by the American Standards Association. It is arithmetically progressive; a film that has twice the value of another is twice as sensitive to light. It is now incorporated in the universally accepted ISO system. *See also* **ISO.**

Aspheric lens Lens in which at least one surface has a curve that is not a section of a sphere. Although expensive to grind, aspherical elements help to reduce certain aberrations.

Astigmatism Lens aberration in which a point off the lens axis is focused at the image plane not as a point but as two short lines, at right angles to each other.

Autofocus Camera system in which the lens is focused automatically, either passively by measurement of a small central area of the picture, or actively by responding to an ultrasonic or infra-red pulse emitted by the camera.

Automatic exposure Camera system in which a photo-electric cell measures the light reflected from the scene and adjusts the amount of it that is admitted to the film accordingly.

Back focus Distance between the rear of the lens and the image plane for an infinitely distant object. In lenses designed to save space behind the rear elements, such as telephotos, the back focus is less than the focal length.

Barrel distortion Lens aberration in which the shape of the image is deformed. Away from the center, the magnification of the image decreases, so that straight lines parallel to and close to the edges appear as convex curves. Characteristic of fish-eye lenses. *See also* **Pincushion distortion.**

Barn doors Adjustable masks fitted to the front of a photographic lamp to prevent light from spilling at the sides.

Bellows Light-tight flexible sleeve, usually of a concertina-like construction, that allows the lens to be moved for focusing and other changes to the image. Fitted to view cameras, some rollfilm cameras and close-up extenders.

Between-the-lens shutter Shutter located within a compound lens which operates by means of the opening and closing of a central aperture.

Blur Unsharpness in an image caused by movement, either of the subject or the camera, or by inaccurate focusing.

Bracketing Shooting technique in which the same picture is photographed a number of times, with varying exposure settings. It is mainly used to overcome uncertainty as to what will be the most appropriate exposure.

Bright-line viewfinder Non-reflex camera viewfinder in which a bright frame outlines the exact image area.

Brightness range The range of luminance in a subject, from the darkest to the lightest tones. Commonly measured as a ratio or in *f*-stops.

Cable release Flexible cable that attaches to the shutter release; used for firing the shutter without the risk of vibration from touching the camera body.

Cadmium sulfide cell Abbreviated to CdS cell. Battery-powered photosensitive cell used in light meters. The amount of light varies its electrical resistance.

Camera angle The direction of view of a camera, particularly with reference to the angle above or below horizontal.

Camera movements Mechanical adjustments to the position or angle of the lens and the camera's film back. Usually refers to movements other than straightforward focusing, such as tilts and shifts, which allow changes to the shape and position of the image, and to the distribution of sharpness within it.

Cartridge Film supplied in container designed to be dropped into the camera without threading. Used mainly in inexpensive amateur camera formats.

Cassette Metal or plastic film container in which the film is wound on a spool, unwinding from a slit when loaded in the camera. Used for 35mm film and some rollfilm formats.

Catadioptric lens *See* **Mirror lens.**

Center of curvature The center of the sphere of which a lens surface is a section.

Center-weighted exposure Method of measuring the light reflected from a subject used in TTL metering. Extra value is given to the center of the frame, because this is typically where the most important parts of the subject are composed.

Chromatic aberration Lens aberration in which different wavelengths of light (colours) are brought to a focus at different distances behind the lens, so causing unsharpness, and sometimes a colour fringe.

Circle of confusion The appearance of points in the subject as projected by the lens onto the image plane. When they appear to the eye as discs rather than points, the image is unsharp. The circle of least confusion is the smallest image of a point obtainable by focusing a lens at a given aperture.

Click stop Graduation of the lens aperture control ring, by means of bearings, that allows the steps between *f*-stops to be heard and felt.

Close-up In general terms, a close, frame-filling image of a subject. Specifically, the scale of photography between the point at which exposure compensation is needed (due to lens extension) and life-size.

Coating Thin deposit on the surface of a lens designed to reduce flare through interference.

Colour balance The adjustment of any part of the photographic process to ensure that neutral greys in a subject will have no colour bias in the image.

Colour bias/colour cast Overall tinting of the image towards one hue.

Coma Lens aberration in which parallel oblique rays of light that pass through different zones of the lens come to focus at different distances behind the lens, producing comet-shaped images of object points.

Compound lens Lens constructed from two or more separate elements. Different shapes and curvatures make it possible to correct certain aberrations with a compound lens.

Concave lens Lens element in which the surfaces curve inwards towards the center, so causing the light rays passing through the lens to diverge.

Contact sheet print of all the frames of a roll of film made by exposing printing paper in direct contact with the negatives or transparencies.

Contrast Subjective appearance of the difference in brightness between different tones in the image.

Contrast range The range of tones, from darkest to lightest, in an image.

Convergence A perspective effect whereby parallel lines in a subject appear as non-parallel when projected as an image. It occurs when the camera angle is not perpendicular to the lines.

Converging lens *See* **Convex lens.**

Convex lens Lens element in which the surfaces curve outwards from the center, so concentrating light rays that enter. A convex lens allows parallel rays to be brought to a common focus.

Correction filter Coloured filter placed in front of the lens to record the colours of the subject on film as the eye sees them. The differences in response between the eye and film make this necessary.

Coupled rangefinder Focusing system for measuring distance which is connected to the focusing system of the lens.

Covering power The maximum diameter of image of a useful quality that is projected by a lens. It must be larger than the diagonal of the film format, and considerably larger if camera movements are to be used.

Darkcloth Black cloth used to shield the photographer from surrounding light when looking at the relatively dim image on the focusing screen of a view camera.

Darkslide Metal or plastic sheet that protects sheet or rollfilm from light in its holder or magazine. Can be removed after the holder has been attached to a camera, thereby allowing the film to be exposed.

Daylight film Colour film balanced for use with daylight and electronic flash. In practice, different makes of film are balanced for colour temperatures of between 5000°K and 5500°K.

Dedicated flash Portable flash unit designed for use with a specific camera model, linking directly with the camera's internal circuitry.

Depth of field (DOF) The distance between the nearest and farthest points in a subject that appear acceptably sharp in an image. The smaller the lens aperture, the greater this subjective impression.

Depth of focus The distance that the film can be moved towards and away from the lens and still give an acceptably sharp image without the need for re-focusing.

Diaphragm The adjustable construction of a lens aperture.

Diffraction Lens aberration in which light rays are scattered by the sharp edge of the aperture, causing unsharpness.

DIN German speed rating for film (Deutsche Industrie Norm), being logarithmically progressive.

Diopter Measurement of the refractive power of a lens; positive for convex lenses, negative for concave. Used to express the strength of supplementary close-up lenses.

Direct reading Common term for reflected light measurement.

Distortion Deformation of subject shape in an image.

Diverging lens *See* **Concave lens.**

Double exposure Making two separate exposures on one frame or sheet of film.

Effective aperture Diameter of entering parallel beam of light that will just fill the opening of the lens diaphragm.

Electronic flash Light produced by passing an electric charge at high voltage through an inert gas in a sealed transparent container.

Electronic shutter Camera shutter timed and operated by electronic rather than the traditional mechanical means.

Endoscope Optical device incorporating a miniature lens and fiber optic channel to project an image from small, otherwise inaccessible locations.

Exposure In photography, the amount of light that reaches the film. It is a product of the intensity of the light and the time it is allowed to fall on the film.

Exposure latitude The amount of over-exposure or under-exposure that can be given to a film and still produce an acceptable image with standard processing.

Exposure meter Instrument for measuring the amount of light reflected from a subject or falling on a subject. May be incorporated in a camera or separate.

Exposure value Abbreviated to EV. Series of values for light that link the shutter speed and aperture. A single EV number can represent, for example, $\frac{1}{60}$ sec at $f5.6$ *and* $\frac{1}{250}$ at $f2.8$.

Extension tube or ring Rigid tube that fits between the lens and camera body to allow increased magnification. Available in different thicknesses.

f-number/f-stop The standard notation for relative aperture of a lens. Calculated from the lens focal length divided by its effective aperture, it allows direct comparison of the light transmission of different lenses. The standard series, $f1$, $f1.4$, $f2$ and so on, is in steps of a factor of two; each higher number represents a halving of the light transmission.

Fast film Film that is more sensitive than average to light.

Fast lens Lens with a wide maximum aperture (described by the smaller *f*-number), and so greater light-gathering ability.

Fiber optic Bundle of flexible glass strands that carry light with very little loss over a distance. If the strands are ordered along the length of the bundle, they will carry an image.

Field camera View camera of light-weight construction that can be folded for portability. Designed for outdoor use.

Field curvature Lens aberration in which the image is focused as a curve rather than as the flat surface of the film plane. Causes loss of sharpness across the image.

Fill or fill-in light Illumination of shadow areas in a subject.

Film holder For sheet film, a light-tight container that fits into the back of a view camera to allow exposure once the dark-slide has been withdrawn.

Film plane The plane at the back of the camera on which the film lies and on which the image is focused.

Film speed The sensitivity of film to light, now measured as its ISO rating.

Filter Transparent attachment for a lens that is usually tinted or coloured to absorb or modify some of the wavelengths of the light entering the lens.

Filter factor Number by which the exposure must be multiplied to compensate for the amount of light absorbed by a filter.

Fish-eye lens Extreme wide-angle lens in which curvilinear distortion remains uncorrected to allow coverage of over 180°.

Flag Sheet of black material or card used to obtain desired lighting effect or to shade camera from light that could cause flare.

Flare Non-image-forming light caused by scattering in the lens, degrading the image quality.

Flash Artificial light source, giving a very brief pulse that must be synchronized with the time that the camera shutter remains open. Flash bulbs are expendable, but now much less common than electronic flash. *See* **Electronic flash.**

Flash synchronization Method of ensuring that the light output from a flash unit coincides with the time that the camera shutter is open.

Flat-bed camera View camera construction in which the front and rear parts are supported on and move along a flat rigid base.

Floating lens elements Elements in a compound lens that move in relation to the others during focusing. Used particularly in zoom lenses, to ensure optimum correction of aberrations at different focus settings.

Focal length Distance between the rear nodal point of a lens and the focal plane, when the lens is focused on infinity. Used to classify lenses.

Focal plane Plane perpendicular to the lens axis at which the image is sharply focused.

Focal plane shutter Camera shutter system consisting of blinds immediately in front of the focal plane. The blinds open and travel across the plane.

Focal point Point on the lens axis where light rays from a subject meet.

Focusing Moving the lens or lens elements in relation to the focal plane to produce a sharp image.

Focusing hood Raised shield on a camera to prevent surrounding light from interfering with the view projected onto the focusing screen.

Focusing screen Glass or plastic screen mounted in the camera either at the film plane or at an equivalent off-axis distance, to allow accurate composition and focusing.

Follow focus Technique in which the focusing ring on the lens is turned at the same rate as the approach of a

moving subject, so that the subject remains sharply focused.

Format Size and shape of film or picture area.

Fresnel lens An almost flat lens that has the properties of a convex lens, by means of a series of concentric circular steps. Combined with a focusing screen, it distributes the image brightness evenly across the frame.

Fully automatic diaphragm Abbreviated to FAD. SLR camera system that allows full-aperture viewing up to the moment of exposure, stopping the lens down to a pre-selected aperture when the shutter release is pressed and just before the shutter opens.

Gelatin filter Thin filters for use in front of lenses, made from dyed gelatin sheet.

Grey card Card used as a standard subject for a reflected light meter such as the TTL meter in a camera. It reflects 18% of the light striking it, and so represents mid-tones.

Ground glass screen Sheet of glass etched finely on one side. Used for focusing panels in cameras, the image is viewed from the other, clear side.

Guide number Measurement of light output commonly used to designate the power of a flash unit. When the guide number is divided by the distance in feet or meters to the subject, it gives the aperture setting for a given film speed.

Highlights The brightest areas of a subject.

Hot shoe Fitting on the outside of a camera similar to an accessory shoe, but containing the electrical contacts necessary to trigger a flash unit when the shutter release is pressed.

Hyperfocal distance The closest distance to the camera that appears sharp in the image when the lens is focused on infinity; it varies with the aperture. If the lens is focused on this point, the depth of field beyond it will extend just to infinity.

Incident light The light that falls on a subject, as opposed to the light reflected by it.

Incident light reading Exposure measurement of incident light, made with a translucent attachment to the exposure meter. This reading is independent of the subject reading.

Infinity Designated ∞ on lens distance scales. The distance from which light rays reach the lens parallel to each other.

Instant picture cameras and film Photographic system invented and marketed by the Polaroid Corporation in which processing is completed within seconds or minutes of the picture being taken, allowing the results of the photography to be assessed on the spot.

Instant-return mirror Mirror in a SLR camera that is angled to reflect the image upwards to a focusing screen before the picture is taken, but which flips out of the light path to the film during exposure, returning to its original position immediately afterwards.

ISO Current, internationally accepted film speed rating (International Standards Organization) made up of the ASA/DIN ratings (commonly abbreviated everywhere except Germany to the ASA rating).

Kelvin (°K) The standard unit of thermodynamic temperature, calculated by adding 273 to °C.

Key reading Exposure reading of the key tone only.

Key tone The most important tone in the subject being photographed, as judged by the photographer.

Latitude *See* **Exposure latitude.**

LCD (liquid crystal diode) Solid-state display used to show information in the camera viewfinder, in which the surface changes from transparent to black when an electrical charge is applied.

Leaf shutter *See* **Between-the-lens shutter.**

Lens axis Line through the center of curvature of a lens, in the direction of the angle of view.

Lens shade Attachment to shield the lens from flare, fitting the front of the lens.

Lens speed Measure of capacity of lens to admit light to the image, usually expressed by the *f*-number.

Light meter *See* **Exposure meter.**

Long-focus lens Lens with a focal length longer than that considered to give normal perspective. In practice, for 35mm format, longer than 50mm.

Luminance The amount of light reflected or emitted by a subject.

Macro lens Lens specifically designed to produce the best image quality at magnifications close to life-size.

Magnification The size relationship between a subject and its image.

Medical lens Macro lens designed specifically for medical and dental photography, which incorporates a ringflash.

Microprism Patterned array of small prisms used on certain focusing screens as a focusing aid.

Mid-tone Average level of brightness, between highlight and shadow, equivalent to a reflectance of 18%.

Mirror lens Lens, normally long-focus, that produces an image by combining transparent elements and mirrors. The mirrors reflect light back and forth and reduce the physical length of the barrel.

Mode The form of operation of a programmed automatic camera. There is normally a choice of modes in such cameras.

Monorail camera View camera construction in which the operating parts are supported on a monorail, similar to an optical bench.

Motor-drive Powered method of film transport and shutter operation that allows rapid sequences of photographs to be shot. Either an attachment or built into the camera.

M-sync Synchronization system for using a camera with flash bulbs.

Multiple exposure Making several exposures on one frame or sheet of film.

Multiple flash Firing a flash unit several times to build up the exposure on one frame or sheet of film.

Multi-pattern metering TTL metering system in which the exposure is measured from different parts of the frame, and the setting calculated accordingly.

Neutral density filter Grey filter that reduces exposure to the film when placed over the lens, without any alteration to the colour.

Night lens Fast lens, usually with an aspheric front element, designed for low-light photography.

Nodal plane Plane perpendicular to the lens axis that passes through the nodal points.

Nodal points Points in a compound lens where light rays converge (when entering) and from which rays diverge (when leaving). There are two such points: the front nodal point and the rear nodal point.

Optical axis *See* **Lens axis.**

Optimum aperture Aperture that gives the highest image quality for a given lens and conditions; a balance between conflicting aberrations.

OTF metering Off-the-film metering. A TTL metering system in which measurements are made at the last possible moment in shooting, when the shutter is open and the image is reflected off the surface of the emulsion.

Panning Swinging the camera to keep a moving subject centered in the frame.

Panoramic camera Camera that produces a film format longer than 1:3 for a wide horizontal field of view.

Parallax The apparent movement of objects in relation to each other when the viewing position is changed.

Pentaprism Five-sided prism used in the viewing system of a reflex camera; it rectifies the image projected onto the focusing screen.

Perspective-correction (PC) lens Lens that allows movement perpendicular to the lens axis and has greater covering power than the film format; this combination allows converging verticals to be corrected.

Photomacrography Photography at magnifications of between about $1\times$ and $10\times$.

Photomicrography Photography at extreme magnifications, using the optical system of a microscope.

Picture area The area of the subject that fills the picture frame of the camera.

Pincushion distortion Lens aberration in which image points are displaced outwards. The amount of distortion increases further from the lens axis, so that straight lines parallel to the edges of the image appear as concave curves. Converse of barrel distortion.

Plane of sharp focus The plane in front of the camera that is focused sharply as an image by the lens. Tilting the lens or film tilts the plane of sharp focus.

Point source A source of light that appears as a point, without dimension.

Polarization The action of reducing the random vibration of light waves to a single plane.

Polarizing filter Filter that polarizes light entering the lens.

Prism Transparent optical element with flat surfaces shaped to refract light.

Process lens Lens designed to produce the best quality images of flat subjects.

Pulling Under-rating the speed rating of a film and then under-processing to compensate.

Pushing Over-rating the speed rating of a film and then over-processing to compensate.

Rangefinder Device for measuring distance, fitted to non-reflex cameras as an aid to focusing.

Reflected light reading Exposure measurement taken directly from a subject of the light reflected from it. The normal method of TTL systems.

Reflex camera Camera that allows direct viewing of the image through the lens, by means of a mirror between the lens and a focusing screen. *See* **Instant return mirror.**

Refraction The bending of light rays as they pass through a transparent material.

Relative aperture Focal length of a lens divided by its effective aperture.

Reproduction ratio Relative proportions of the subject and its image.

Shutter Mechanical or electro-mechanical system for controlling the time of the exposure of film to light.

Selenium cell Photo-electric cell which generates its own electrical charge in proportion to the light striking it.

Shift Movement of the lens or film holder in a camera, perpendicular to the lens axis.

Shift lens *See* **Perspective-correction lens.**

Single-lens reflex Abbreviated to SLR. Camera design that allows the lens used for projecting the image onto film to be used for viewing also. *See* **Reflex camera.**

Slow film Film with low sensitivity to light, usually producing a fine-grained image.

Slow lens Lens with small maximum aperture.

Soft-focus filter Filter that deliberately reduces image sharpness in a controlled manner.

Speed *See* **Film speed.**

Spherical aberration Lens aberration in which light rays passing through the edges of a lens focus in front of the rays that pass through the lens axis. Can be corrected with an aspheric lens.

Spot meter Exposure meter that takes reflected light readings from a very narrow angle.

Standard lens Lens with a focal length that produces an image with a perspective similar to that of the unaided eye. For 35mm format, 50mm is considered the standard focal length.

Substitute reading Exposure measurement of a surface with reflective characteristics similar to the subject.

Supplementary lens Lens attached to the front of the prime lens that alters the effective focal length.

Swing Rotating movement of the lens or film holder around a vertical axis in a camera to alter the shape of the image or the distribution of sharpness within it.

Tele-converter Supplementary lens that fits between the prime lens and the camera body, to increase the focal length.

Telephoto lens Design of long-focus lens in which the lens-to-film distance is less than the focal length; in other words, a means of making the lens more compact.

Through-the-lens (TTL) meter Exposure meter built into a camera, measuring reflected light from the subject.

Tilt Rotating movement of the lens or film holder in a camera around a horizontal axis to alter the shape of the image or the distribution of sharpness within it.

Time exposure Exposure of several seconds or more.

View camera Large-format camera in which the image is viewed on a ground glass screen in the position of the film plane. After viewing, the film is inserted and exposed.

Viewfinder Optical aid to framing, usually on a non-reflex camera.

Viewpoint Camera position.

Vignetting Fall-off of illumination at the edges of an image.

Wide-angle lens Lens with an angle of view wider than that of a standard lens for the format.

Zoom lens Lens with a continuously variable focal length over a certain range.

Selected Bibliography

Adams, Ansel, *Camera and Lens,* Morgan & Morgan, 1970.

Auer, Michel, *The Illustrated History of the Camera: From 1839 to the Present,* New York Graphic Society, 1975.

Cox, Arthur, *Photographic Optics,* Focal Press, 1966.

Focal Encyclopedia of Photography, Focal Press Ltd, 1978.

Freeman, Michael, *The Complete Guide to Photography: Techniques and Materials,* Phaidon, 1982.

Freeman, Michael, *The Photographer's Studio Manual,* Collins (UK); Amphoto (US), 1984.

Freeman, Michael, *The 35mm Handbook,* Windward Books 1987.

Kingslake, Rudolf, *Lenses in Photography,* A. S. Barnes, 1963.

Langford, Michael, *The Complete Encyclopaedia of Photography,* Ebury Press, 1982.

Lens Work, Canon Inc., 1984.

'The Camera', *Life Library of Photography,* Time-Life Books, 1970–3.

Photography Year (annual series), Time-Life Books, 1973.

Stroebel, Leslie, *View Camera Technique,* Focal Press, 1970.

The Techniques of Photography, Time-Life Books, 1976.

Magazines
Modern Photography
Popular Photography

Index